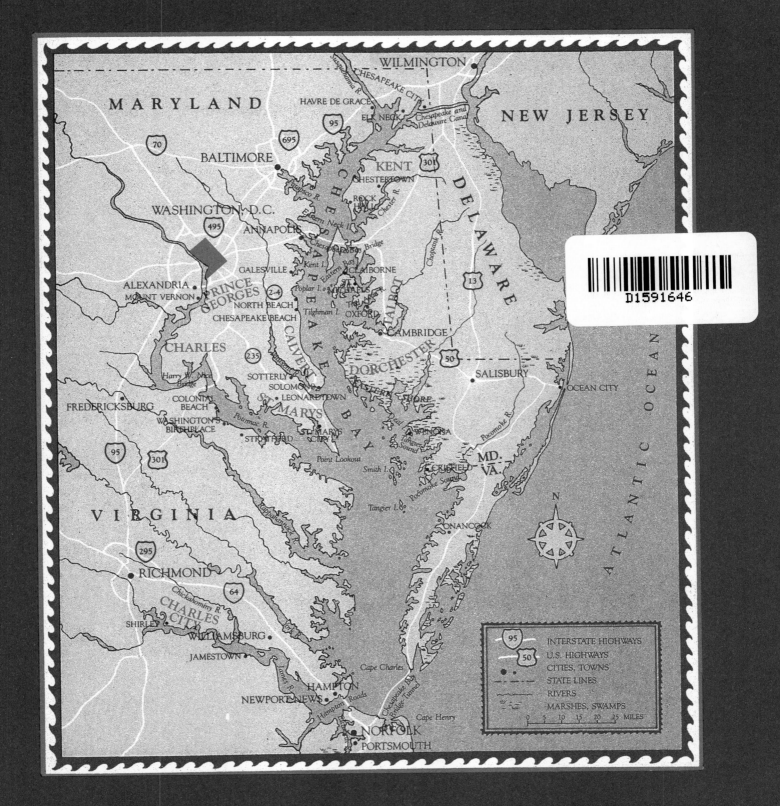

Chesapeake Country

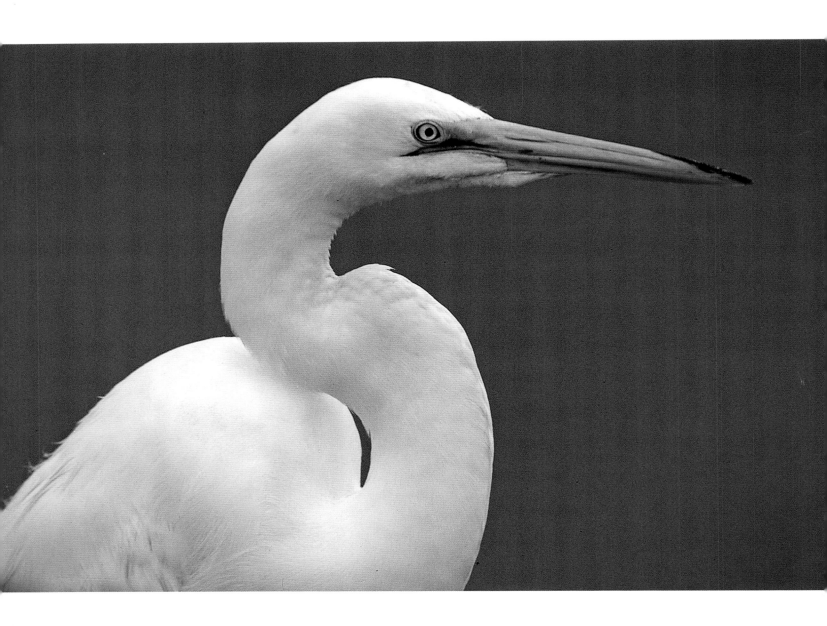

PHOTOGRAPHS BY LUCIAN NIEMEYER
TEXT BY EUGENE L. MEYER

CHESAPEAKE COUNTRY

Second Edition

ABBEVILLE PRESS PUBLISHERS

NEW YORK LONDON

To my mother, Lucie Lenzner Niemeyer,
whose love of nature I received
—Lucian Niemeyer

To my wife, Sandra, and sons, Eric, David, and Aaron
—Eugene L. Meyer

JACKET FRONT: Skipjacks at sunset, Wenona,
Deal Island, Maryland

JACKET BACK: Skipjack at sunrise, Chesapeake Bay

FRONTISPIECE: Great white egret (*Casmerodius albus*)
at Eastern Neck National Wildlife Refuge, Kent County,
Maryland

For the first edition
EDITOR: Alan Axelrod
DESIGNER: Nai Chang
PRODUCTION MANAGER: Dana Cole

For the second edition
EDITOR: David Fabricant
PROOFREADER: Ashley Benning
COVER DESIGN: Misha Beletsky
PRODUCTION MANAGER: Louise Kurtz
COMPOSITION: North Market Street Graphics

Second edition
10 9 8 7 6 5 4 3 2 1

ISBN 978-0-7892-1214-6

A previous edition of this book was cataloged as follows:
Library of Congress Cataloging-in-Publication Data
Niemeyer, Lucian
 Chesapeake country/photographs by Lucian Niemeyer; text by
Eugene L. Meyer.
 p. cm
Includes bibliographical references.
 1. Chesapeake Bay Region (Md. and Va.)—History.
2. Chesapeake Bay Region (Md. and Va.)—Description and
travel—Views. 3. Natural history—Chesapeake Bay Region
(Md. and Va.) 4. Natural history—Chesapeake Bay Region
(Md. and Va.)—Pictorial works. I. Meyers, Eugene L. II. Title.
F187.C5n54 1990 89-17638
975.5'18—dc20 CIP

For bulk and premium sales and for text adoption procedures,
write to Customer Service Manager, Abbeville Press, 137 Varick
Street, New York, NY 10013, or call 1-800-ARTBOOK.

Visit Abbeville Press online at www.abbeville.com.

Contents

Chesapeake Country Revisited 7

Introduction 17

The Landings 37

The Plantations 61

The Watermen 97

Tidewater Towns/Chesapeake Cities 141

Chesapeake Country: Back to the Future 187

Epilogue 205

Suggestions for Further Reading 221

Acknowledgments 223

Index 225

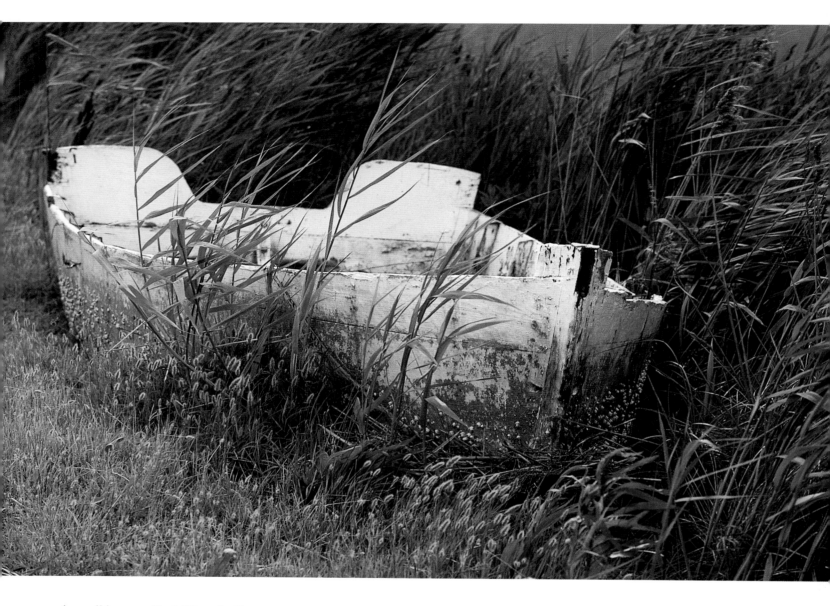

A small boat on Back River, by Poquoson,
Virginia, north of Hampton Roads

Chesapeake Country Revisited

It's a weekday afternoon in July, and I'm sitting at the bar of Lowes Wharf Marina on Maryland's Eastern Shore, gazing at a low-lying island that stretches for four miles across a narrow strait. This is Poplar Island, once nearly washed away and now nearly restored to its 1847 footprint. It's a modern miracle: the U.S. Army Corps of Engineers and other government agencies have teamed up to dredge sediment from the bottom of the bay, in order to keep the shipping lanes into Baltimore harbor open for commerce, and the muck has been barged down here to re-create the island as a wildlife sanctuary.

The reappearance of Poplar Island is one remarkable event that has occurred since *Chesapeake Country* was first published twenty-five years ago. It is emblematic of two titanic and contrary trends: Due to climate change and the rising sea level, the land is receding. At the same time, humans have made monumental efforts to stem the tide—literally, if only ephemerally.

There have been other changes as well. Off Smith Island in the late 1990s, I saw pelicans for the first time. I knew of these odd-looking birds from trips to Florida, but up here they seemed not quite right, perched on a piling as if they owned the place. And, increasingly, they do, as thousands of brown pelicans have colonized the remaining bay islands, a visible vanguard of climate change that, according to the best science, is also changing.

Change can be good or bad, sometimes both—but it is inevitable, despite human attempts to stop or reverse it. As a resident of Chesapeake country, I've observed these efforts with a mixture of reportorial detachment and personal concern. Over time, I will admit, I've developed much more than a professional relationship with the bay, the land, and its people. I do, as the special Maryland license plate urges, "Treasure the Chesapeake."

Writing for the *Washington Post* and other publications, I've been privileged to harvest a bounty of stories from the bay. Many were about people swimming against the tides of change—natural or manmade. If

change was inevitable, it was seemingly not immediate, more glacial than abrupt. Yet, as I reflect on the past twenty-five years, there are questions to ask. Is the bay more crowded, or less so? Is its water quality improving, or getting worse? Can oysters survive in a tidal environment deluged with more and more fresh water from the storms that occur with increasing frequency? Will the blue crabs ever rebound to historic levels? Will the watermen survive, economically and culturally, or will they become extinct? What will be—has been—the effect of the sea level rising and the land sinking, a long-term result of glacial retreat?

What does Chesapeake country look like today? What does the future hold?

Observe any marina around a busy harbor like Annapolis or St. Michaels on a quiet summer weekday. The fleet of pleasure craft—sail and power—hardly seems diminished, although their presence on the water away from the docks is felt largely on weekends. That part of the bay's ecology seems more subject to the national economy than to natural forces. The number of boats may rise and fall like the tides, depending on the vagaries of the stock market.

But there are natural changes that are more visible. Twenty-five years ago, there was much talk about the erosion of Chesapeake islands and Atlantic Ocean beaches due to occasional storms. It was sad, of course, but not surprising. People and governments either shrugged or spent vast sums to "shore up" the beaches and wrap the islands with bulkheading or stone riprap. Talk of climate change? Hardly any.

Now, climate change is on the public's mind and part of the latest government plan to save the bay—for good reason. The projections for sea level rise on the Chesapeake by 2050 range up to two feet. At that rate, large portions of the Eastern Shore will be submerged—including an estimated two-thirds of Dorchester County, home to Harriet Tubman, heroine of the Underground Railroad, and to the Blackwater National Wildlife Refuge, established in 1933. "These tidal wetlands define Dorchester County and make it a magnet for wildlife," Blackwater wildlife biologist Matt Whitbeck tells me. When I canoed the refuge in 1980, the Blackwater River cut through great expanses of marsh. Today, the marshes are mostly gone. "Shocking," is how Whitbeck describes it. Yet, he adds, "If you don't know, you look at big open water, it's beautiful." Not only climate change but also nutria—a rodent imported from Louisiana for fur trappers—were destroying the marsh; however, a recent eradication program has all but eliminated the noxious critters. There is also a federal and state proposal to restore the marsh, but it will cost many millions of dollars that will not be available for many years, if then. Meanwhile, even as old marshes disappear, upland areas are becoming marshy as the sea level rises.

The plan to save Blackwater would involve the use of dredged spoil

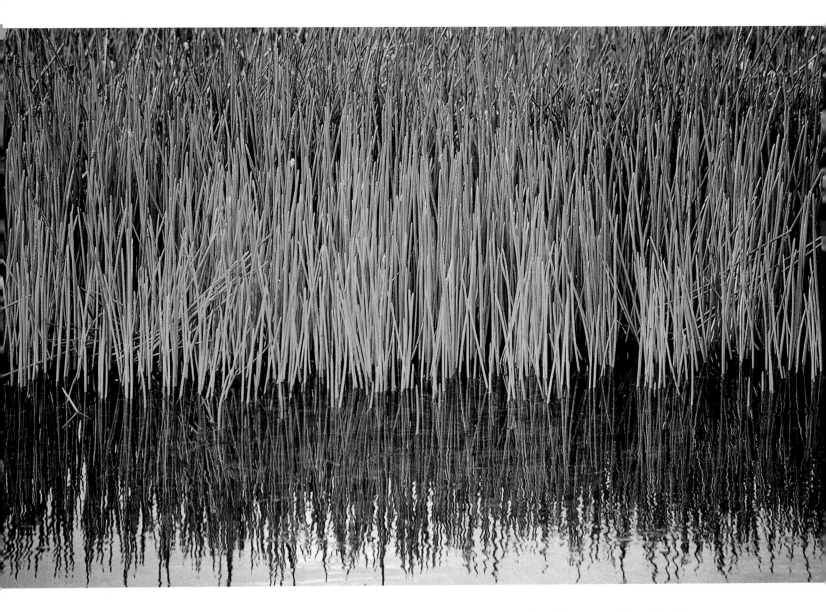

Spartina grass reflected in the
waters of the bay

from shipping channels, but the spoil is first being employed to shore up the bay islands, whose very existence protects the Eastern Shore from the forces of erosion and sea level rise. As noted, this method has already been used to re-create the mid-nineteenth-century footprint of Poplar Island, which had shrunk from 1,100 acres to less than 10. The projected cost of the Poplar project, which began in 1998, is $670 million. Whether or not these efforts are sustainable in the long term remains to be seen, but they seem a better bet than the millions spent annually—an estimated $81 million over the next 50 years—to shore up ocean beaches with their invariably shifting sands.

It is the islands where the change is most visible and the outlook most daunting.

The Navy guns that used to shell Bloodsworth Island for practice, rattling windows on nearby Deal Island, have gone silent. Similarly, the mosquitos that plagued Deal Islanders have been much less in evidence since the Department of Natural Resources introduced the crane fly, or "mosquito hawk," a larger insect that preys on the pests.

Skipjacks—oyster-dredging sailboats that once numbered in the hundreds—still dock at Deal, one of the two remaining skipjack ports, but there are just four there. Remarkably, Art Daniels, whom I once wrote about as the oldest skipjack captain at seventy-five, has continued to dredge under sail in his nineties. Sadly, Charles Abbott, skipper of the *Thomas Clyde*, who once took me aboard for a day dredging under sail out of Cambridge, died too young at fifty-eight, on Father's Day in 2002. A few years before, he'd had a stroke that left him partially paralyzed, but he continued to work on the water with C.J., his son. Charles was a good and courageous man, and I miss him.

"What's changed most in twenty-five years is the husbands unfortunately are passing and there are a lot of widows" on Deal Island, his widow Jeannie Abbott laments. "A lot of the younger ones have had to go up the road for their employment. There's not the people like Charles Abbott that stuck it out, no matter what. He would always say next week it will get better, but even he told his son you've got to go into the land for employment, as much as it hurt him" to say that.

True, the bay harvests fluctuate. A five-year moratorium on catching rockfish helped restore the endangered fishery. Despite grumbling from watermen, restrictions on the harvesting of egg-bearing females promise to bring back the iconic Chesapeake blue crab, which has been in decline. Improbably, oyster harvests have rebounded from a low of 26,000 bushels in 2004 to more than 400,000 in 2013–14—partly because 24 percent of oyster habitats have been placed off-limits to watermen. Still, nobody expects to see a return to the annual peak harvests of 15 million bushels that made the bay the supplier of nearly half the world's oysters in the 1880s.

With the uncertainties of commercial fishing, the number of working watermen has dropped sharply, from some twelve thousand a quarter century ago to fewer than half that today. Some have replaced or supplemented their income from fishing by turning to "heritage tourism." Skipjack captains are booking sightseeing trips. There is even a formal Heritage Tourism Training Program for watermen. In 2012, more than one hundred watermen participated in three-day workshops around the bay, and eighty became certified tour operators. Of the forty-two remaining skipjacks, most are either inoperable or owned by museums or foundations. Only seven are still working dredge boats, four at Deal and three at Tilghman Island.

As the colorful watermen are struggling to survive on the Chesapeake, most of the bay islands are gone or going. Holland Island once had 350 people living in sixty houses in four different settlements, a school, stores, a church, and a fleet of one hundred workboats. When I visited Steven White, a former Salisbury minister and the island's sole owner, in September 1996, the island was down to its last house and a marshy graveyard. White was determined to prevail over the rising waters and sinking land—he poured more than $150,000 of his own money into stopping the erosion and tried to raise more from others. But few people in or out of government were interested in throwing good money after bad, and the two-story frame house collapsed into the bay in October 2010.

Still clinging to life, barely above sea level, is Smith Island, a few miles south of Holland. The island—actually an archipelago—is underwater during many storms. After Hurricane Sandy in 2012, FEMA offered $2 million to buy out the remaining homeowners, but the native islanders weren't interested. They wanted money to restore and rebuild, not to leave. Ironically, it was mainland Crisfield, once hailed as the Seafood Capital of the World, eleven nautical miles to the east, that bore the brunt of Sandy: the storm flooded the town and demolished the city dock, which the government paid to have rebuilt. The waterfront condos for weekenders that had risen improbably in Crisfield now seemed less of an escape than a trap. With so much lowland threatened, it would be difficult to sell, much less inhabit, these vacation homes, which seemed doomed to succumb to rising waters.

Janice Marshall is my human barometer of the ebb and flow of life on Smith Island. She and her husband, Bobby, trace their island roots to the beginnings of English settlement. Living in Tylerton, one of Smith's three villages, Janice founded the Smith Island women's crab-picking co-op with some government grants after, as she tells it, she was "busted" by state health inspectors as she emerged from a boat in Crisfield with crabmeat she'd picked in her kitchen. The co-op declined as inspections lagged, the women went back to picking crabmeat at home, and Janice, in her sixties,

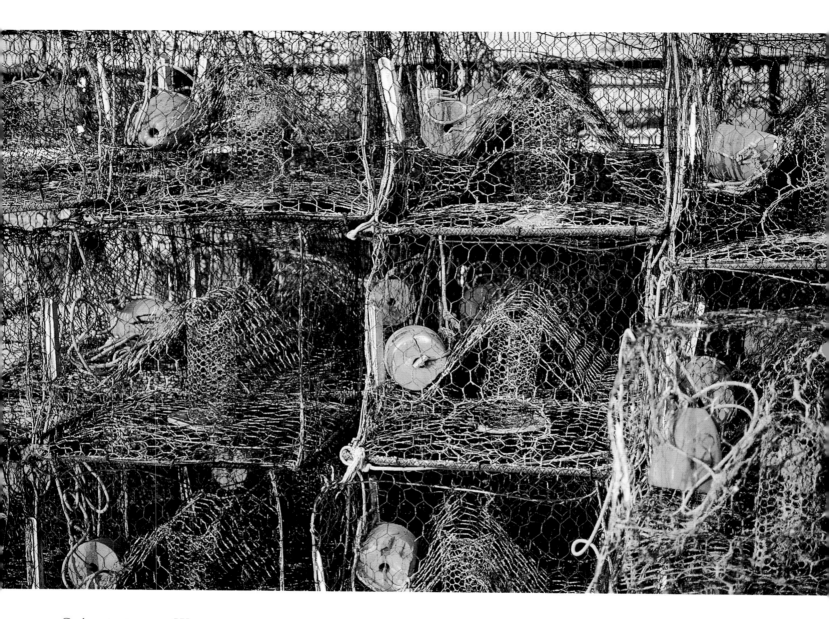

Crab pots at sunset, Wenona,
Deal Island, Maryland

went to work as a prison guard for the Eastern Correctional Institution in Princess Anne. This required her to divide her time between Tylerton, where Bobby continued to crab, and Crisfield, where they maintain another home, a small brick Cape Cod that belonged to her mother.

When Sandy hit, her Crisfield property—1.3 miles from the city dock—fared worse. "We had two or three inches in our yard," she tells me. "People who live here said they've never seen it as high." Because of her husband's health, she says, she doesn't go back to the island as much, "but my heart's there." Her daughter is still in Tylerton, working in the co-op, but a son works at the jail in Rock Hall, in Kent County. Her oldest granddaughter works at the prison in Princess Anne, a grandson works for a well company on the mainland. "He just seen no future for watermen anymore. It's really sad to say. I don't even like to think about it." Most young people from Smith, after finishing high school in Crisfield, don't go back.

"I used to say to older people it looks like someday this island will dissolve. They'd say, don't talk like that. But sometimes you have to face the fact. But it's funny, everybody likes to go back for those holidays. Fourth of July and Christmas, it's packed. They still want to hold it for their children to experience, a little bit of the island tradition." Being lost in the transition, however, is the distinctive island dialect, which has been described as Elizabethan. "My granddaughter Kelly went to high school in Crisfield, picked up a mainland" accent, she says. "The brogue is part of our culture, made us unique. A lot were ashamed of it. I never was."

The exodus from Maryland's last inhabited Chesapeake island seems assured, but for reasons of economics, not climate change. As the costs of working on the water exceed the benefits, land jobs increasingly beckon. The year-round population of Smith has dropped from 350 in 1990 to just 176 in 2014. In 1996, the *Washington Post* sent me to cover the closing of the state's only one-room schoolhouse, in Tylerton, where Janice Marshall was the custodian. The architecturally modern structure soon became the occasional weekend home of a Pennsylvania couple. When I last visited Smith in 2008, the trend was already clear, as more and more homes were sold to city dwellers in search of the mystical retreat from urban stress that the island seemed to offer. But they came only infrequently, leaving the houses dark at night and lending the island a ghostly quality. In Ewell, the "capital" of Smith Island, the last school was down to a dozen students.

On the Virginia side of the invisible state line, just south of Smith, Port Isobel Island has shrunk from 210 to 140 acres in the quarter century since the nonprofit Chesapeake Bay Foundation acquired it, according to Will Baker, the foundation's president. A large pine forest existed on a spit of land there, but no longer. "There's not a tree out there," Baker tells me. "It's all water. Every element of 'Save the Bay' is more difficult as climate change is more manifest," he adds, invoking the foundation's mantra.

"Nature craves moderation, and ten inches of rain over ten weeks is better than ten inches over one week. Big storms increase the velocity of water," which has, one might say, a spillover effect, accelerating erosion even as the sea level rises. Indeed, the scientists say the risk of hundred-year storms has nearly doubled from global warming.

In much of Chesapeake country, meanwhile, little seems to have changed. Back Creek in the Eastport section of Annapolis is as full of pleasure craft as ever. Big yachts continue to tie up at the dock in "Ego Alley," the state capital's waterfront inlet. The full marinas in bay towns from Annapolis to St. Michaels, from Herrington Harbor to Solomons, testify to the economic well-being of many citizens of Chesapeake country.

Along the bay's major tributaries, the old plantations continue to stand sentinel by ageless rivers. Yet even here there have been changes, most notably in coming to terms with a part of the past that had for too long been swept aside: the very significant role played by America's "peculiar institution," slavery. At Sotterly, on the Patuxent River, a descendant of a slave and a descendant of a slave owner sat together on the governing board of the nonprofit foundation that owns it. At Stratford, the birthplace of Robert E. Lee, on the Potomac, slave descendants held two well-attended reunions, in 2001 and 2011. Even Shirley Plantation, on the James, had begun to acknowledge this unsavory aspect of its own history, with archaeological digs and a new exhibit on the enslaved African Americans who toiled there. At the same time, there is an ongoing family legacy at Shirley, as Charles Hill Carter, Jr., passed on in 2009, leaving stewardship of the plantation to his son, Charles III, the tenth generation to reside there.

Meanwhile, over in Easton, the seat of Talbot County on Maryland's Eastern Shore, after much haggling and delay, they dedicated a statue, in June 2011, of native son Frederick Douglass, who fled from slavery to become a leading African American abolitionist, diplomat, writer, and orator. (It sits right next to a monument to the "Talbot Boys" who fought for the Confederacy.) Two years earlier, the State Highway Administration had dedicated Route 33 to Douglass; the road runs from Easton through St. Michaels to Tilghman Island, encompassing the Bay Hundred district, where he toiled as a slave.

This, then, is welcome change—and continuity—that has come to Chesapeake country over the past quarter century. There is comfort in that, even as the sea level rises and the land retreats. For many, this is still, as its boosters say, "the land of pleasant living." For now, and for the foreseeable future, Chesapeake country—with its distinct culture, history, resources, beauty, and, yes, challenges—lives on, and so does my love affair with it.

I had first visited Claiborne, a onetime ferry landing on the Eastern Shore, in 1982, on a reporting assignment. The postal service was threatening to shut down the town's post office, presided over by Martha Hamlyn, who handled the mail, while her husband, Jim Richardson, sold groceries. It was the town's last commercial establishment, and also their home. After some publicity, a national backlash against the closure forced the postal service to retreat.

Eventually, Jim and Martha stopped selling groceries and sorting mail. Then, in 2011, a remarkable thing happened. The old United Methodist Church, which had closed for lack of churchgoers, became the Claiborne Village Hall, a place where residents could still get their mail and also hold community events. Jim and Martha were part of the group that made it happen.

They had raised two daughters in Claiborne, their adopted home. When I visited them again in the summer of 2014, they were still there. The village—not quite a town—had held its own. At the former ferry landing, a waterman docked his workboat with the day's catch of crabs. Claiborne had also become a popular launching spot for pleasure craft, and a dozen trailers were parked there. The village even had its own newspaper, the online *Claiborne Clarion*. Jim, a trained artist, had become the go-to sign painter in Talbot County, a one-man enterprise that also allowed him time to sail his thirty-five-foot sloop. I came now not for a story but for friendship, and for a brief respite from urban pressures.

Their home, where they live above the former post office and store, overlooks the bay. One evening I sat in their second-floor screened porch talking until midnight with Jim and Martha and two of their neighbors— none Eastern Shore natives but people who now wouldn't live anywhere else. It would be a good night for sleeping, without air-conditioning, without the sounds of the city. I felt becalmed, like a sailor content to anchor in place with no strong winds to rock the boat. Sad to say, the Chesapeake country mellow would evaporate in the traffic jam leading to the Bay Bridge the next day. But for now at least, I was happy to be just where I was, in a quiet place by the bay.

—EUGENE L. MEYER, SILVER SPRING, MARYLAND, 2014

EDITOR'S NOTE: The chapters that follow were written in 1990. Certain of the captions have been updated for this second edition.

Introduction

It began fifteen thousand years ago with the receding Ice Age. The primordial Susquehanna River flowed all the way to the Atlantic Ocean. Then, as a greenhouse effect took hold, the river valley flooded to become Chesapeake Bay.

Chesapeake. The name is Indian in origin, meaning "Great Shellfish Bay." And great it is. From its headwaters fed by the Susquehanna, to the Virginia capes that form the opening of the bay onto the Atlantic, the nation's largest estuary stretches for 185 miles. It varies in width from three miles to twenty-two—so wide in places that it seems like an inland sea, no shore in sight, nothing but water and sky. A deep channel—the fossilized Susquehanna riverbed—cuts through its center, allowing ocean-going vessels to navigate. Yet in places the bay is so shallow that it is almost possible to walk across. Forty-six main rivers from six states drain into Chesapeake Bay, mixing fresh water with the ocean's salt to form the brackish tidewater that distinguishes the bay from an inland lake. Half its fresh water cascades down from the Susquehanna, which begins as a tiny stream in upstate New York, the basin's northernmost reach.

At times, the Chesapeake Bay seems like a very tame body of water. But on hot, humid summer afternoons, when thunder rolls and lightning strikes, the wind whips the bay into frenzy. Sudden storms don't differentiate between the artifices of man and the creations of nature. Boats seek refuge in any nearby harbor, even as large chunks of shoreline disappear into the water. Over the years, entire islands have simply washed away, along with any trace of human habitation.

This is Chesapeake country, the crucible of much that is America. It is the cradle of American democracy—and slavery. It encompasses the site of the first "permanent" English settlement in America and, along the James River, the place where settlers celebrated the first Thanksgiving in 1619—a year before the Massachusetts Pilgrims celebrated theirs. Major naval events of the American Revolution, War of 1812, and the Civil War were enacted here. Cornwallis scuttled the British fleet on the York River to prevent French troops from boarding and seizing it. Three decades later, U.S. Commodore Joshua Barney sank his fleet on the Patuxent, to keep it out of British hands. Fort McHenry was bombarded from Baltimore Harbor, inspiring Francis Scott Key to write "The Star-Spangled Banner." The *Monitor* and the *Merrimack* clashed at Hampton Roads, and a new

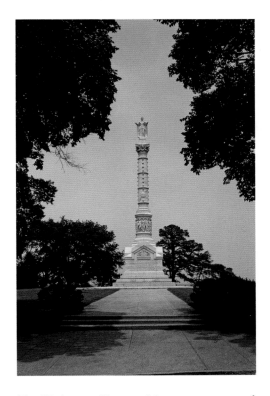

The Yorktown Victory Monument, erected to mark the surrender of British forces to George Washington's Continental Army at Yorktown on October 19, 1781

OPPOSITE
Wakefield Plantation at Pope's Creek, a Potomac tributary on Virginia's Northern Neck, where George Washington was born in 1732

era in naval warfare began. From the shipyards of Hampton Roads and Baltimore went forth the Liberty Ships, destroyers, and other naval vessels of two world wars.

Battles have been fought, too, over the bay's bounty. Marylanders clashed with Virginians and with each other over the succulent oysters. The Maryland Oyster Navy tried to enforce the laws and keep the peace, with limited success, and the oyster wars of the Chesapeake Bay were as fierce and bitter as any range battle fought in the Wild West.

Water is what ties it all together. Early explorers hoped the bay and its rivers would lead them to the Pacific and, ultimately, Asia. While they never found the Orient, they did discover a land rich in resources and ripe for the taking. The water would transport them to it. As is true today, waterfront property was at a premium, and the earliest colonists were quick to establish their "plantacions" along the rivers. Well into the twentieth century, waterways were often the only way to get anywhere around the Chesapeake.

Towns sprang up by decree, rather than by chance or choice, though the planters resisted them. "Our country being much intersected with

Blackwalnut Cove, from Bar Neck at the southern tip of Tilghman Island, Talbot County, Maryland

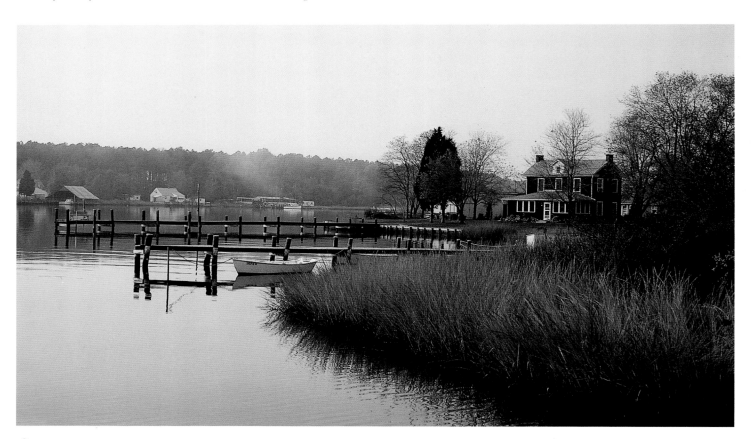

navigable waters, and trade brought generally to our doors, instead of our being obliged to go in quest of it," observed Thomas Jefferson in 1782, "has probably been one of the causes why we have no towns of any consequence." Towns of consequence did develop—eventually—and all of them on the water: Washington on the Potomac; Baltimore on the Patapsco; Richmond on the James; Norfolk at Hampton Roads.

More than any other city, Baltimore became the capital of Chesapeake country. Steamboat lines emanated from it and brought the people of Tidewater Maryland and Virginia to Baltimore as *the* place to shop and visit. Southern Maryland tobacco growers shipped their crop in caskets from river wharves to the hogshead market in Baltimore until 1938, when five regional "basket" markets were established to cut hauling costs.

Captain John Smith, exploring the bay in 1608, catalogued its seemingly endless abundance of seafood. H. L. Mencken called it a "giant protein factory." Self-styled the "Land of Pleasant Living," the Chesapeake is quintessentially American, yet also distinguished by a unique culture and identity: it is the land of the skipjacks, the last commercial sailing fleet in America, and of the waterman, an independent breed of bay-based entrepreneur who, like the farmer, lives by the seasons and the weather rather than the clock. It's Crabtown, also known as Baltimore. It's Chesapeake City, Chesapeake Beach, Colonial Beach, Cobb Island, Crisfield, and Claiborne.

It is a pitcher of beer and a table full of steamed crabs, seasoned with Old Bay spice and attacked with a wooden mallet on plain brown wrapping paper. It's a bumper sticker that proclaims, "There Is No Life West of the Chesapeake Bay." It is sunrise over the Eastern Shore and sunset over the Western Shore. It's the Chesapeake Bay Bridge, a 4.7-mile link between the two.

It is defined by a jagged eight-thousand-mile shoreline of bay and rivers, among them the James, the York, the Rappahannock, Potomac, Patuxent, the West, the Severn, Patapsco, Magothy, Bush, Gunpowder, the Bohemia, Sassafras, Chester, Miles, Tred Avon, Choptank, Nanticoke, Wicomico. It's the Holland and Honga straits, Tangier and Pocomoke sounds, Eastern Bay, Kent and Knapps narrows. It's sleepy little towns, newly gentrified communities, and former resorts within commuting distance of Capitol Hill. It's John Barth's *Sot-Weed Factor* and James Michener's *Chesapeake*.

It is a drive down a deserted road leading to Eastern Neck Island National Wildlife Refuge, while the car radio broadcasts reports of traffic jams on the Washington and Baltimore beltways.

As a youngster growing up on Long Island, I easily escaped the water culture so close at hand. It somehow never dawned on me that place names like Oyster Bay, Port Washington, Glen Cove, Sea Cliff, Little Neck, and Great Neck were decidedly nautical. The sailboats of Long

Boating on the Sassafras River, Maryland's Eastern Shore

A sailboat anchored on the Sassafras River

A flock of snow geese (*Chen caerulescens*)
reposing in the mist and marsh, Dorchester
County, Maryland

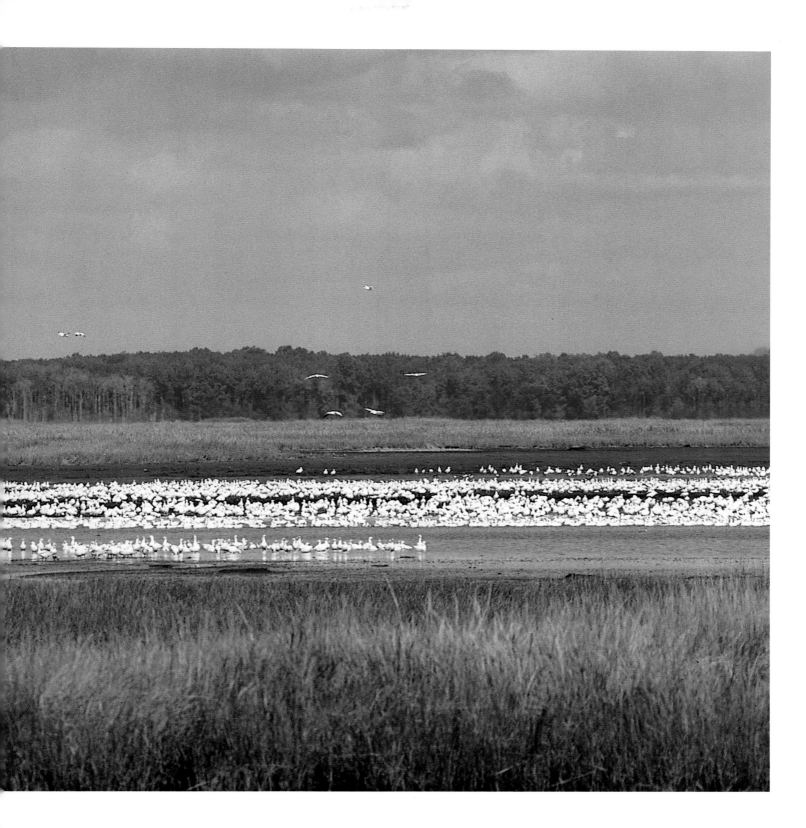

A quiet pier at Grandview, Virginia

Island Sound seemed of another world, and commercial fishing vessels were altogether foreign. A whaling museum in Sag Harbor told of another time, not mine.

But to live on or around the Chesapeake Bay is different, or so it appears to me at least. It seems inconceivable that anyone could live within the bay's sphere of influence and not feel a part of it. There is a sense of place that sets it, and the people who inhabit it, apart. Living here engenders a certain possessiveness, a protectiveness; it's *everybody's bay*, but it is also *my bay*. I not only enjoy it, I thrive on it. I relish the memory of my first fresh-shucked oysters, given me by a member of the Bowen clan of Calvert County, southern Maryland; their home overlooked the Patuxent River. And few images are as deeply etched in my memory as the purple hues of sunrise from the pilot house of a crabber's workboat. Or there is the view I enjoyed of a fleet of oyster-dredging skipjacks in full sail on the Choptank River. There is almost nothing I can think of that is as relaxing as anchoring in a back creek, or as exhilarating as riding the bowsprit of a sailboat driven by blustery ten-knot winds.

I have seen the bay from the air, land, and water. I've flown over it at fourteen hundred feet, on a twenty-minute shuttle flight from Washington National Airport to Easton, Maryland; it unclutters the mind, to pass from metropolitan madness to Eastern Shore serenity. I've flown, too, in the single-engine craft of aerial fish spotters, searching for the dark patches on the water that signal the presence of schools of menhaden. I've driven down many of the bay's countless necks to water's

A soft-shell crab shed on the channel at Rhodes Point, Smith Island, Maryland

edge; some I have approached from the water itself. I've been on research vessels with scientists surveying the latest crop of baby oysters on the Potomac or taking water samples near the Chesapeake Bay Bridge-Tunnel tying the Eastern Shore to Tidewater Virginia. I've taken the mailboat to Smith Island, where Elizabethan speech survives despite the presence of cable television and other modern intrusions.

Among other things, my Chesapeake travels have taught me that water time is different from land time—and that time apparently lost in the slow passage over water isn't really lost at all. Yet, in the two decades that I have come to know the bay, covering it as a *Washington Post* staff writer, I have seen change work at an alarming—and accelerating—rate. Centuries of glacial shifts seem to have been telescoped within my own lifetime—some drastic, some more subtle. Studies have documented the negative effects of industry, agricultural pesticides, and population growth. But while environmentalists crusade to "Save the Bay," sport fishermen and watermen chafe at any restrictions government would place on their catches, and they recall other—apparently premature—obituaries for the bay.

Indeed, eels marketed to Europe and Japan and clams harvested for New England buyers still thrive on the Chesapeake. And, even as landings of freshwater fish have declined, the ocean-spawning bluefish have burgeoned on the bay (but declined sharply in 1989). Seemingly endless resources have dwindled, threatening to make the waterman—along with the oyster, yellow perch, shad, and rockfish—an endangered species.

OVERLEAF
Snow geese (*Chen caerulescens*) in flight, Maryland's Eastern Shore

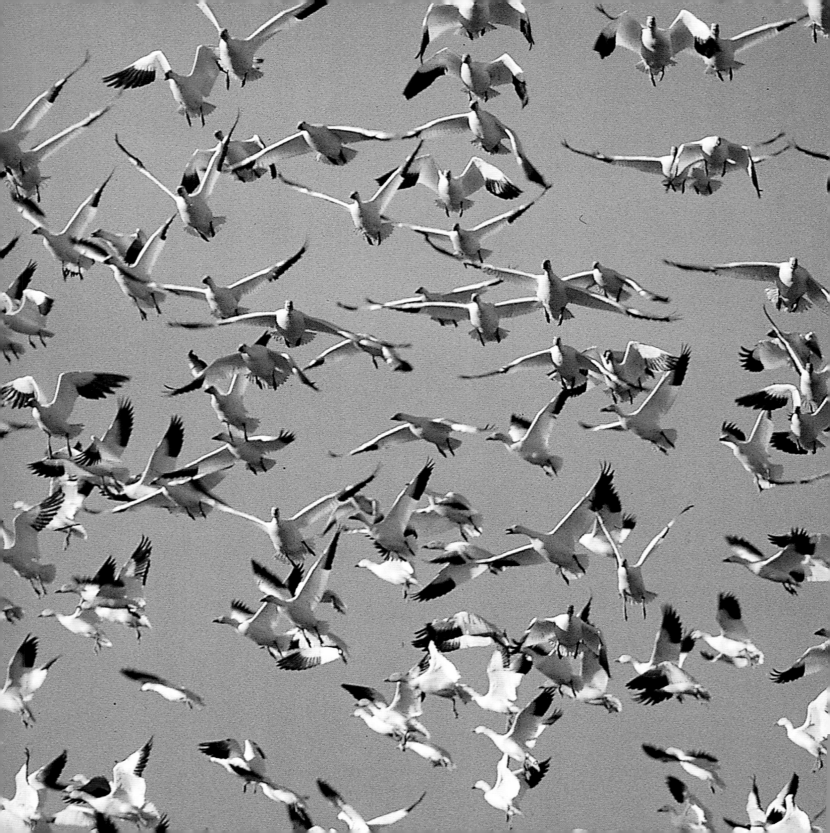

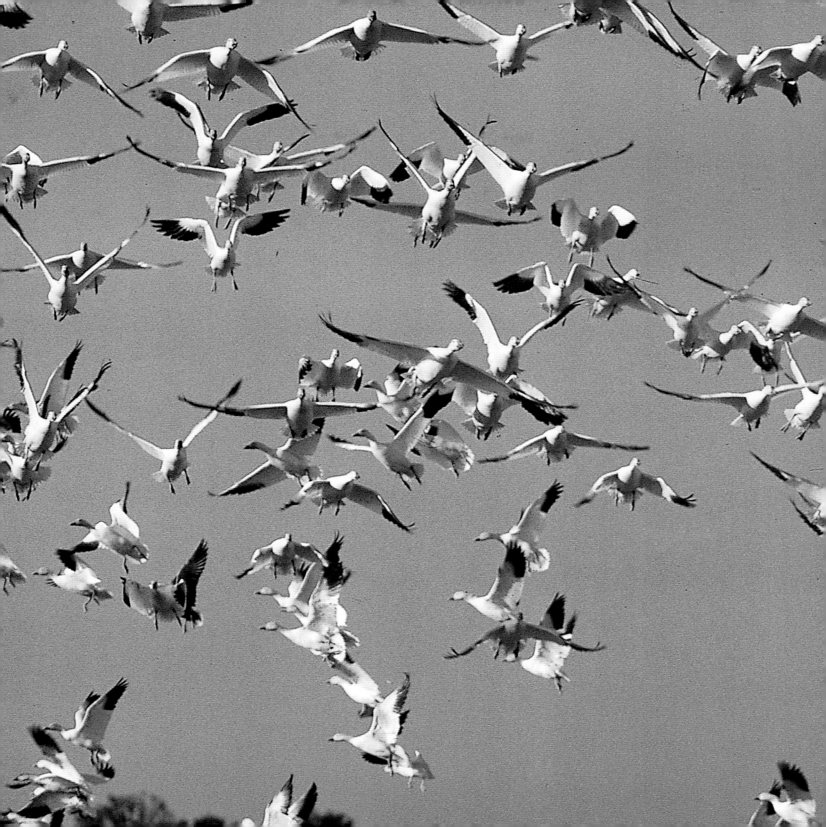

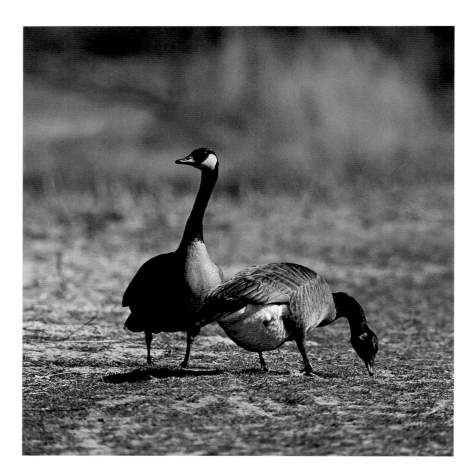

LEFT
Two Canada geese (*Branta canadensis*), Dorchester County, Maryland. Arriving here by the thousands each fall, the Canada geese are an Eastern Shore tradition.

OPPOSITE
A white-tailed deer (*Odocoileus virginianus*) at Elk Neck State Park, Maryland

BELOW
A green-backed heron (*Butorides striatus*), Eastern Shore

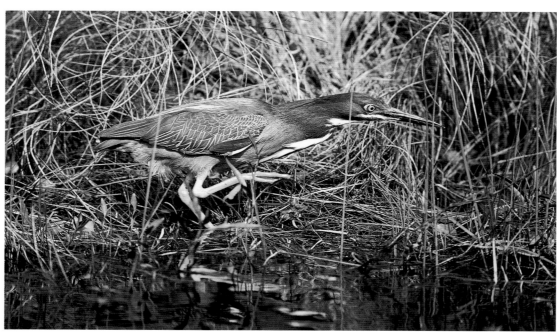

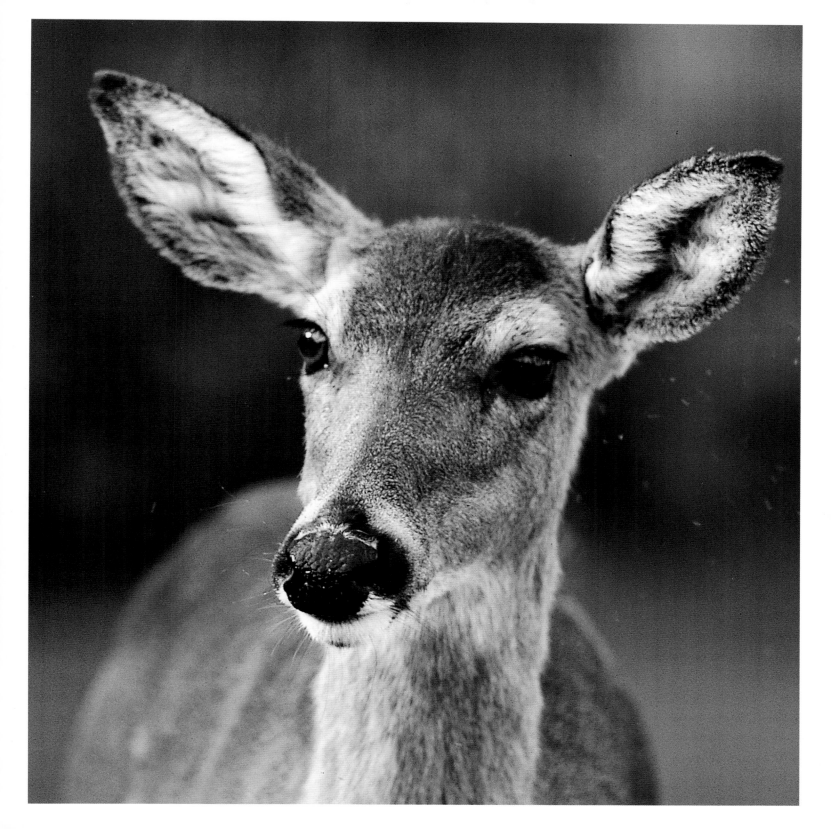

Marsh and water intermingle at
Blackwater National Wildlife Refuge,
Dorchester County, Maryland

OPPOSITE
A long-legged great white egret
(*Casmerodius albus*) pauses in the marsh of
Smith Island.

Villages that for so long seemed happily remote and secure havens for
classic Chesapeake culture have become homogenized by the relentless
advance of metropolitan affluence. *Quaint* has become a commodity,
pricing out watermen and others who toil for a living. Even waterfront
neighborhoods in working-class Baltimore have gone upscale.

The Chesapeake community of the future may be little more than a
cluster of museum buildings, antique and gift shops, marinas for pleasure
craft, and pastel-painted homes and condos for wealthy retirees. There is,
in such a picture, a great sense of impending loss. But sadness over what
may be is mixed with gratitude for what is: the variety and the vitality of
the Chesapeake country as it exists today.

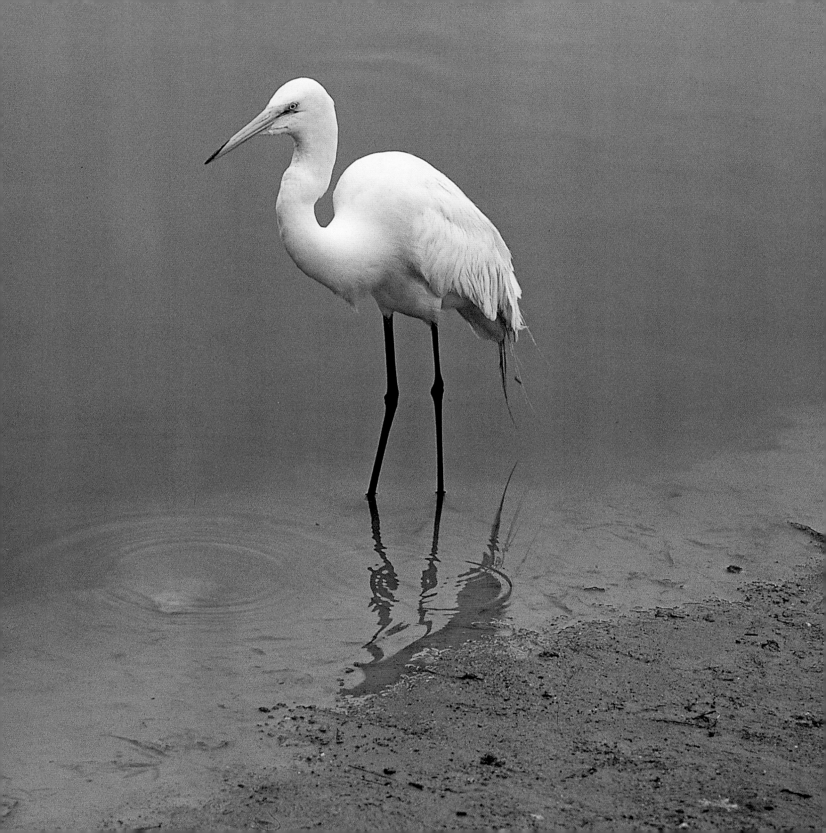

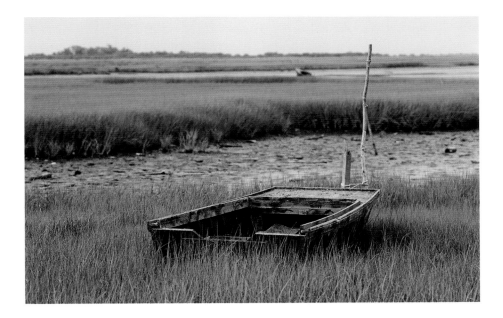

ABOVE
A derelict boat left to decay in the marsh at
Grandview, Virginia

LEFT
Small boats at Plum Tree Island National
Wildlife Refuge, Poquoson, Virginia

OVERLEAF, TOP LEFT
Early morning at Crocheron, on Hooper
Strait, Dorchester County, Maryland

OVERLEAF, BOTTOM LEFT
A derelict boat at St. George's Island on the
Potomac in St. Mary's County, Maryland

OVERLEAF, RIGHT
Iced-in at Rock Hall: the workboat
Sea Raven

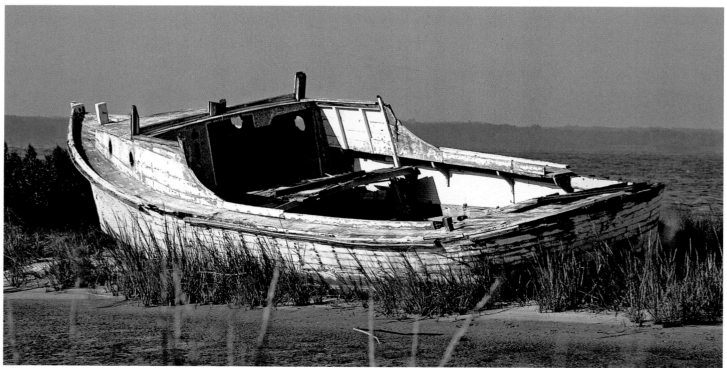

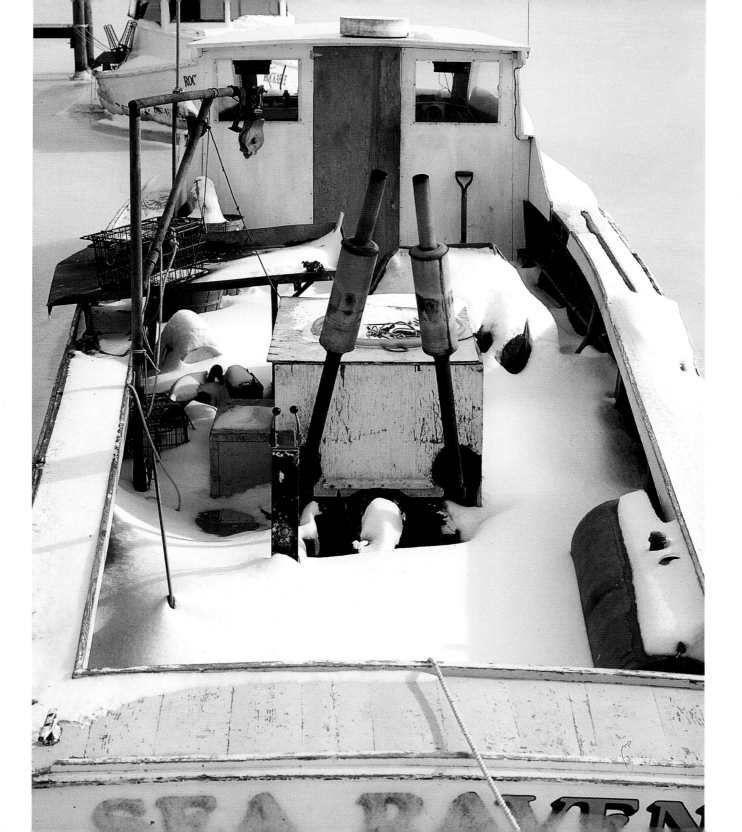

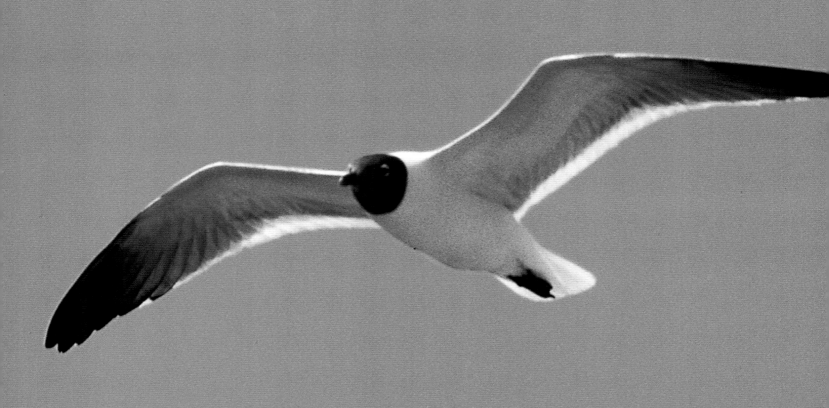

The Landings

Colored by legend, the discovery and settlement of the Chesapeake Bay was actually an inglorious affair. The first colonists faced hardship, death, and deprivation largely of their own making. That they survived and eventually prospered was more a miracle than a tribute to their courage, intelligence, or grit.

Economics, pure and simple, motivated the founding fathers of Virginia. Following the mysterious disappearance of Sir Walter Raleigh's colony of Roanoke in the Carolinas, the Virginia Trading Company of London, chartered April 10, 1606, dispatched a fleet of three ships—the *Susan Constant,* the *Godspeed,* and the *Discovery*—to the New World. The voyagers, all bachelor men, and their backers in London sought riches and a passage to the Orient that would net them even greater riches. It was a dream that would sustain their efforts and explorations for nearly a century.

After three months at sea, the ships reached the Chesapeake capes in April of 1607. They proceeded some forty miles up the river they named the James, after their king, to what they thought was an island—actually, it was a peninsula—and they called it Jamestown when they landed on May 13. It was a low-lying, uninhabited land washed by brackish tidewater.

The colonists had been ordered "not to settle in a low or moist place because it will prove unhealthful." But the Jamestown site did not appear so forbidding in the spring. With good anchorage, plenty of timber, and lots of game for hunting, it seemed quite a fine place for the first settlement.

It turned out to be the worst of places. The stagnant island swamps were mosquito infested, the water unsuitable for drinking. The colonists died of malaria, dysentery, and other diseases, becoming the victims rather than the beneficiaries of the promised land. Long before chemicals like kepone made the bounty of the James unsuitable for human consumption, the first colonists became the first of European stock to get sick on the Chesapeake tributary's waters.

Judging from Jamestown, the American dream was laid on a very shaky foundation.

A lucky forty men returned immediately to England. But 104 Englishmen stayed behind. By the time another ship arrived from

The eighteenth-century lighthouse at Cape Henry, where the Jamestown colony settlers first made landfall on their 1607 voyage from England

OPPOSITE
Laughing gull (*Larus atricilla*) in flight, Virginia's Eastern Shore

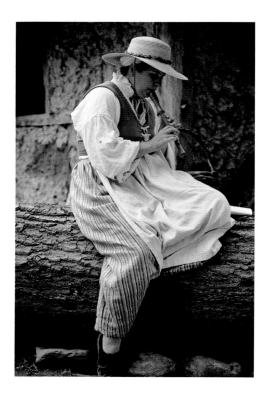

Kathleen Lesh playing a recorder at Jamestown Festival Park

RIGHT
The original fort at Jamestown recreated at Jamestown Festival Park

OPPOSITE
A replica of the *Susan Constant,* one of three ships that landed at Jamestown in 1607, is moored at nearby Jamestown Festival Park, created by the Commonwealth of Virginia to mark the 350th anniversary of the colony's founding.

England the following January, all but fifty of them had died. More ships brought more colonists, but the deaths continued. After the winter of 1609–10 produced more deaths—440 of 500 inhabitants in what was called "The Starving Time"—the survivors set sail for home. But before entering the bay, they learned that a ship was arriving with fresh supplies and settlers, and they returned to Jamestown.

Among those survivors was Captain John Smith, a larger-than-life figure whose landing at Jamestown and subsequent salvation by the Indian Princess Pocahontas have been immortalized in painting, pageant, and song. Smith would later characterize Jamestown as an "unwholesome place" entirely unsuited to the "gentlemen" colonists. "Notwithstanding our misery," he reported, these fair-weather settlers "little ceased their malice, grudging and muttering."

An adventurer and a soldier of fortune, Smith had fought against the Spanish in Flanders and against the Turks in Hungary and Transylvania. He claimed to have beheaded three Turkish gladiators, which earned him a coat of arms with three turbanned heads. But Smith was eventually captured and sold as a slave to a "sultan" who gave him as a gift to his young sister. Smith killed the sultan and escaped. Back in England, he signed on with the Virginia Trading Company of London. On the way to the New World, Smith allegedly was involved in a mutiny plot and arrived at Jamestown in chains. There, to his captors' chagrin, he was freed when it was discovered in a sealed box of directions from King James that Smith had been made a member of the colony's governing council.

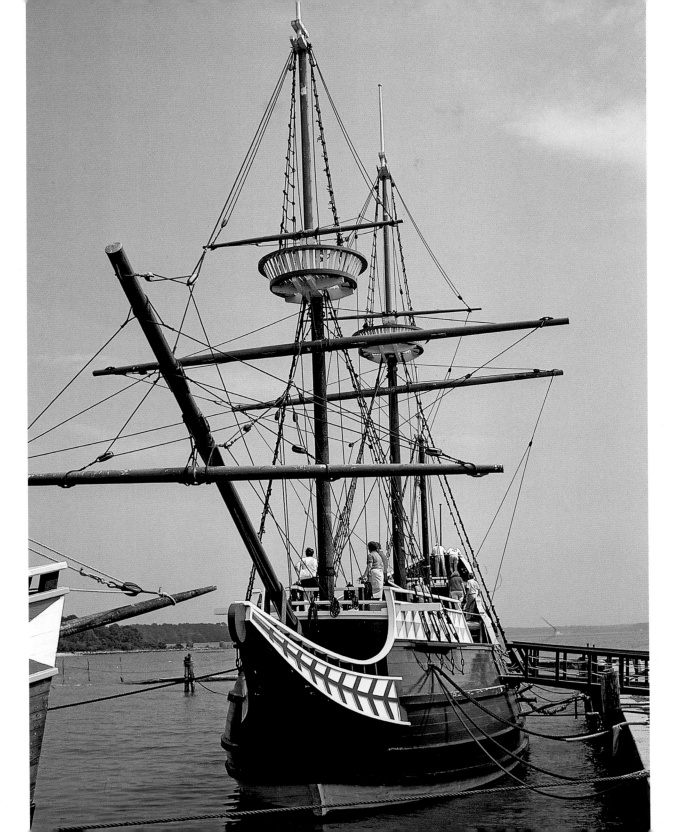

Brash, boastful, abrasive, and stubbornly independent, Smith aspired to a position of leadership in the new colony and achieved it—but grudgingly and not right away. He was simply too rough around the edges. Traits that made him both effective and offensive would become part of the myth of the American frontiersman, but to the English who controlled the colony, the man was unacceptably crude. Yet it seemed that the good gentlemen of Jamestown could accomplish little without him.

Smith was a born explorer, and the Virginia Company's settlers had been directed to employ men "for two months in the discovery of the river above you, and on the country about you." They first explored the James River, up to the fall line, near the future site of Richmond. They also explored the Chickahominy River. It was during this expedition that Smith was captured by Indians and brought before Chief Powhatan at his capital, Werowocomoco, on the York River.

It was here, in January of 1608, that Smith was supposedly saved by Powhatan's daughter, Pocahontas. At first, Powhatan, chief of a confederacy of twenty-eight Indian tribes, was a hospitable host, fêting Smith with a meal of roast turkey and venison. Then, for reasons lost to history, the chief and his warriors decided to execute the captain. Two stones were brought forth, a clubbing place for Smith's head. But as the club was about to descend, the story goes, Pocahontas threw herself on him and pleaded for his life. Powhatan spared him, and Pocahontas got

Smith's Fort Plantation (1760s), built on land given by Powhatan to John Rolfe after he wed Pocahontas in 1614; it is located in Surry County across the James River from Jamestown.

her man—if only briefly, as Smith was allowed to return to Jamestown after just a few days, and from that point their paths diverged. In 1614, Pocahontas married John Rolfe, who introduced the cultivation of Spanish tobacco in Virginia, which turned out to be more lucrative and less elusive than the inland sea to the Orient. Pocahontas and Rolfe produced a son, Thomas, whom they took to England. There, the Indian princess was the toast of London society. She apparently still carried a torch for John Smith, however, going into seclusion for days after meeting with him there. Preparing to set sail for Virginia, she became ill and died in England, where she is buried.

In June of 1608, Smith set out in an open barge with sails and oars and a crew of fifteen to explore the Chesapeake Bay. They were looking for the Lost Colony of Roanoke and for the inland sea to Asia, but found neither. They did, however, encounter mostly friendly Indians and sudden, threatening summer storms. They also discovered and explored Tangier and Smith islands, which they named Russel's Islands, after the doctor/scribe on board. Out of these voyages came Smith's widely published map and his later *Generall Historie of Virginia, New England and the Summer Isles,* extolling the wonders of this brave new world and assuring Smith's place in history.

"There is but one entraunce by sea into this country and that is at the mouth of a very goodly Bay," Smith wrote.

A goat at Yorktown Festival Park; the Park is on the site of the decisive American victory over the British forces in 1781.

> Within is a country that may haue the prerogative over the most pleasant places of Europe, Asia, Africa, or America, for large and pleasant navigable rivers, heaven & earth never agreed better to frame a place for mans habitation being of our constitutions, were it fully manured and inhabited by industrious people. Here are mountaines, hils, plaines, valleyes, rivers and brookes, all running most pleasantly into a faire Bay compassed but for the mouth with fruitfull and delightsome land. . . .
>
> The mildnesse of the aire, the fertilitie of the soile, and the situation of the rivers are so propitious to the nature and use of man as no place is more convenient for pleasure, profit and man's sustenance.
>
> Under that lattitude or climate, there will live any beasts, as horses, goats, sheep, asses, hens &c. as appeared by them that were carried thether. The waters, Isles, and shoeales, are full of safe harbours for ships of warre or marchandize, for boats of all sortes, for transportation or fishing, &c. The Bay and riuers haue much marchandable fish and places fit for Salt coats, buildings of ships, making of iron, &c.

Smith zigzagged across the bay and followed the western shore midway up, then headed south to the Potomac River, where the expedition

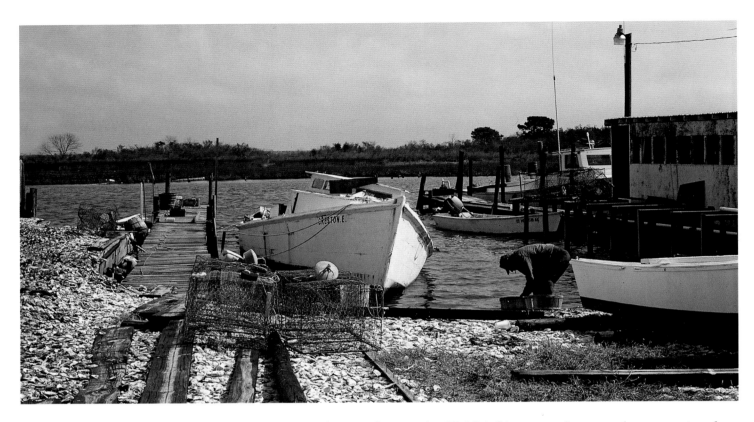

A hardworking waterman cleaning oysters at Ewell, the largest of three settlements on Smith Island, Maryland.

spent three or four weeks. "Of fish," he wrote, "we were best acquainted with Sturgeon, Grampus, Porpus, Seales, Stingraies, whose tailes are very dangerous, Brettes, mullets, white Salmonds, Trowts, Soles, Plaice, Herrings, Conyfish, Rockfish, Eeles, Lampreyes, Catfish, Shades, Perch of 3 sorts, Crabs, Shrimpts, Creuises, Oysters, Cocles and Muscles."

After a trip of forty-nine days, he returned to Jamestown for four, during which time he got himself elected president of the colonial council, and then set off on a second voyage of exploration. This time, Smith journeyed north to the bay's origin, at the mouth of the Susquehanna River, where he parleyed and partied with the Susquehannock Indians, who tried to enlist his help in fighting their tribal enemies. Smith then proceeded south, primarily along the Western Shore, exploring the Patuxent and the Rappahannock rivers, encountering more Indians and more storms.

The second Smith expedition ended at Jamestown on July 7, 1608, one day short of six weeks after it had begun. They had not returned with riches, but, wrote voyager Anas Todkill, "we chanced on a lande even as God made it . . . and tell mee how many ever, with such small meanes as a barge of 2. Tunnes, sometimes with 7.8.9. or but at most 15 men, did ever discover so many faire and navigable rivers."

As for Smith, he directed physical improvements at Jamestown and then, the following year, went back to England. He never again returned to Virginia—although he did visit New England twice, in 1613 and 1615, and even applied for the job of leading the Pilgrims to that northern corner of the New World. But he was no Puritan, and the assignment went to the less colorful Miles Standish. In 1612, Smith published his remarkably accurate map of Virginia, with commentaries by himself, Dr. Walter Russel, Anas Todkill, and others. He published his *Generall Historie* in 1624. Smith did not become rich. He did not even have a home of his own; instead, he moved around and lived with friends, until he died in 1631, aged fifty-one. Shortly before his death, he composed his own epitaph:

Here lies one conquer'd that hath conquer'd Kings:
Subdu'd large Territories, and done things
Which to the World impossible would seeme,
But that the truth is held in more esteeme.

Smith's encounters with the Indians around the Chesapeake had been sometimes hostile, sometimes friendly, but always circumspect and calculated. He made pledges of allegiance and support he never intended to keep; he traded trinkets for safe passage. And he was lucky, as witness his legendary meeting with Chief Powhatan and Pocahontas.

According to one of the early colonists, the Indians "are much desirous of our Commodityes . . . and demand after Copper, white beades, howes . . . for which they will give . . . deare skyns, furrs of the wyld catt, black-Fox, bever, otter, arrachowne . . . Fowle, Fish, dears or bears flesh . . . their Country-Corn, Pease, Beanes. . . ." But Powhatan, less beguiled than his daughter, had told Smith: "many doe informe your coming here is not for trade, but to invade my people and possesse my Countrie."

The Indian chieftain nonetheless befriended the newcomers, but Powhatan's successors did not share his tolerance toward the English colonists. Mounting Indian resentment led to what came to be known as the massacre of 1622, in which natives killed 347 James River colonists— one quarter of the entire English population. A similar Indian attack occurred twenty-two years later. But the English would not be stopped. They met violence with violence, killing with killing. They engaged in "harshe visitts" and "feedfights," taking corn from the Indians while growing nothing for their own sustenance, except tobacco for export. In the end, the Indians retreated: their "manifest destiny" would be banishment from their Chesapeake homelands.

The earliest Jamestown settlers lived in thatched homes inside a triangular fort, with a church and storehouse in the middle. Military law prevailed

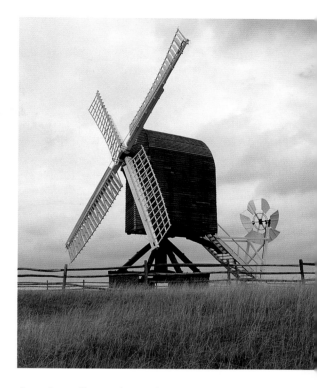

A replica of an eighteenth-century windmill at Flowerdew Hundred Plantation, now the site of a large archaeological excavation on the south side of the James River.

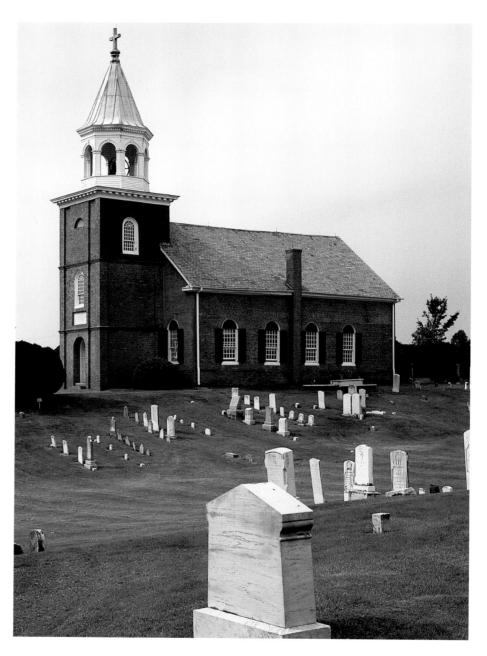

The 1704 Old Bohemia Church—St. Francis Xavier Roman Catholic—still in use near Georgetown, Maryland, on the Upper Eastern Shore

until 1619, when an assembly was created. The same year, the first shipload of single Englishwomen arrived, and, just as momentous, a Dutch ship arriving at Old Point Comfort traded its cargo of twenty black indentured servants for food and supplies. By this time, the colony was of more than passing interest to the English royalty. In 1624, King James revoked the Virginia Company charter and converted the territory into

a crown colony. By 1625, Jamestown had 175 people and, according to a contemporary inventory, the following: "church, 2; a large court of guard, 1; pieces of ordnance mounted, 4; and 15 houselots from one-sixth acre to seven acre." Virginia's ten largest planters had their primary residences in Jamestown. But the town's rise more or less ended there. In 1637, the Virginia General Assembly offered anyone willing to settle in Jamestown land for a house and garden. There were only a dozen takers.

Jamestown had survived the 1622 Indian attacks; the colonists had received advance word from a friendly native and were able to defend themselves. But Indian attacks on the Virginia frontiersmen also affected Jamestown. Governor William Berkeley's failure to react strongly and effectively to such incidents triggered a rebellion led by Nathaniel Bacon. Oxford-educated Bacon came to the colony in 1674, a year before conflict with the Susquehannocks. When Berkeley failed to back the settlers, Bacon took the lead. For this, the governor declared him "the greatest rebel that ever was in Virginia" and his movement an outright rebellion. In 1676, Bacon and his men marched on Jamestown, which consisted, according to an observer, of but "16 or 18 houses . . . and in them about a dozen families." There were few, if any, to resist as Bacon's forces set fire to the statehouse. Berkeley fled, and Bacon declared that Virginians should defend their rights or forsake the colony. Bacon's Rebellion, born of the European interlopers' conflict with the Indians, became part of the mythology of the colonial fight for democracy. Its leader, however, died of a fever soon after his apparent victory.

After a fourth statehouse burned in 1698, the colonial capital moved to Middle Plantation, since 1691 the home of the College of William and Mary. Middle Plantation was renamed Williamsburg, and Jamestown

The Governor's Palace Gardens pond at Colonial Williamsburg

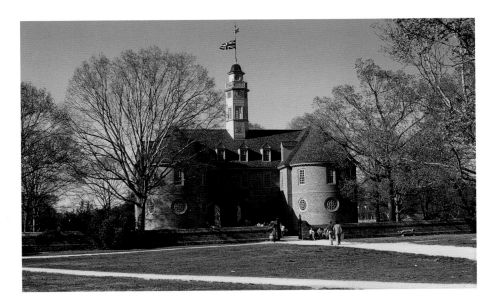

A replica of the colonial capitol at Colonial Williamsburg

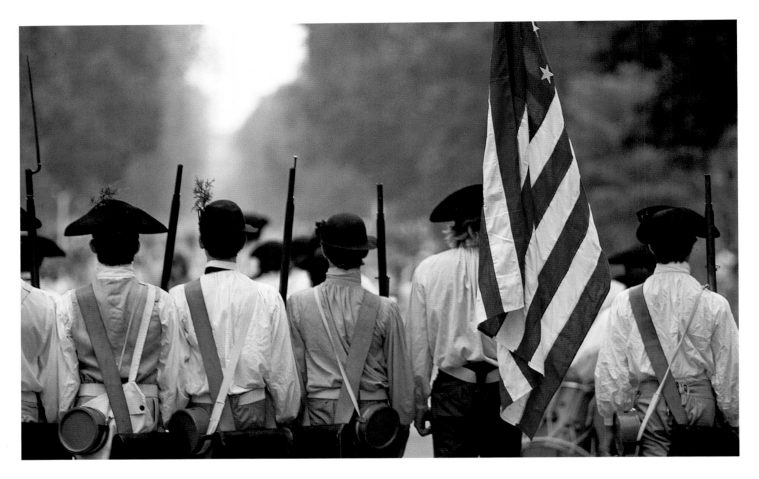

The Colonial Williamsburg fife and drum corps marches down Duke of Gloucester Street.

Early morning light casts shadows on the restored 1812 Roscoe Cole house at Colonial Williamsburg.

A well at Colonial Williamsburg

Two docents chatting while eating candy at Colonial Williamsburg

Lock and chain, Colonial Williamsburg

An apple-bedecked front door marks Christmastime at Colonial Williamsburg.

faded into history. Jamestown's population never exceeded five hundred. It is usually described as "the first permanent English settlement in America," but permanent it was not. In time, it was reclaimed by the forest, leaving to posterity few tangible reminders of its seminal place in American history.

The English settlers in Virginia ranged far and wide around the

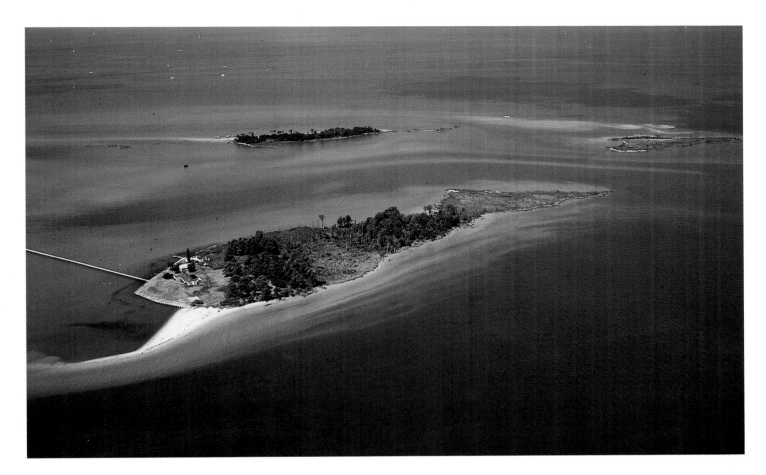

Chesapeake. Fur trader William Claiborne—who had also paid "harshe visitts" on the Indians, stealing their corn and then selling it for tobacco—sailed up the Chesapeake and founded a settlement in August 1631 on Kent Island. He also established himself and his men on the nearby islands of Popeley's (Poplar) and Claiborne's (later known as Sharps, and now entirely washed away), and he planted a trading post on Palmer's (Poole's) Island, in the upper Chesapeake. These Claiborne settlements were the first by any English-speaking people in what would later become Maryland. But, except for Claiborne, Maryland, a former Chesapeake Bay railroad and ferry terminus, no statue, plaque, or place name in Maryland recalls him or his role.

Claiborne notwithstanding, official "Maryland" traces its roots to 1632, when King Charles I granted to George Calvert, the first Lord Baltimore and a Catholic, all the land between the 40th parallel and the low-water mark of the Potomac River to its source. Calvert had attempted a settlement in Newfoundland but found the climate inhospitable; he

Time and tide divided Poplar Island, once a thousand-acre tract, into several fragments. In the foreground is Jefferson Island, which once boasted a post office and general store, along with the Jefferson Island Club, used by presidents and lesser politicians of the Democratic persuasion. In the background are other islets belonging to the Poplar chain. In 1998, some years after this photograph was taken, the U.S. Army Corps of Engineers began restoring the island to its 1847 footprint with sediment dredged from shipping channels leading to Baltimore.

Before the Bay Bridge, ferries landed here in Claiborne, Maryland, named after Captain William Claiborne, the Virginian who first settled Maryland in 1631 and whom history has largely ignored.

sought a Chesapeake charter after a visit to Jamestown in 1629. When George Calvert died shortly before the grant was official, it was passed on to his son Cecilius, the second Lord Baltimore. He dispatched brother Leonard to start a colony to be named in honor of the English Queen Henrietta Maria. Leonard's ships, the *Ark* and the *Dove,* sailed from the Isle of Wight in November 1633, the *Ark* with 140 passengers and the tiny *Dove* carrying supporting supplies. This was no democratic assemblage: 120 of the passengers were servants of the governor, two were commissioners, one a priest, and fourteen others were "gentlemen." A majority were Protestants. Cecil Calvert planned to grant land in return for a yearly rent. His success would hinge, therefore, on attracting settlers, and he was pragmatic enough to woo Protestants along with Catholics. As Leonard left England, his brother directed him to be "very carefull to preserve unity and peace amongst the passengers on shippboard" and to "suffer no scandell nor offense to be given to any of the Protestants."

The crossing took four months, during which the ships separated in a storm and were reunited in Barbados for the last leg of their trip. On their way, they stopped at Jamestown, where Leonard informed Claiborne that he was now a subject of Maryland proprietary. The trader asked the colonial council for guidance. The council told him there was no reason to relinquish his rights "to the place in the Isle of Kent." In fact, upon learning of the charter granted Lord Baltimore, the House of Burgesses had petitioned the king against it. Notwithstanding such protests, the Calvert expedition landed on March 25, 1634, at St. Clement's Island on the Potomac River, in what would become St. Mary's County. The date is

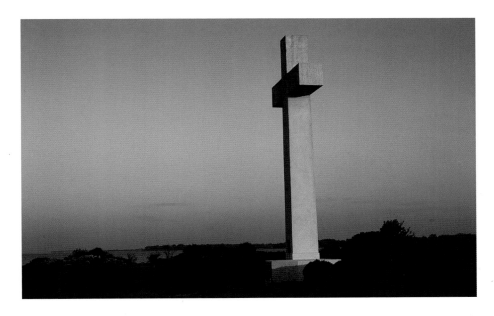

A towering cross on St. Clement's Island in the Potomac commemorates the spot where Leonard Calvert's Maryland colonists landed and celebrated a thanksgiving mass in 1634.

annually celebrated as "Maryland Day," with appropriate closings of state offices and courts, as if nothing had happened there before.

On the surface, at least, there seemed a certain nobility about the Maryland venture that was lacking in Virginia's. Even today, Maryland loyalists refer derisively to Claiborne as a mercantile trader from Virginia, whereas all kinds of spiritual motives are attributed to the Calverts. In truth, the Calverts were no less motivated by gain, but their Catholicism cast them in the role of underdogs. Much is made of the first mass on these shores, led by Father Andrew White, a Jesuit priest. The first thing the new arrivals did was pray. (Father White also had a secular side: "The place abounds not alone with profit, but also with pleasures," he noted in his brief 1634 report on the voyage to Maryland.)

To secure a piece of ground, Governor Leonard Calvert sailed in the *Dove* back down the Potomac. He met the chief of the Piscataway Indians and bought a piece of land on which to settle. "To make his entry peaceable and safe," wrote Father White, "hee thought fit to present the Werowance and the Wisoes of the Towne with some English cloth, Axes, Howes, and Knives, which they accepted very kindly, and freely gave consent that hee and his company should dwell in one part of their Towne. . . . The Governour tooke possession of the place, and named the Towne Saint Maries. . . . Is not this miraculous that a nation . . . should like lambes yeeld themselves [and be] glad of our company, giveing us houses, land, and liveings for a trifle?"

The palisaded town was on a tributary of the Potomac, near where the main river meets the Chesapeake Bay. "St. Maries Citty" became the colony's first capital—and St. Mary's became Maryland's "Mother

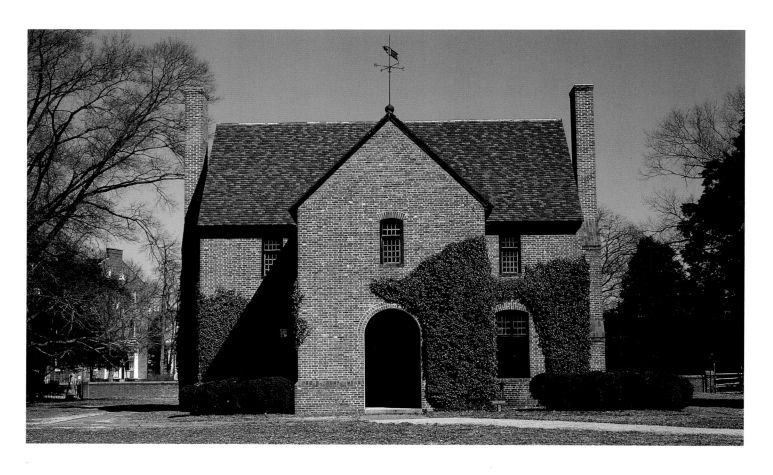

This replica of the 1676 State House at St. Mary's City, Maryland, was built in 1934 to mark the colony's tricentenary.

County," a label it still carries with pride, if not with total historic accuracy. (After the Calvert regime came to an end, the capital would be moved to the Protestant stronghold of Annapolis, which a group of Puritans from Virginia had founded in 1649 as the town of Providence.)

On April 24, the *Dove* was dispatched to explore the Chesapeake and establish trading relationships with Indians. The ship next went to New England, then returned to the bay in November 1634. At Point Comfort, Virginia, the captain and crew abandoned ship for lack of pay, returned on another vessel to England, and sued Lord Baltimore. The *Dove*, loaded with beaver pelts and timber, finally set sail for England in August 1635, but she was lost at sea.

It did not augur well for the new colony. Like Virginia, Maryland was off to a shaky start. The well-ordered vision of Lord Baltimore dissolved amid squabbles and schisms. The Jesuits wanted tax-exempt land and to make Maryland a theocracy. Lord Baltimore not only opposed this, he encouraged Puritan Protestants—religious refugees from Anglican Virginia—to come to the new colony. At least partly for their protection,

he urged the Maryland General Assembly to pass the colony's short-lived Act of Toleration in 1649. But the newcomers quickly turned against him; in 1654, the Protestant majority enacted another law stating that the right of Catholics to practice their faith—in their very own colony—would no longer be protected.

Further problems arose from transplanting the English Civil War across the Atlantic. The Calverts were loyal to the king. Richard Ingle, a Protestant ship captain who had been trading in Maryland as early as 1639, obtained a letter of marque from Parliament and marched on St. Mary's City, which he looted and burned, though its citizens surrendered without a fight. Leonard Calvert sought refuge across the Potomac in Virginia, and Ingle returned to England with Catholic priests and others as prisoners in chains.

During this so-called "time of troubles"—also known as "the plundering time"—some Marylanders crossed the Potomac to become the earliest settlers on Virginia's Northern Neck. Returning two years later, Leonard regained a semblance of authority. But after a tumultuous decade, Maryland's survival as a separate colony was no sure thing. There had been only seven hundred colonists in 1642. After what became known as Ingle's Rebellion, there were no more than two hundred and possibly even fewer. The colony of Virginia, meanwhile, counted 1,300 by 1615 and 4,914 by 1634.

Leonard lacked charisma and Cecilius tried to run the colony from England, where he also had to fend off the "Virginia interests" of London merchants and colonial planters, who continually challenged the validity of the proprietorship. In England, Maryland also had something of an image problem: nearly everyone thought it was a part of Virginia. "Maryland is a province not commonly known in England," wrote one John Hammond in 1656, "because the name Virginia includes or clouds it."

Claiborne, a Protestant from Virginia, did not recognize the Calvert claim, and, indeed, he had a case. The charters of 1606, 1609, and 1611 to the Virginia Company of London included the land around the entire bay. But the colony's charters were revoked in 1623 by an English court, and the company was dissolved in 1624. Virginia then became a crown colony, a commonwealth. The younger son of an English merchant, Claiborne had come to Virginia as a colonial surveyor in 1621 and gone on to become a member of the colonial council and secretary of state. He sighted Kent Island on a fur-trading expedition up the bay in 1628 or 1629. Impressed by what he found, he returned to England to raise money and a crew and in 1631 sailed with twenty servants in the ship *Africa* for Kent Island, where he bought land from the Indians and established his Chesapeake headquarters. By the time the *Ark* and *Dove* landed, the Claiborne fur-trading post at the south end of the island had a population of perhaps a hundred settlers. The settlement boasted a fort, shipyard, cabins, two mills,

Trinity Protestant Church, built around 1675 on the shore of Church Creek in Dorchester County, Maryland

Trinity Protestant Episcopal Church, at St. Mary's City, Maryland, was built in 1829 with bricks from the first state house.

storehouses, and an Anglican church. Claiborne issued land grants under the Virginia charter, and the settlers were numerous enough in 1632 to be accorded a representative in the Virginia House of Burgesses.

Small wonder that Captain Claiborne regarded the Calverts as little more than land grabbers. But, after establishing a beachhead in what would later become St. Mary's County, Calvert was ordered by his brother the Lord Baltimore as early as September of 1634 to seize and punish Claiborne if he would not submit to the proprietary government. Nevertheless, Claiborne continued to challenge the Calverts even after the Maryland General Assembly accused him in 1635 of "grievous crimes of pyracie and murther" and passed a bill of attainder against him, holding forfeit to the proprietary all his Kent Island property. Further, in 1638, the Lords Commissioners for Plantations declared "the Right and Tytle of the Ile of Kent and other places in question to be absolutely belonging to the Lord Baltimore, & noe plantations or Trade with the Indians ought to be within the precincts of his Pattent without Lycense from him."

It was in a sense America's first civil war. The two sides clashed in 1635 on the Pocomoke River of the bay's Eastern Shore, where Leonard had sent two armed pinnaces to engage Claiborne's naval forces, which consisted of one ship. Who fired first is lost to history, but three of Claiborne's and one of Calvert's men were killed. Then, while Claiborne was in England filing his claim under the Virginia charter, Leonard's troops took Kent Island and shipped Claiborne's cattle to St. Mary's. In Claiborne's absence, his kinsman-associate Richard Thompson pressed his case.

Claiborne returned to Kent in 1644, only to be greeted by a proclamation from Calvert "prohibiting any trade with that island till ships had first been at St. Maries" and declaring "Captain William Clayborne and Richard Thompson, planter, to be enemies to the Province, and prohibiting all intelligence or correspondence with them or agents." Then Parliament in 1650 appointed a board of commissioners, including Claiborne, to establish the authority of the new commonwealth of Virginia. They hoped to subject Maryland to Virginia rule. Claiborne's forces won a naval battle on the Severn River in 1655, but it was not decisive. Two years later, Virginia officials formally recognized the proprietary.

Lord Baltimore's rule was to last only until 1689, when, in the wake of the Glorious Revolution and the ascension of William and Mary, Protestants captured the statehouse. Five years later, the capital was moved from St. Mary's City to the Protestant stronghold of Annapolis. Maryland was now a crown colony, and its Catholics were quickly disenfranchised, an injustice lasting nearly a century.

Claiborne returned to his Virginia estate. There, at Romancoke in King William County or in another county he is said to have named New Kent

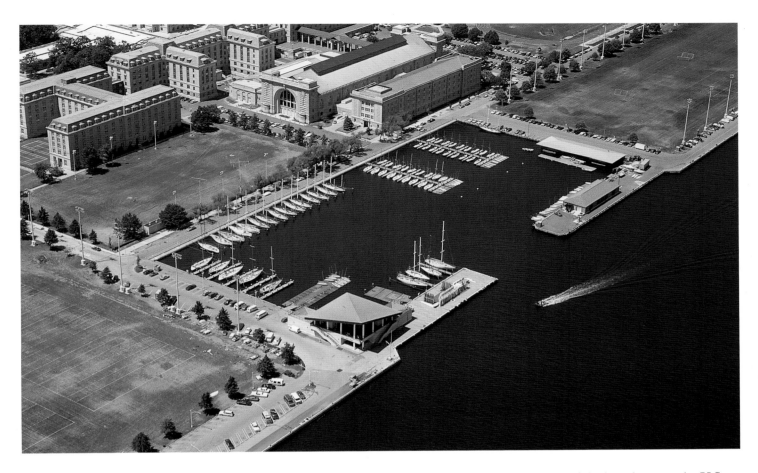

after his ill-fated settlement, he lived to be nearly ninety. His battle with Maryland was over, but the border wars did not end. In one shape or another, they have continued between Maryland and Virginia for 350 years.

In 1785, the warring parties came together at George Washington's Mount Vernon estate in a futile effort to settle the boundary dispute for all time. The line across the bay was moved three times thereafter, with Maryland the loser each time. Maryland and Virginia watermen resorted to violence to protect their turf. In what were known as the Oyster Wars, they shot at each other back and forth across the line, well into the middle of the twentieth century. In 1877, at the behest of Virginians who settled on the lower tip of Smith Island, the line across the bay was moved 320 feet farther north. Eventually, erosion washed away Smith Island's southern end, and Marylanders came crabbing below the line, only to be arrested by a marine policeman from Tangier Island, Virginia. Finally, in 1981, watermen from the Maryland side of Smith Island challenged the state line in court and won. Henceforth, a federal judge decreed that Maryland watermen could follow the crabs below the line into Virginia.

Aerial view of the boat basin at the U.S. Naval Academy at Annapolis on the Severn River

History notwithstanding, the Jamestown Tercentennial Exposition in 1907 managed to glorify the first colonists and their early days in the New World. In keeping with the colony's economic imperative, the Exposition at Hampton Roads was also an exercise in merchandising. At Jamestown itself, a 103-foot granite shaft was erected, and the Colonial Dames of America built a new church over the foundation of an old one, attaching the new building to a brick tower, the only surviving seventeenth-century structure on the island. For Virginia's 350th anniversary in 1957, the state built a replica of the original colony across the causeway from Jamestown itself. Jamestown Festival Park quickly became a major tourist attraction with its James Fort and its three full-scale replicas of the ships that brought the colonists. The historic theme has also spilled over into the surrounding area, inspiring the nomenclature of such enterprises as the First Settlers Campground as well as residential subdivisions like First Colony on the James (you enter on John Rolf Drive) and Heritage Landing.

Maryland marked its own tricentennial in 1934 with similar pomp and pageantry at the site of the St. Mary's County landing. A replica of the original State House arose at St. Mary's City, and a large cross was erected on St. Clement's Island. And, in 1984, not to be outdone by Virginia, Maryland produced for its 350th anniversary Lord Baltimore's World, a modern-day re-creation of a seventeenth-century "Old World" English village and a "New World" settlement at St. Mary's City, where "hearty settlers and craftsmen" were "busy building, cultivating and defending their new home." A replica of the *Dove* sat at dockside on the St. Mary's River. The reproduction State House and seventeenth-century-style "Farthing's Ordinary"—tavern—represented the original capital. Adjoining what was Lord Baltimore's World is St. Mary's College, a state undergraduate institution known for its fleet of twenty good-sized sailboats, as well as for its academics.

During the celebration, a mock Maryland General Assembly met at the re-created State House "to discuss problems with the rival Virginia colony." Of course, the battle with Claiborne had been fought and won long ago. There were 350th-anniversary license plates and other souvenirs memorializing the Calverts. As for Claiborne, the little island to which he once gave his name—soon thereafter to be known as Sharps Island—had completely washed away. On Kent Island, a modest sign was posted, announcing it as "The First English Settlement Within Maryland." Thousands of beachgoers drove by it on their way to Ocean City; otherwise, the Virginian's role in history was ignored during Maryland's celebration. None of the commemorative material distributed for the year's big anniversary weekend mentioned him or his settlement.

A high point of the commemoration was to be a reenactment of the landing, to be held on Maryland Day, March 25. But there were

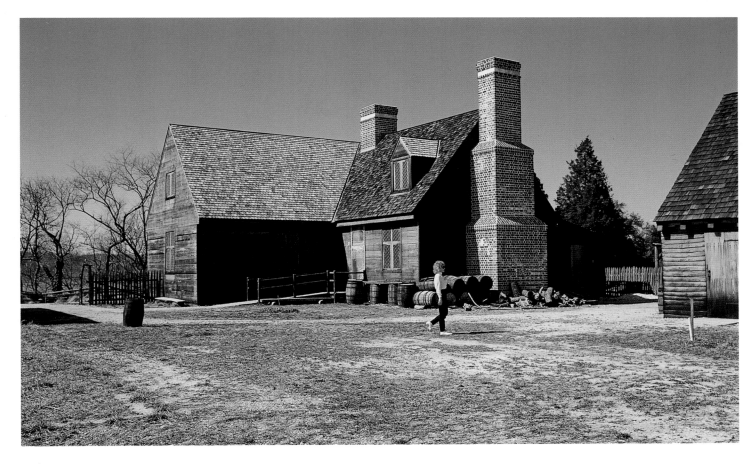

Farthing's Ordinary, a modern-day
approximation of a seventeenth-century
tavern, at St. Mary's City, Maryland

disappointments. Britain's Prince Charles passed up an invitation to
attend. Also among the no-shows were members of the Society of the
Ark and Dove, 250 venerable descendants of the original settlers; Davis
Calvert, an engineer from Baltimore and the society's president, explained
that most of the members were elderly and feared large crowds.

And then it rained. And rained and rained—a cold, unrelenting
downpour in the rolling tobacco country two hours from Washington.
Four thousand soggy spectators, brought over in a gray U.S. Navy landing
craft, crowded on to St. Clement's Island for a reenactment that was all
but rained out. After forty-five costumed "settlers" arrived by powerboat,
the stars of the show remained offshore in a small dinghy, which their oar
power could not quite bring aground. When they finally landed, most of
the politicians and spectators had returned to the mainland. Maryland
Attorney General Stephen H. Sachs jokingly called it "Inclement Island."
It was William Claiborne's revenge.

A bright afternoon sun highlights the hues of winter on the marshes at Elk Neck National Wildlife Refuge.

Sunrise over South Marsh Island, as seen from Holland Straits

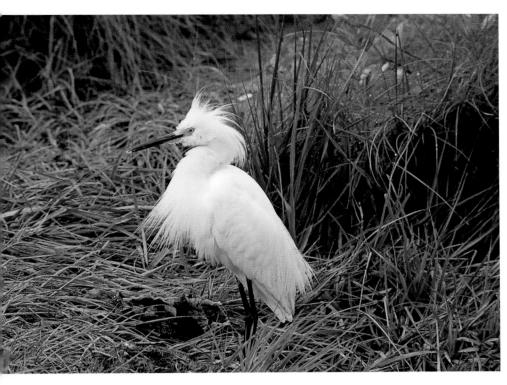

Snowy egret (*Egretta thula*), Blackwater
National Wildlife Refuge, Dorchester
County, Maryland

The Plantations

The rule of the road in Chesapeake country is this: those who don't have a lot of money live near the highway, those who do live on the water. It has always been this way. Lacking roads, the Chesapeake colonists relied on the rivers as their major thoroughfares. Plantation chimneys became landmarks for sea captains. So they remained well into the twentieth century when steamboats, more than cars, connected Tidewater towns and villages with Baltimore and Washington. In the same way, the Chesapeake plantations were tied to England.

Today, from the upper bay to the lower James, tree-lined lanes lead back from the roads to the river. They dead-end at impressive, stately houses that, often as not, face the water. The sight evokes images of antebellum wealth, of an era of a genteel, aristocratic way of life long idealized in history books. Much more than that, these plantation houses are a tangible link to the upwardly mobile beginnings of America.

Plantation society began along the James River in Virginia, then spread to the Potomac, the Patuxent, and to other rivers of the eastern and western shores of the Chesapeake. In this setting, the English gentry quickly established itself. As early as 1625, there were as many as twenty-seven separate plantations in Virginia. The owner of a large plantation, observed a British traveler, "lives more luxuriantly than a country gentleman in England on an estate of three or four thousand pounds a year."

The plantation masters controlled what amounted to self-contained communities, each with its own artisans and craftsmen. A "great house" was at the center of it all. Around this main plantation building were "dependencies," outbuildings for cooking, curing meat, and schooling. And, of course, there were the slave quarters.

Hogshead caskets of tobacco were rolled down narrow "rolling roads" to riverfront wharves, which served as ports of entry into and exit from the country. They contained customshouses and warehouses, where planters stored tobacco awaiting export to England. From these river wharves, the planters also imported the necessities and luxuries of life, including fine clothes, porcelain dishware, and glassware.

In the absence of any other settlements of size or consequence, plantations grew. Despite the passage of English laws mandating the creation of towns, the absentee rulers simultaneously enacted protectionist

A tiger swallowtail butterfly (*Papilio glancus*) lands on Queen Anne's lace.

OPPOSITE
Day lilies peek over a white picket fence at Colonial Williamsburg.

statutes that seemed almost designed to discourage them. Manufacturing, which would justify a town's existence, was prohibited, and colonists were forced to import the finer things in life from England. This they did, but with growing resentment.

The plantations were built by colonialists whose sons and grandsons would become patriots. Those who had come to America as Englishmen to exploit the New World produced a new breed of Americans determined *not* to be exploited by other Englishmen. They came to resent such laws as the Navigation Acts, which limited tobacco sales to English markets at prices set in England. Economic self-interest motivated these colonial planters to break away from the mother country, even as it had previously linked them to it. It may seem ironic that this essentially hierarchical society, whose economic survival rested on slavery, should serve as the cradle of American democracy. Nonetheless, it was among plantation owners that the American Revolution took shape, as plantation life produced several signers of the Declaration of Independence, future presidents, governors, and leading judicial thinkers before it vanished with the winds of civil war.

Tidewater Maryland and Virginia shared a social and economic system of agriculture underpinned by slavery. Plantation society transcended the natural and political boundaries of the two colonies. Without towns of any consequence, "southern hospitality" became a much-hallowed tradition, and families intermarried across the necks and rivers of the Tidewater. The connections created a sort of floating aristocracy around the Chesapeake.

But plantations were more than economic units to support an aristocratic lifestyle. They were communities of people, of different stations and fortunes in life. If plantation life has been idealized, the plantation owners venerated and elevated to a status approaching royalty, the reality was quite different. There were those of noble birth and behavior, to be sure, but others squandered their fortunes and good names.

The human dramas tracing the rise and fall of the plantations— and their latter-day reincarnations as museums of a bygone era—are prominently played out at Shirley on the James, at Stratford on the Potomac, and at Sotterly on the Patuxent. While they share a common heritage, each plantation is unique. Shirley, the oldest in America, dates to 1613. Stratford's claim to fame is as the birthplace of Robert E. Lee. Sotterly calls itself "the nation's longest continuously operating plantation." Though miles and rivers apart, the three plantations are linked through family, ownership, and history.

In the beginning were the land grants. By the divine right of kings, seventeenth-century rulers claimed the land their agents had discovered in the New World and liberally bestowed it on others. In Maryland, Lord Baltimore, under a charter from King Charles, gave four thousand acres

on the Patuxent River to Captain Thomas Cornwallis. If the Calvert clan of Lord Baltimore had had a navy, Cornwallis would probably have been its admiral. As it was, Calvert owed him one for doing naval battle with rival Virginian William Claiborne on the Pocomoke River of Maryland's Eastern Shore. Cornwallis, who named his tract "Resurrection Manor," may have been a speculator; or, perhaps life in the colonies just wasn't his cup of tea. After nine years, he sold the land and returned to England to live. Within a few more short years, the property was subdivided. It changed hands several times, the largest chunk of it—890 acres—winding up in the hands of a James Bowles. Before he died in 1727, Bowles opened a riverfront landing and began building the low-lying hundred-foot-long manor house that has survived to this day as Sotterly. It sits on a prominent bluff with a sweeping view of the river.

Along the James, the earliest recorded grant was made in 1613 to Sir Thomas West and his two brothers. Together, they established the West and Sherley Hundred (after the family of his wife, Cecily Sherley). Two of the brothers served as governors of Virginia, but they would transfer the riverfront land to Colonel Edward Hill, a sort of colonial gadabout. In return for bringing eight settlers into the colony, he had earlier received 450 acres in Charles City County "for personal adventure." Shortly thereafter, he trooped off to Maryland to keep an eye on the Calvert interests during the short reign of parliamentarian-privateer Richard Ingle and the political exile of Governor Leonard Calvert across the Potomac on Virginia's Northern Neck.

When Hill returned to Virginia, he acquired Shirley (as it came to be spelled) as part of a 2,000-acre grant, which he doubled in size by marrying a landed widow. He would leave the entire estate to his son, Edward Hill 2d, who, in the tradition of *noblesse oblige,* served as the colony's treasurer, attorney-general, councillor, and speaker of the House of Burgesses.

Meanwhile, on the Northern Neck, Nathaniel Pope, an English yeoman from St. Mary's City in Maryland, had crossed the river and acquired the land that would later become Stratford. He patented the property in 1651 for the growing of tobacco. Situated on a high bluff by the river, it naturally became known as the "Clifts Plantation." Pope and his sons had been "marriners" of London and Bristol, the latter a major port in the Virginia tobacco trade. They maintained their landholding of 1,550 acres until 1716, when it was sold to a man named Thomas Lee.

Lee's grandfather, Richard, had immigrated to Jamestown in 1630, settled on a York River plantation, exported tobacco, and served on the colonial council. He bequeathed to his son Richard Lee 2d a house on the Potomac ten miles downriver from Stratford. Richard's son, Thomas, bought the Clifts. When the other Potomac River home burned down—allegedly torched by felons Lee had sentenced as a justice of the peace—

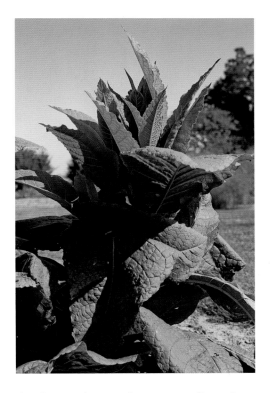

A tobacco plant, midsummer at Sotterly

OVERLEAF, LEFT
A replica of a seventeenth-century wagon sits outside Farthing's Ordinary, St. Mary's City, Maryland.

OVERLEAF, TOP RIGHT
A thatched English house is part of the colonial tobacco plantation recreated as the "Godiah Spray Plantation" at St. Mary's City, Maryland.

OVERLEAF, BOTTOM RIGHT
Maryland tobacco air-curing in a barn at Beauvue, near Leonardtown, St. Mary's County

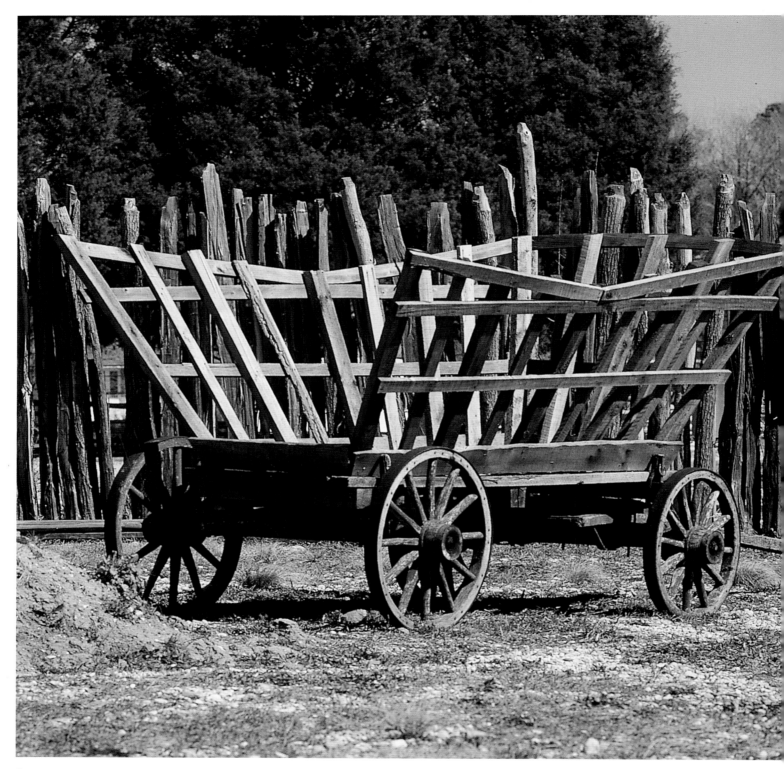

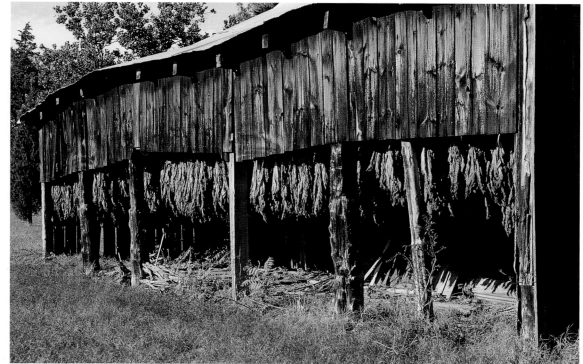

he built Stratford, the impressive H-shaped manor house that sits today at the top of a wide meadow within view of the Potomac River. Under Lee, Stratford Landing soon became a bustling public wharf. As many as fifteen ships a month put in there to drop off and pick up cargo. Seeking to control the shipping along with the shipment, the Lees themselves owned several vessels that participated in the Stratford–England trade.

Stratford was only the centerpiece of Thomas Lee's extensive landholdings, which included as much as 30,000 acres. When the voracious sotweed wore out Stratford soil, Lee switched to grains there and grew his tobacco elsewhere. By the middle of the eighteenth century, Stratford Plantation was sufficiently prosperous to support a population of more than 200 slaves and servants.

Stratford also spawned a tradition of patriotism and public service. Thomas Lee served as president of the colonial council of Virginia. His third and fourth sons, Richard Henry and Francis Lightfoot Lee, signed the Declaration of Independence, the only two brothers to do so. His youngest two, William and Arthur, were among the first U.S. envoys to Europe. Thomas Ludwell Lee, his second son, was a revolutionary patriot and a judge of the Virginia Commonwealth under the first state constitution. Richard Henry Lee was president of Congress under the Articles of Confederation, in 1784.

The big house at Shirley, built in the Georgian style, was begun in 1723 and completed in 1738 as a wedding present from John Carter to his bride Elizabeth Hill. The year before, Carter's career had been assured by his father, Robert "King" Carter, who owned 300,000 acres, 1,000 slaves, and 2,000 cattle. The elder Carter had paid the crown 1,500 pounds for his son's lifetime appointment as secretary of the colony. Shirley was but one of three residences the couple maintained in the colony. When John died in 1742, his enriched widow, Elizabeth, remarried and had eight more children before succumbing to a fever in 1771.

After her death, the plantation passed to her son Charles Carter, a Loyalist turned Patriot. Charles Carter fancied horses, which he raced; he even purchased a silver bowl in London for one of them, Nestor, his favorite. Whenever Nestor won a race, the story goes, the horse was treated to champagne from the silver bowl. Carter had eight children by his first wife, who died in 1770. With his second wife, he added fifteen more to the Shirley line. Among them was Anne Hill Carter, and here the lines of Stratford and Shirley merge. In 1793, she married Henry ("Lighthorse Harry") Lee, a three-term governor of Virginia from another branch of the family. (Harry Lee is probably best remembered for eulogizing George Washington as "first in war, first in peace, and first in the hearts of his countrymen.") It was Harry Lee's second marriage; his first had been to his second cousin, Matilda Lee, a granddaughter of

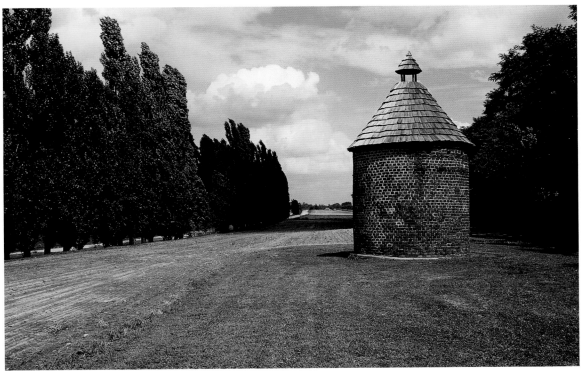

Thomas Lee, and they had lived at Stratford. After Matilda's early death, he pursued her friend, Anne, whom he courted and married at Shirley. After his terms of office, they returned to Stratford, where, on January 19, 1807, a son was born: Robert Edward Lee.

The child would become more famous even than his father.

Young Robert spent a good deal of time at Shirley while his father struggled to make ends meet at Stratford. But with six children, Lighthorse Harry Lee, a Revolutionary War hero, fell hopelessly into debt and wound up in the debtors' prison at Montross, the Westmoreland County seat. From his cell, he nonetheless managed to write a history of the American Revolution in the South. Freed from prison, he moved his family in 1810 to Alexandria, where they lived off Anne's legacy.

Ownership of Stratford fell to Henry Lee IV, a son of Harry's by his first wife, Matilda. Henry (who would be known as "Black-Horse Harry") married a rich neighbor, sixteen-year-old Anne McCarty, and they proceeded to repair and refurbish Stratford with her money. But theirs would not be a happy lot. Their only child, Margaret, while a toddler, died in a fatal fall from the great hall steps, as had a young cousin, Philip Ludwell Lee 3d, in 1779. Anne became addicted to the morphine she took to relieve her grief, and Henry took up with her sister, Elizabeth McCarty, who had come to live with them as his ward. In scandal and disgrace, both sisters left Stratford (although Elizabeth would later return to live), and Henry Lee, broke, sold the entire plantation of three thousand acres for $25,000 to William Clarke Sommerville of Mulberry Fields, a St. Mary's County plantation across the Potomac River in Maryland.

Family ties would also link Stratford to Sotterly. Ownership of Sotterly had passed to the "ravishing rich widow" of James Bowles, as the *Maryland Gazette* described her. Two years after her husband's death, Rebecca Addison Bowles married George Plater II, a Cambridge-educated lawyer from Port Tobacco and deputy governor of Maryland. Her three daughters inherited the property, but each of them married and moved to Virginia; together, they sold Sotterly to their stepfather.

George Plater II held the post of customs collector, thus making Sotterly Landing an important port of the Maryland colony. George III, one of his five children, named the place Sotterly, after Sotterly Hall, the ancestral Plater home in Suffolk, England. Educated at William and Mary College, George III also practiced law and was active in Revolutionary politics. He represented Maryland in the Continental Congress, and served as president of the state convention that ratified the Constitution and as a member of the electoral college that elected Washington the country's first president. To cap his career, he was elected governor of Maryland in 1791, and, in that post, deeded over a portion of Prince George's County to form the District of Columbia, the new

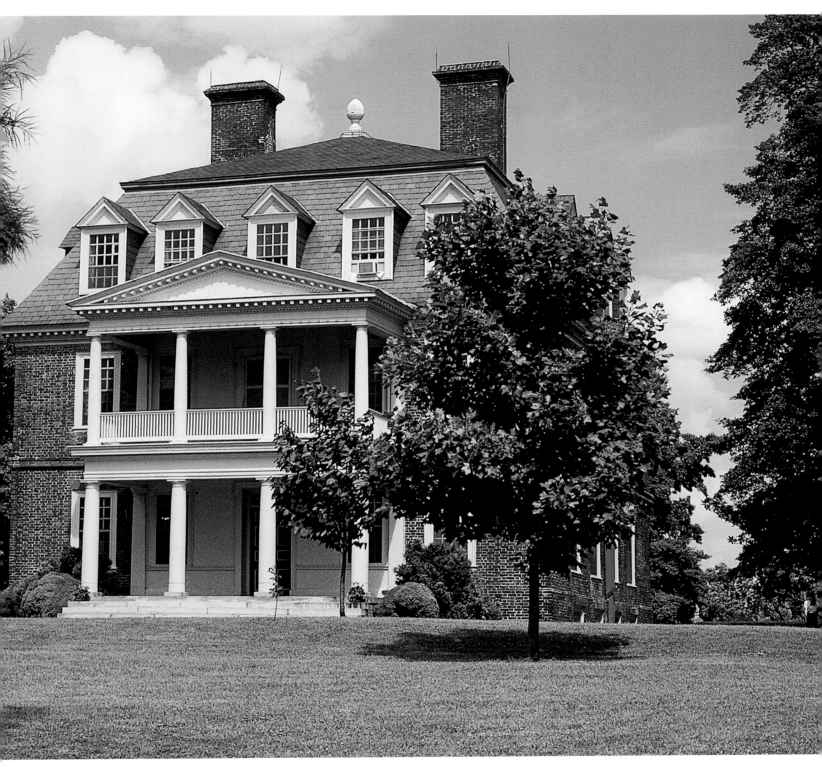

national capital. George III married twice. His first wife was Hannah Lee, of Stratford.

George Plater IV married Elizabeth Sommerville of Mulberry Fields. Both died in 1802, leaving the entire estate to George IV's five-year-old son. George V grew up to be a gambler, but not a successful one. He lost the plantation in a dice game in 1822 to Colonel William Sommerville of Mulberry Fields, brother of his late stepmother and the man who acquired Stratford the same year.

Sommerville immediately sold Sotterly to a Thomas Barber, who died within three years and left it to his stepdaughter, Emeline Dallam. In 1826, she married Dr. Walter Hanson Stone Briscoe, whose ancestor nine generations before had been ship's surgeon on Leonard Calvert's *Ark*. The Briscoes lived at Sotterly for more than sixty years, raising a dozen children there.

Shirley also had its ups and downs. Robert Hill Carter proved to be the polar opposite of his father, Charles. He didn't drink or gamble, and he hated slavery. Instead of running the plantation, Robert became a physician and went off to Paris, where he died of a fever. In 1806, ownership of Shirley passed to ten-year-old Hill Carter under the guardianship of two uncles.

A 1799 census of the plantation showed 201 slaves, but tobacco had depleted the soil, and the uncles who ran Shirley squandered plantation funds and sold most of the furniture. They even stripped the roof of lead to make bullets in the War of 1812. In 1816, Hill Carter, having come of age, evicted his uncles, burned down the tobacco barns, and inaugurated a system of crop rotation and the use of fertilizer. Within fifteen years, he had paid off all debts and replaced the roof and furniture. By the 1830s, the plantation was back on a sound economic footing.

Antebellum life at Shirley was good for the owners and guests. According to Henry Barnard, a New Englander visiting in 1833, eight A.M. breakfast consisted of coffee or tea, "fashionably" cold ham "of real Virginia flavor," and hot breads. At one P.M., the gentlemen partook of grog. Dinner was at three, topped with champagne and desserts. "When you have eaten this," recounted Barnard, "off goes the second table cloth, and then upon a bare mahogany table is set the figs, raisins and almonds and . . . two or three bottles of wine. . . . After the glasses are all filled, the gentlemen pledge their services to the ladies, and down goes the wine; after the first and second glasses, the ladies retire, and the gentlemen begin to circulate the bottle pretty briskly."

Such high living would not last; the Civil War saw to that. Though only Shirley was directly in the path of the war, all three plantations were affected in one way or another. Sotterly, the plantation where British troops had encamped during the War of 1812, was least touched. Three

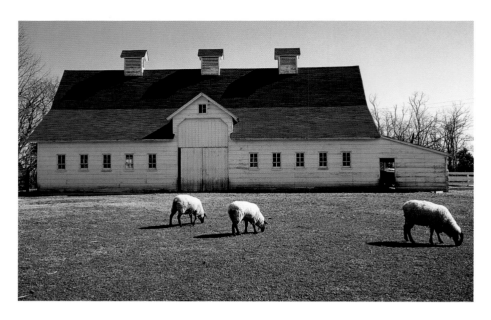

Sheep grazing at Sotterly Plantation in St. Mary's County

Briscoe sons left the plantation to fight for the Confederacy, then returned to Maryland after the war.

At Shirley, Hill Carter, sixty-six, and six of his sons joined the Confederate forces. Carter, who like his father opposed slavery even though he owned large numbers of slaves, was wounded and permanently disabled. His oldest son died in the Battle of Chancellorsville. While the men were off to war, Shirley was run by Hill's wife, Louise Carter.

But war soon engulfed the plantation itself. Shirley was occupied by the forces of Union General George B. McClellan and used as a hospital for a thousand wounded Yankees, following the nearby Battle of Malvern Hill in June 1862. McClellan and Louise Carter dealt graciously with each other: she made bread and soup and helped nurse the troops; he sent her a thank you note. It was McClellan's reluctance to wage total war on the South—reflected in his polite treatment of Shirley—that would cost him his job after Antietam.

After the war, Robert E. Lee journeyed up the James past the Shirley plantation. From Lexington, where he had assumed the presidency of Washington College, Lee wrote cousin Hill Carter on April 17, 1868: "I passed Shirley twice last December with a heavy heart at my inability to stop. I took a long look each time at the House, the grounds & farm from the hurricane deck of the Steamer, hoping to see some of the family, to no purpose. I thought if I could only see your 'white eyebrows' as our uncle Randolph described them, I would have been content."

By now, Stratford was three ownerships removed from the Lees. Soon after acquiring the place, William Sommerville had died in France, en route to assuming the post of U.S. ambassador to Greece. He left

Stratford to his brother, who proceeded to default on a mortgage held by Henry and Elizabeth McCarty Storke, Black-Horse Harry Lee's former lover and sister-in-law. Henry Storke died in 1844, leaving Stratford to his widow, Elizabeth, who lived there through the Civil War and until her death in August 1879.

Stratford narrowly escaped being torched during the war. Samuel Baker Folke, a steamboat captain, had been directed to burn the place down at the outset of the conflict. Although he was a Union sympathizer, Folke was friends with Mrs. Storke and declined to set the blaze. Instead, he took his boat and family into exile at Farley Vale on the Rappahannock. Receiving news that his two sons in the Union army were sick with smallpox, he went to see them. Within a few weeks, his sons were dead and so was Folke.

Far removed from the battlefields, Stratford was invaded briefly by Yankee troops. As Folke's daughter related years later to Ethel Armes, Stratford's sympathetic chronicler, "Mrs. Storke lay ill in bed. The Northern troops came and drove away the slaves. They even took Mrs. Storke's house servant, Uncle Billy Payne. Mrs. Storke, sick as she was, was left alone in the house. Uncle Billy begged and pleaded to be allowed to go back to Stratford. Finally, the soldiers let him go and he walked back a long, long distance. He never left the place again."

Though the Lees no longer owned Stratford and he had spent only a few years there, Robert E. Lee deeply missed the place. Married to Mary Custis, granddaughter of Mary Washington, Lee lived at Arlington, the Custis mansion overlooking Washington from the Virginia side of the Potomac. Though against slavery, Lee was loyal to his state. When Virginia seceded, Lee turned down an offer to lead the Union armies and pledged his allegiance to the South. With Lee gone to war, Arlington was soon seized by Union troops. Homeless, the general pined for Stratford. From Savannah in November 1861, he wrote to "My Darling Daughters," who had recently visited Stratford: "It is endeared to me by many recollections and it has been always a great desire of my life to be able to purchase it. Now that we have no other home, and the one we loved has been so foully polluted, the desire is stronger with me than ever."

On Christmas Day of the same year, from Coosawhatchie, South Carolina, Lee wrote his wife that, "In the absence of a home, I wish I could purchase Stratford. That is the only other place I could go to, now accessible to us, that would inspire me with feelings of pleasure and local love. You and the girls could remain there in quiet. It is a poor place, but we could make enough cornbread and bacon for our support, and the girls could weave us clothes. I wonder if it is for sale, and how much."

Lee would not get his wish. The mistress McCarty continued to occupy the great house. Tenant farmers leased most of Stratford's 1,123 remaining acres. Upon Elizabeth McCarty's death, Stratford went to two distant

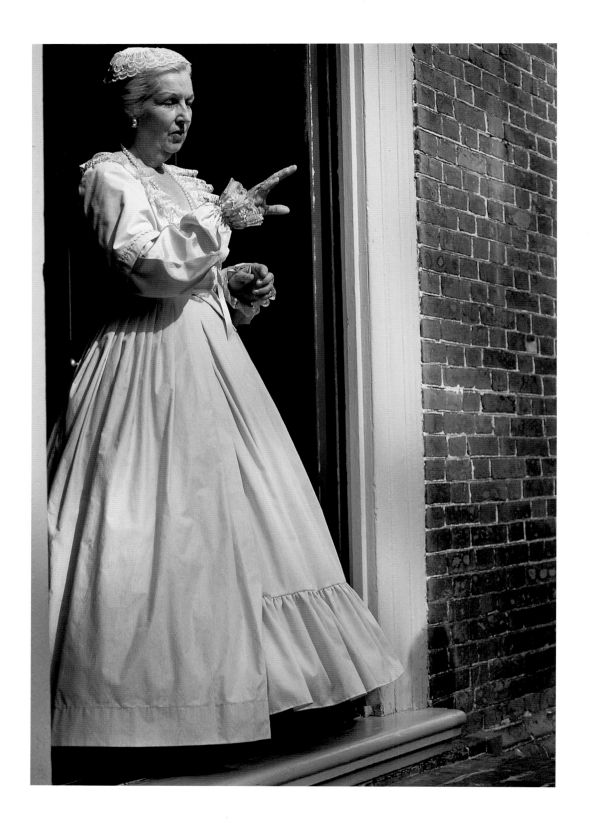

heirs, Charles Edward Stuart, of Alexandria, and Dr. Richard Henry Stuart, who lived on the property. Charles sold most of his land to a lumber company, and the plantation buildings fell again into disrepair. Richard's son, a local lawyer, lived at Stratford from 1924 to 1929; during his short tenure, he marketed Stratford Brand Tomatoes ("Fresh from Fields, packed by Deep Point Canning Co., Stratford, Va.").

Finally, as the stock market crashed, the Stuarts sold an option to buy Stratford for $240,000 to the Robert E. Lee Memorial Foundation organized by Mrs. Charles D. Lanier, of Louisville and Greenwich, Connecticut. She was the daughter-in-law of southern poet laureate Sidney Lanier, who, after the Civil War, had called upon the sons and daughters of Dixie to erect a shrine to the memory of Robert E. Lee. To that end, she raised money and organized the Lee Foundation, with female directors from each state, similar to the Mount Vernon Ladies Association that had acquired and renovated George Washington's Potomac River plantation. Stratford was rededicated and opened to the public in 1935.

Today, the ninety-foot-long great house at Stratford is authentically restored, providing the public with a somewhat sanitized view of plantation life at its peak. The old Lee family plantation employs more than one hundred workers on sixteen hundred acres. They toil as guides, researchers, and field hands. The plantation raises Black Angus cattle, along with the corn, sorghum, and grain grown to feed them. The governing body, an assembly of women from forty-three states, convenes twice a year to oversee the entire operation.

It is still a sprawling place in a largely rural setting. A long, winding road leads to the cliffs of the Potomac, where archaeologists have unearthed fragments of life at the seventeenth-century Pope plantation. The river is seven miles wide here, broader than the Chesapeake where it is spanned by the Bay Bridge. Across the way is the mouth of the Wicomico, which divides Charles and St. Mary's counties in Maryland. Not far downriver is St. Clement's Island, where the Maryland colonists landed. From this vantage point, the political boundaries of states and colonies appear to be very arbitrary indeed.

Stratford is located off two-lane Route 3, a few miles from Washington's birthplace at Pope's Creek. A billboard along the highway underscores both its prominent place in American history and its continued isolation from the American mainstream: "Route 3: Historyland Highway or Colonial Cowpath? Washington, Lee and YOU Deserve a Better Road Home."

The main "road" to Sotterly remained for many years the Patuxent River. An oyster-packing house operated at Sotterly Landing in the nineteen-

OPPOSITE
Docent Joanne Boyer guides visitors at Stratford Hall, the birthplace (in 1807) of Robert E. Lee.

OVERLEAF
The brick horse barn at Stratford Hall

Pen and inkstand in Stratford Hall where Robert E. Lee was born

teens. During Prohibition, the river and shore were so heavily trafficked by bootleggers that "you could walk across the Patuxent without getting your feet wet," an oldtimer recalled. Steamships also regularly stopped until 1933, when a hurricane took out the long pier. Today, the former tobacco-rolling road still leads to a shortened dock, where a few watermen tie up. Downriver is the Patuxent River Naval Air Station, where the early astronauts received their test-pilot training. But at Sotterly, the view of Calvert County across the Patuxent River is uncluttered, and the space age seems very far away.

The Briscoe family lived on at Sotterly until the 1880s. A son, James, who was an Episcopal priest in Baltimore, bought the property from the estate and owned it until he died in 1904. He, in turn, left Sotterly to his son and daughter, who summered there and then sold it in 1910 to Herbert Satterlee, whose ancestors had lived at Sotterly Hall in England at the time of the Norman conquest. Satterlee, who was J. P. Morgan's

son-in-law, planted trees, worked on the gardens and in the mansion, tore down slave cabins, and added acreage to the property before he died in 1947. He passed it on to his daughter, Mabel Satterlee Ingalls, who opened it to the public. In 1961, she deeded the property to the Sotterly Mansion Foundation. In 1988, at age eighty-seven, she resided in Manhattan but still visited Sotterly.

From 1886 to 1907, Sotterly had its own post office and, into the 1920s, its own public school. In 1930, the Plater family held an "old home week" there, leaving to posterity a scrapbook of faded photographs. Today, the buildings and grounds are rented out for weddings and meetings, and the land is planted in corn, wheat, and barley. Beef cattle are raised, and sheep graze on the sloping meadow overlooking the pristine Patuxent.

The Shirley story ends differently. After the Civil War, the James River plantation was carved up among five sons, each of whom received 791 acres. Robert Randolph Carter got the big house, which he entrusted to daughter Alice. Widowed at the age of twenty-seven, she continued to manage the place until she died in 1925. No high-strung mistress, she fed the mules and shelled peas herself; times were tough on the old plantation.

"The farm looks pretty bad and will probably look worse," she wrote in her journal in 1917. "No tenant can keep Shirley up. I am down and out and can no longer do it . . . have had no cook and no house maid for a year." Charles Hill Carter, Sr., a cousin living across the road, helped her manage the farm and, in 1928, three years after her death, moved his own family there. Carter farmed and ran a sawmill. "Times were hard, roads poor," his son Charles Hill Carter, Jr., says. "Most farm produce was shipped by boat. My father would go to Richmond by wagon. He never finished high school." The slave quarters were occupied by whites and blacks, who worked on the farm, and were torn down after the Depression.

Charles, Jr.—Hill Carter, as he is called—and his children became the ninth and tenth generations of the Carter family to live at Shirley. Hill worked for his father and went to Virginia Tech, but Shirley has been his life. He opened Shirley to the public in 1952. A farmer like his father, he semi-retired in 1972 and rented much of the land to other farmers. Today, soybeans are grown on 315 acres, and sand and gravel are quarried on an adjoining farm, leased to a materials processing company. Hill Carter affects neither the trappings of wealth nor the bearing of aristocracy. He wears rumpled clothes and drives a modest late-model American car. Indeed, he is often mistaken for a handyman at Shirley, where he lives with his family on the second and third floors. As many as 42,000 tourists a year troop through the first floor. Until Carter leased some of his land to the sand and gravel company, his only income came from those tourists, who pay up to five dollars a head for the run of the place.

Hill and Helle Carter, master and mistress of Shirley Plantation on the James River. Hill Carter was the ninth generation of his family to live there. After his death in 2009, his son, Charles Hill Carter III, became steward of the estate.

From all proceeds must be subtracted the cost of upkeep and a payroll for farmhands, guides, and gift-shop employees. With 150 windows, the house is expensive to heat, and painting the trim alone cost $15,000 one year.

"We're here," he says, "if we don't get overturned by unexpected [tax] appraisals or inheritance taxes or something like that."

Whatever else Shirley stands for, to Hill Carter it is home. The plantations have been home as well to the slaves and their descendants. But, most often, their stories of hardship and kinship have been lost amid those of their masters. At Sotterly, one slave cabin remains—down the hill and off to the side of the plantation house. Who actually occupied it is a mystery, but other facts are known, thanks to Agnes Kane Callum, a postal worker from Baltimore. A genealogy buff, she discovered that her slave ancestors had come to Sotterly in 1848 and remained, past emancipation, as late as 1888. Armed with her research, she organized three family reunions held at the plantation in 1978, 1979, and 1981. As many as 270 family members traveled to Sotterly, most of them arriving by bus and many of them meeting each other for the first time. "I felt very close to my people, although I didn't know them," Agnes Callum said. "I could almost feel their presence."

Stratford's slave cabins are gone, although replicas have been built over the foundations. Without fanfare, descendants of the slaves of Stratford work there today, as they have for generations. Two miles from Stratford lives Laura Payne Streets, eighty-one, a granddaughter of "Uncle Billy" Payne, Elizabeth Storke's loyal house slave. Uncle Billy, Laura Streets recalled, lived to be a hundred and stayed at Stratford almost to the end

of his life. Laura Street's Uncle Wes built the cabin that remains on the meadow leading from the great house to the Potomac, both unmarked and unremarked upon by Stratford docents. Wesley Payne, remembered as an "all-purpose employee" at Stratford, died in the 1950s, well into his eighties. Laura Streets started at Stratford in the 1920s, doing housework for the Stuarts. "When they left, I just stayed," she says. "It wasn't in too good a shape." She was still working part-time in the Stratford dining hall—open to visitors—when I spoke with her in 1989. Her two younger sisters, ages sixty-two and seventy, were also at Stratford, doing kitchen work and cleaning the guest cabins used by the women governors who run the plantation.

The descendants of slaves make up the majority of Charles City County surrounding Shirley, but the county's overwhelmingly black first district has repeatedly re-elected Hill Carter to represent it on the board of supervisors.

Hill Carter and Charles City County remain the most tangible links with the region's plantation past. In this county of seven thousand, seven plantations are open to the public, providing employment to no more than fifty people. About 80 percent of county residents commute out of the county to work. Indeed, in Charles City County, there is no Charles City and there are still no towns, not even in the vicinity of the 1730 courthouse. There are also no liquor stores, no bars, no jail, no video stores, no 7-Eleven or McDonald's, no newspaper, no shopping center, no motel, no public library, no pharmacy. On the surface at least, little has changed in three hundred years. The rivers are no longer the avenues of commerce they once were, but Hill Carter can still stand on the lawn at Shirley and watch ocean-going vessels ply the James River channel to and from Richmond. And the old riverfront families still intermarry, attend the same private schools, join Westover Church, and band together to fight the inevitable forces of change.

One county north, Interstate 64 bypasses "Virginia Plantation Country" on the way to Williamsburg. But the Richmond bypass, designated I-295, is rapidly closing in, promising swelling streams of traffic along Route 5, the old John Tyler Memorial Highway to Jamestown.

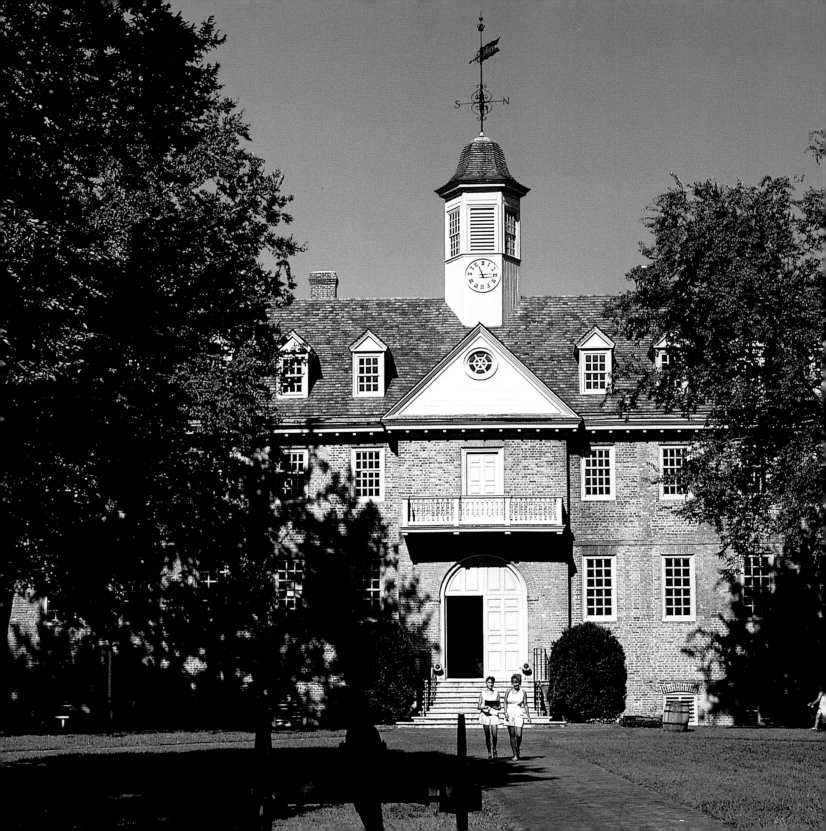

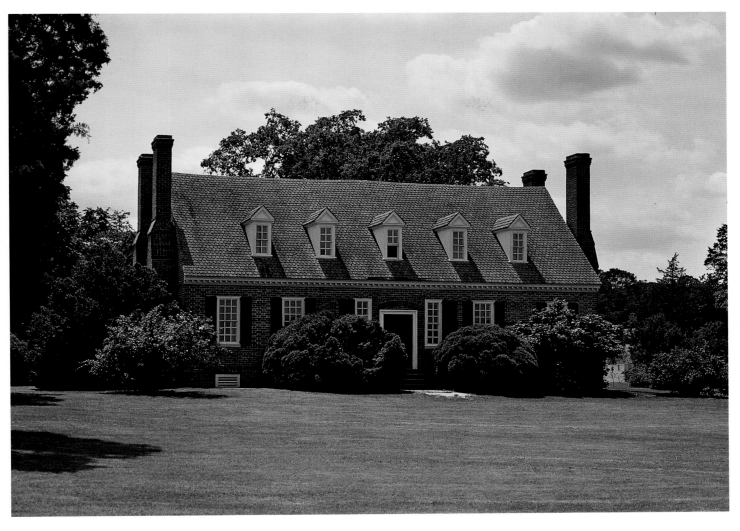

A twentieth-century replica of Wakefield, the one-and-a-half story brick house where George Washington was born on February 22, 1732

The Christopher Wren Building, for which the foundation was laid in 1695, is the oldest academic building in America. Designed by the famed English architect, it is at the College of William and Mary, the country's second-oldest college, established by royal charter in 1693. Among its graduates were presidents Jefferson, Monroe, and Tyler.

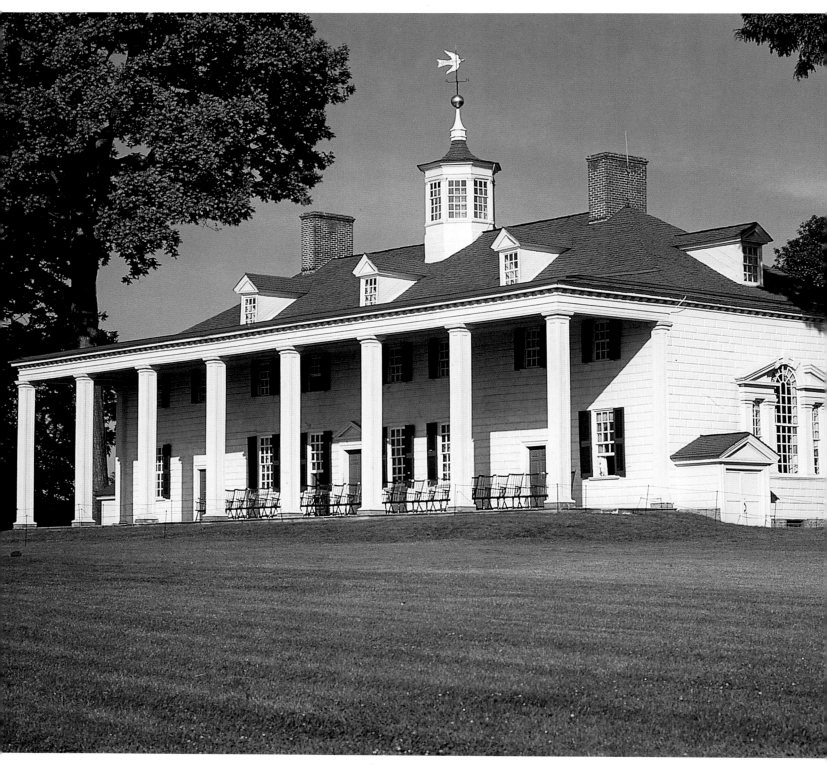

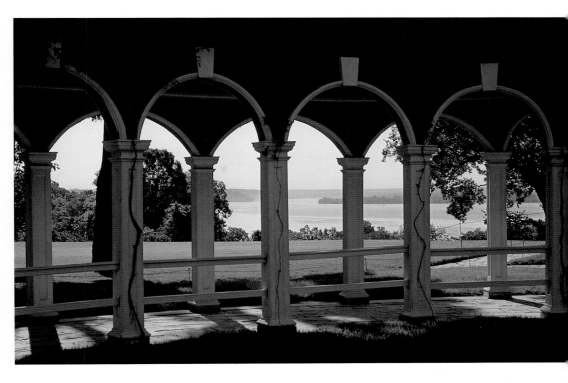

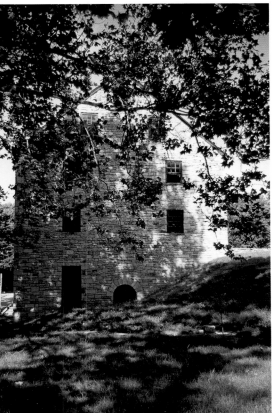

ABOVE
Looking toward the Potomac
through the portico at Mount
Vernon

OPPOSITE
Mount Vernon manor house built
in 1735

LEFT
A grist mill reconstructed at
Mount Vernon was originally
designed by George Washington.

87

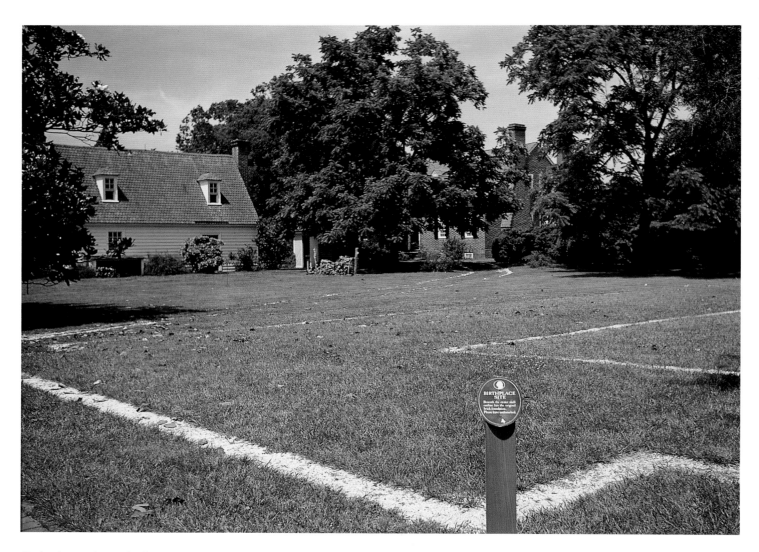

Only the outline of a foundation remains at the original site of Wakefield, the birthplace of George Washington at Pope's Creek, a Potomac River tributary on the Northern Neck of Virginia.

OPPOSITE
Out-kitchen at Wakefield. Separating the kitchen from the main building was a prudent precaution against fire.

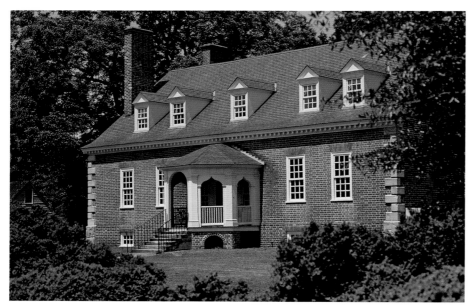

Gunston Hall is the home of George Mason, author of the Virginia Bill of Rights, after which the first ten amendments to the U.S. Constitution were patterned. His Georgian house, built in the 1750s, sits on Mason's Neck, on the Potomac River.

BELOW
Woodlawn Plantation, willed by Washington to his nephew, who married Eleanor (Nelly) Parke Custis, granddaughter of Martha Washington. The Georgian house is in Fairfax County, near Washington, D.C.

OPPOSITE
Westover Church, Charles City County, Virginia.

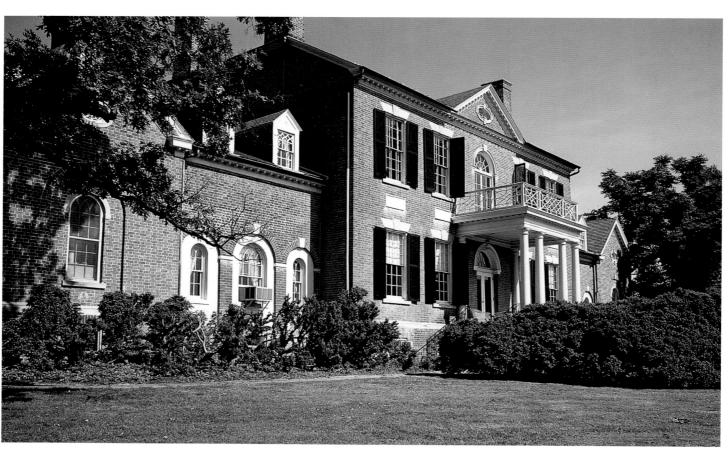

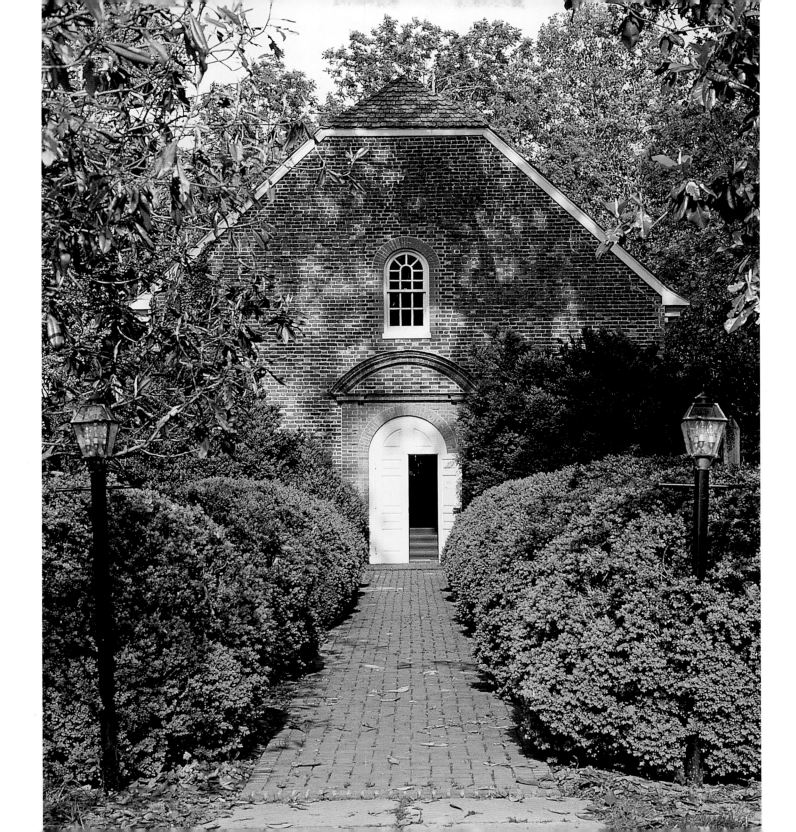

OPPOSITE
A serpentine brick wall at Mount Harmon, World's End, Cecil County, Maryland, looking toward the Sassafras River; the plantation began as a 1651 land grant from Cecil Calvert, the second Lord Baltimore, to Godfrey Harmon.

LEFT
The inner staircase at Mount Harmon, built approximately 1730

BELOW
The gardens of Mount Harmon, a restored plantation on the Sassafras River in Cecil County, Maryland

OVERLEAF
Brandon Plantation, on the south side of the James River, was designed by Thomas Jefferson.

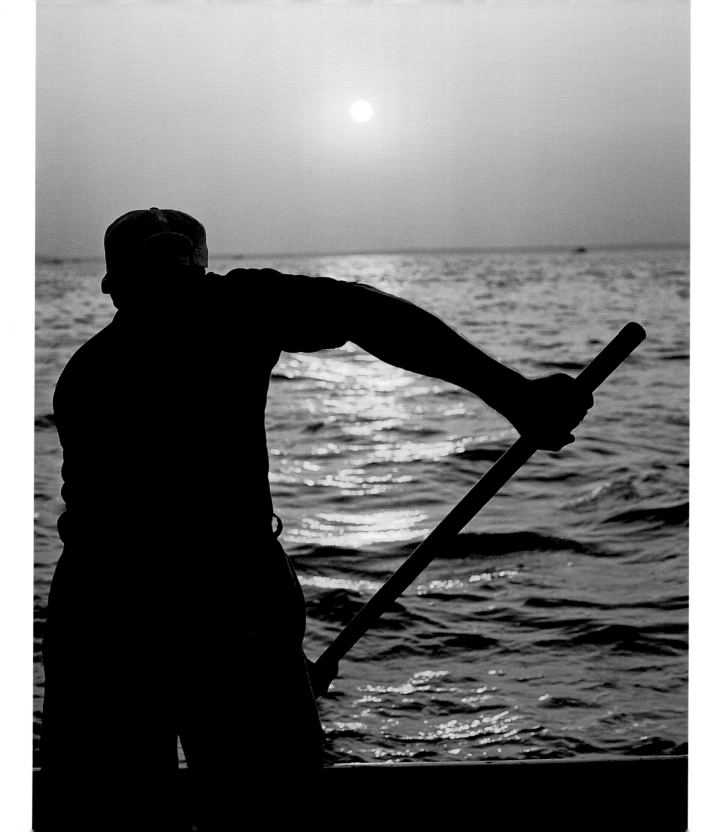

The Watermen

If the planters and their society were tied to the rivers of commerce that led to and from the Chesapeake, there were others whose livelihood came directly from the waters of the bay. These were the watermen—an old word, said to be of English origin, that has survived to this day on and around the estuary. They would be called commercial fishermen elsewhere; on the bay, they are watermen.

They are almost as much an endangered species as some of the shellfish and finfish they harvest from Chesapeake Bay and its tributaries. For generations, they have crabbed in the summer, oystered in the winter, and worked on their boats in between. The technology has changed a little, but not much, and conservation laws were passed to preserve the resources, but to little avail. Dredging for oysters is allowed, but only on certain days can the dredge boats be motorized. On other days, watermen are allowed to dredge only under sail. Crabbers use rectangular metal traps, known as "crab pots," but some still catch crabs the old way, "trotlining" on the rivers, using long lines strategically baited, usually with eel or chicken necks. "Chicken neckers," these river watermen have come to be called.

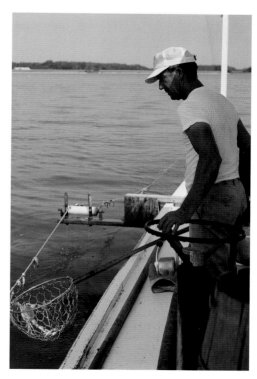

Captain Wade Murphy, skipper of the *Miss Kim*, brings up his trotline to check for crabs.

LEFT
Behold! A Chesapeake Bay blue crab (*Callinectes sapidus*) caught in the net.

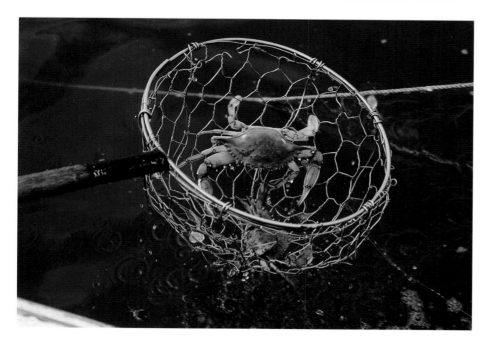

OPPOSITE
Trotliner Captain Wade Murphy of Tilghman Island dips his crab net into the Choptank River at dawn.

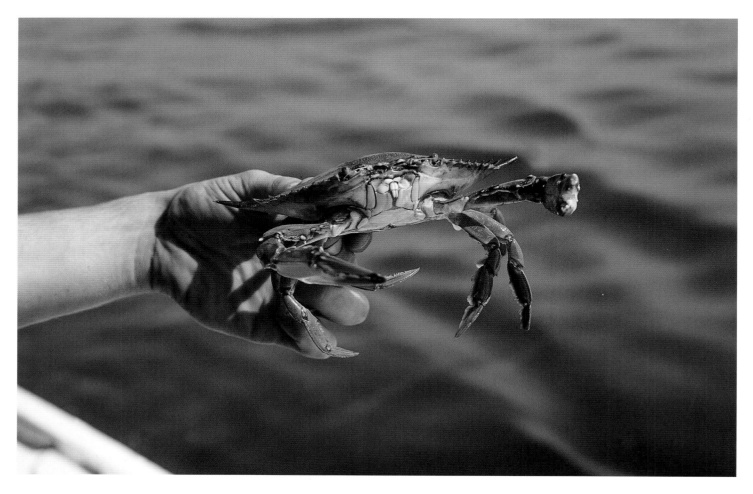

Handling a Chesapeake Bay blue crab
(*Callinectes sapidus*)—carefully

Eels in a barrel: Wade Murphy uses them
to bait his trotline.

Many of the old oystering and crab towns around the bay are yielding to accelerating change, condos and yachts replacing crab shanties and oyster-shucking houses. At Kent Narrows, shuckers' shacks have been razed and the decidedly upscale Oyster Cove town houses now attract Washington and Annapolis commuters. In towns such as St. Michaels and Oxford, which were well-known boatbuilding centers, watermen have to fight for the few remaining public slips. As this is written, in Havre de Grace there's only one waterman left. In other port towns, more and more watermen are looking landward for steady employment. It's hard times on the water, they say, hardly worth the effort.

But 12,000 or so keep at it, three-fourths of them from Maryland. From the mouth of the James River to the waters above the Chesapeake Bay Bridge, they hang on. On isolated islands in the bay—Tangier in Virginia, Smith and Deal in Maryland—they still follow the water as their forefathers did, and they speak a distinctive dialect—pure Elizabethan English, some say. The watermen's language also conveys a strong sense of independence and self-reliance, a grim determination, perhaps, and sometimes a stubborn optimism in the face of depressing statistics. "It's a natural process with the oyster situation," explains Joe Daniels, of Deal Island. "I been on the water but fifteen, eighteen years, and I've seen it [decline and come back] twice since I been doing it."

Stephen Horner, another Deal Island waterman, tells me, "I think they're trying to regulate us out of business. It ain't what we catch. It's the chemicals. It's growth, the people around the cities. But the first they want to do is put a limit on you, like with the rockfish. At the turn of the century, there wasn't no cull law [restricting the catch to hard-shell crabs measuring at least five inches]. You could sell whatever. One sponge [pregnant] crab will produce one to three million crabs, and I won't catch one-half million all year."

Deal Island—first named Devil's Island by survivors of a seventeenth-century shipwreck—is a large patch of marsh and fast land fifteen miles east of the Somerset County seat of Princess Anne. The road to Deal cuts through miles of wetlands. At night, dots of light appear across the marsh as you cross Dames Quarter Creek. The island itself is connected to the mainland by an arching two-lane bridge. Deal is known as the home of Joshua Thomas, "Parson of the Islands," who preached Methodism to Chesapeake islanders in the early part of the nineteenth century and even played a small role in keeping them loyal during the War of 1812, when many were inclined to support the British. Deal Island is also known for its abundant mosquitoes and for the bombing and shelling of nearby Bloodsworth Island, which the military has used for target practice since 1942. The noise rattles and has sometimes shattered windows. (In the

OVERLEAF, TOP LEFT
Lonely watermen's graves on remote Hooper Island, a narrow sliver of land between the Honga River and the Chesapeake Bay

OVERLEAF, BOTTOM LEFT
Tidy houses like this one line the main street of Smith Island's unofficial capital of Ewell. On this unnamed lane, location is defined by a slight rise, as in "up the hill" or "down the hill." (Unnamed, that is, until the county decreed that all streets must have names, under an upgraded 911 emergency response system.)

OVERLEAF, RIGHT
The Council of Ministries, overseen by the Methodist church, is the only government on Smith Island. There are three churches, one for each hamlet. This one, Calvary United Methodist, is at Rhodes Point.

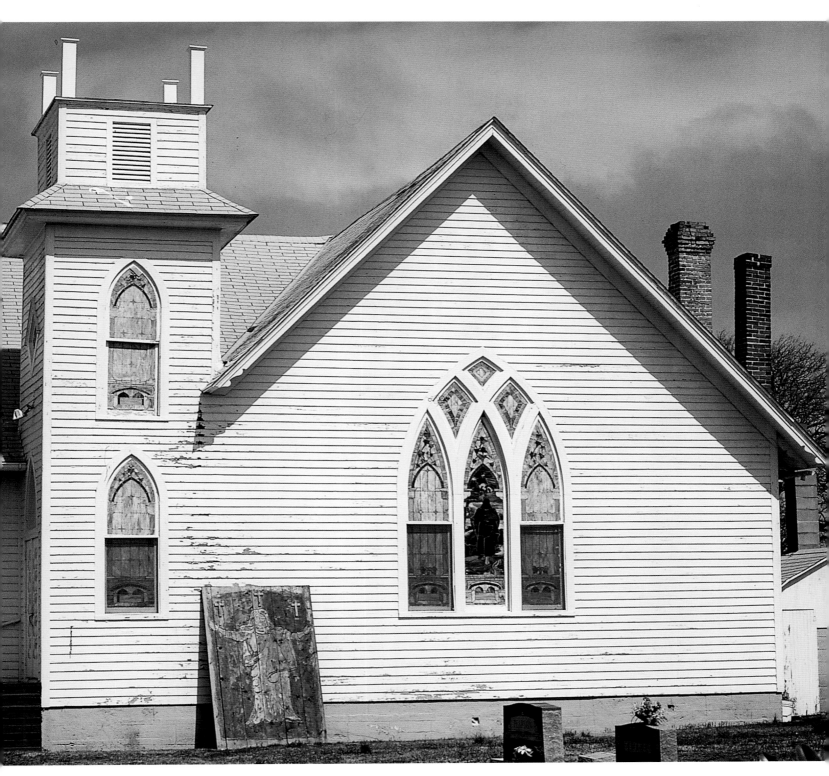

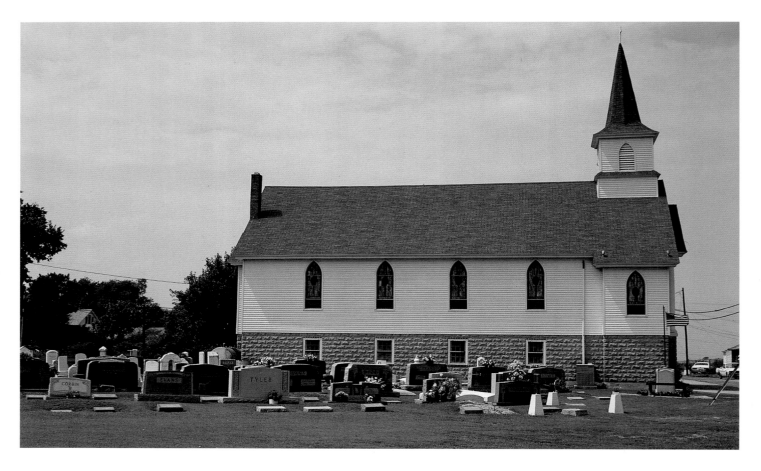

United Methodist Church at Ewell, with tombs located above ground because of the island's high water table

1970s, the government paid out $39,350 to settle noise-related claims.) Otherwise, Deal Island is a quiet place.

The population of several hundred, clustered at opposite ends of the island in the two small settlements of Deal Island and Wenona, remains largely indigenous. There are, to be sure, a few newcomers, mostly of retirement age, but this is no Oxford or St. Michaels—yet. Thanks probably to the mosquitoes, the shelling, and the island's remote location on Maryland's lower Eastern Shore, housing is still cheap, and gentrification seems a long way off. Deal's remoteness is reflected in the lilting accents of its inhabitants, not quite so "British" as the Smith Islanders but distinctive nonetheless. Quaint accents can fool you, however. Backyard satellite dishes here hint at a certain worldliness; so does the wry humor reflected in a cap sold by Arby's General Store in Wenona: "Not the end of the world, but you can see it from here . . ."

Arby's ("A Waterman's Retreat," the sign says) is where the watermen gather for coffee and chatter before dawn and a day's work. The talk is

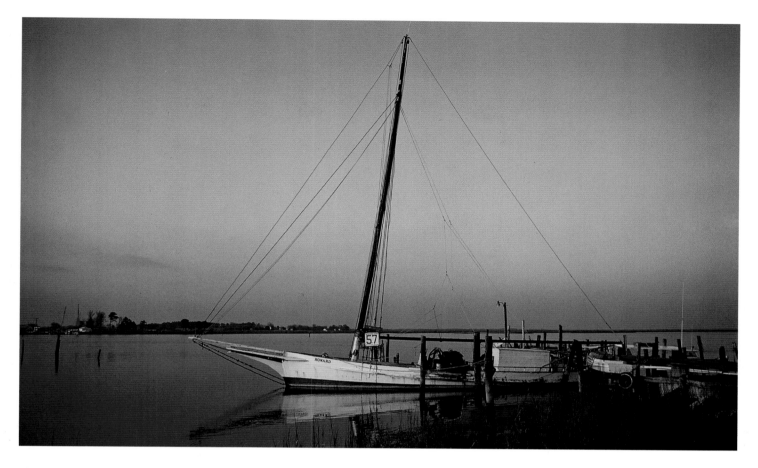

Bathed in sunset, a skipjack reposes at Wenona, Deal Island. By 2014, only seven working skipjacks remained, four at Deal Island and three at Tilghman Island.

about the weather and the catch, or lack of it. At 5:30, on a morning in late September, I find seventeen men starting their day at Arby's. It is almost the oyster season, according to the calendar at least, but the subject of the day is crabbing and the alternatives to it.

A dozen or so Deal Island watermen had given up on the bay the previous winter to work at a new state prison near Princess Anne. "A few more got applications in because the way the oysters are now, you're lucky to make the grocery bill," one man says.

It was the first full-time job for most, with what they consider astounding benefits—such as health insurance and paid vacations. "I never dreamed I'd do anything other than work on the water all my life," says Gary Holland, a prison guard with "a check coming in every week, whether I work or not, even when I'm sick or on my days off." Stopping by Arby's later in the day on his way to work the 4 P.M. to midnight shift, he says he is pulling down $18,000 a year. "It isn't like being your own boss," but it is what he needs to support his family of six. Two of his three sons "wouldn't mind going on the water, but I tell them that's the

last resort. I'd rather they do that as a hobby in their spare time and get something up the road" that leads from Deal Island east to Princess Anne and civilization.

His only regret about leaving the water is that he hadn't done it sooner. "I'm just sorry I didn't start into a state job when I was eighteen. I could be pushing retirement now." And then, what with a regular government pension, he could *afford* to work on the water.

But for others, including thirty-five-year-old Loudy Horner, trading the water for prison work remains a most distasteful alternative. "My little children will go hungry before I go there," says Horner, who runs a soft-shell shedding operation with another brother, Dave.

So scarce are the muck-encrusted bivalves at this writing that, for the second year in a row, another Horner brother, thirty-eight-year-old Stephen, isn't going oystering at all. Even though oyster season—starting the first of October—is here, he figures all the effort and expense just aren't worth it. He's been crabbing since the first of April, pulling five hundred pots a day. This year, he will crab as late as possible, until it gets so cold the crustaceans bury themselves in the muck at the bottom of

OPPOSITE
Stern's-eye-view of a Deal Island workboat

Stephen Horner empties a crab pot onto a culling board while his son Stephen, Jr., looks on.

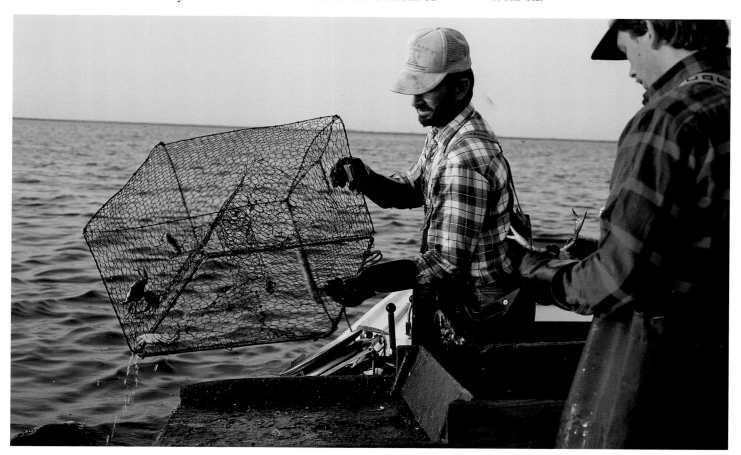

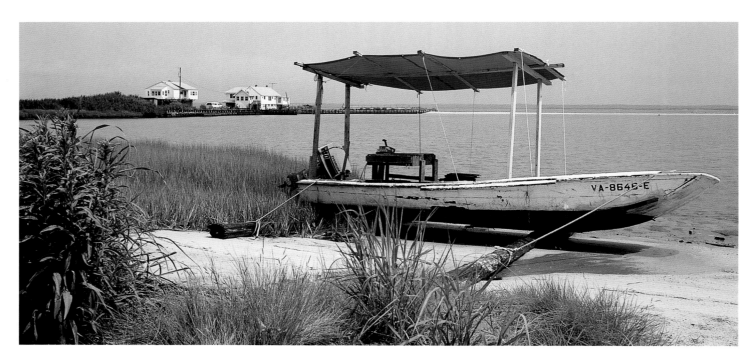

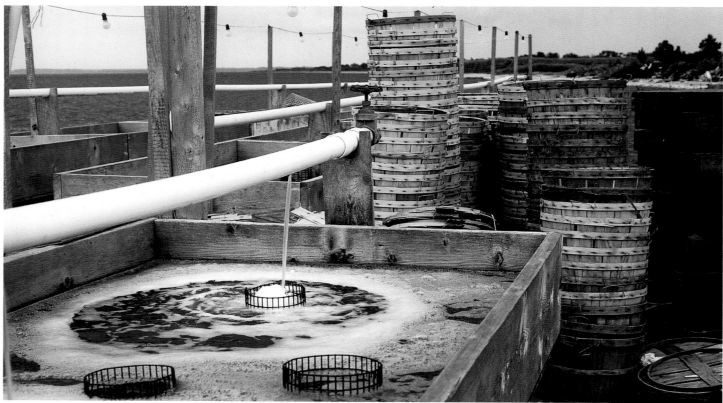

the bay. And were it not for the crabs, Stephen Horner says, he would be "looking for a job, moving probably, and it'd be a ghost town on Deal Island."

The Horner family has almost always made its living from the bay. "My grandfathers on both sides, and, I guess, their fathers did," says Stephen Horner, whose four years away from Deal had been spent in the Navy, in Williamsburg, Cuba, Antarctica, and the Philippines. Ed Horner is the only brother who has worked on land; he had become a state trooper. "I was the only one who worked for the government. I was the bastard child of the family." Even when he was a state cop, he would load the trunk of his cruiser with crabs from the family business and drop them off on his rounds. Now, at age forty-one, he is retired from the force and operating the Waterman's Seafood Restaurant near Ocean City, Maryland's seashore resort, offering Deal Island seafood.

Here as elsewhere on the Chesapeake, watermen ply the water in "workboats," a term peculiar to the bay and used to describe a low-slung, shallow-draft vessel with a small forward pilot house. Stephen Horner uses a thirty-five-foot workboat powered by a six-cylinder automobile engine. The boat is owned by brother Ed, but otherwise he works for himself in the waters off Deal Island.

On a day when the space shuttle is rocketing into the stratosphere, Horner and helper Jackie Carew carry on an age-old tradition: harvesting crabs from the shallow bottom of the Chesapeake Bay. Strong early-morning winds delay their departure from the snug harbor of Wenona, but by 7 A.M. they are working in seven or eight feet of water off South Marsh Island, five miles from Deal. Six days a week Horner fishes his crab pots, box-shaped wire contraptions baited with alewives and containing

OPPOSITE, TOP
A crab-scraping boat at Saxis, Virginia, used to harvest "peelers" about to moult and become delectable "soft shells."

OPPOSITE, BOTTOM
Crab-shedding floats, for soft-shells, in Saxis, Virginia

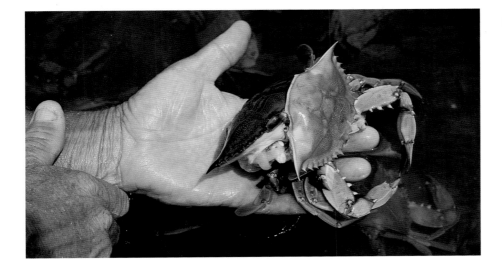

A peeler crab shedding its hard shell, Tilghman Island, Maryland

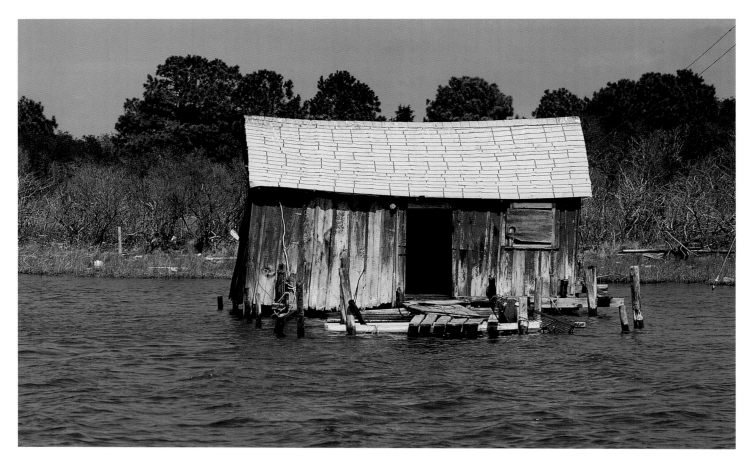

An isolated crab shack sits across from Ewell on Big Thoroughfare, the watery main street of Smith Island.

two funnels for the crabs to enter. The pots rest on the bay bottom and are tied to buoys that float on the surface.

In the early 1970s, Horner had been a "crab scraper," using a dredge that "licks" the bottom in shallow water where the "peeler" crabs, about to moult and become the delectible "soft-shells," hide in the underwater grasses. Then, fresh water from Hurricane Agnes swept away most of the grasses, "and there was nothing for the peelers to hide in," Horner says. The fifty or so Deal Island crab scrapers, including Horner, became crab potters. "But a lot of grass has come back now," Horner says, which sounds like good news. The bad news: "There's so much this year that a lot of scrapers couldn't do anything. So much grass gets in the scraper, they couldn't catch no crabs. All they could catch was grass."

The work is tedious, unchanging. Horner hauls the pots on board his boat, where Carew empties, baits, and returns them to the water. Carew also culls the crabs, tossing them into separate bushel baskets for "jimmies" (males), "sooks" (females), and "peelers." For purely sexist reasons, the jimmies are regarded as the most desirable, destined to be

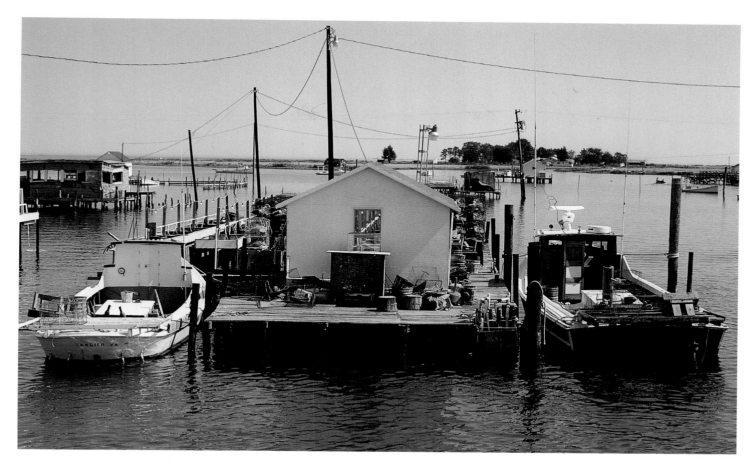

steamed with Old Bay seasoning for dissecting with wooden mallet and knife at crabhouses throughout the Chesapeake region. The sooks will be picked apart by crab-pickers, mostly black women paid by the pound, for packing and selling in supermarkets. The peelers will make an intermediate stop at local soft-shell shedding shanties. After moulting, they will be shipped to big-city restaurants, to be cooked and eaten in their entirety, claws and all.

Back on Tangier Sound, the early October sky is clouding over. By 9:45 A.M., three bushel baskets are filled with crabs. By 10:40, Horner's is the only workboat in sight. An hour later, there are still eighty pots left to pull. The workday, with only two twenty-minute breaks, is over by 1 P.M. "By Saturday morning, it gets tiresome," Horner says. "You're glad to see a Sunday. Sometimes I wish it were Sunday by Wednesday. You can't take it too serious. If you take it too serious, you'll get upset."

This day's catch—from 375 pots—consists of nine bushels of males, five of females, and 216 peelers. The hard-shells will wind up in New York City's Fulton Fish Market, trucked from Deal Island by a Crisfield

Crab shack and boats at Tangier Island, Virginia, where the speech is Elizabethan, the automobile traffic is nil, and a passable living is made from the waters of Chesapeake Bay.

A stack of new crab pots, Ewell, Smith Island, Maryland

OPPOSITE
A mess of crabs caught by Captain Wade Murphy of the *Miss Kim*

company called the Tidewater Express. The peelers will be sold locally for shedding. The total catch has a wholesale value of $360, less expenses.

It hardly seems enough to keep a man on the water. But to men like Horner, there is much more to it: "Really, I don't know anything else. I like the independence more than anything else. Working around people I'm not used to . . . I just like to be out on the water by myself. It's quiet, and you can enjoy what God gave you." Horner speaks movingly of sunrises and waterspouts, funnel clouds "like fingers reaching down. I saw five in an hour's time. They stayed in the same place. . . . You can't put a price on it, really."

In the fall of 1988, while most watermen are pursuing crabs instead of oysters, a state advisory committee is considering proposals to restrict the crab catch as well. "They get into that," says Stephen's younger brother Loudy, "they'll drive us all onto the land."

The year before, the Horner brothers' uncle, also named Loudy Horner, had reluctantly sold the *Clarence Crockett*, an aged oyster-dredging sailboat

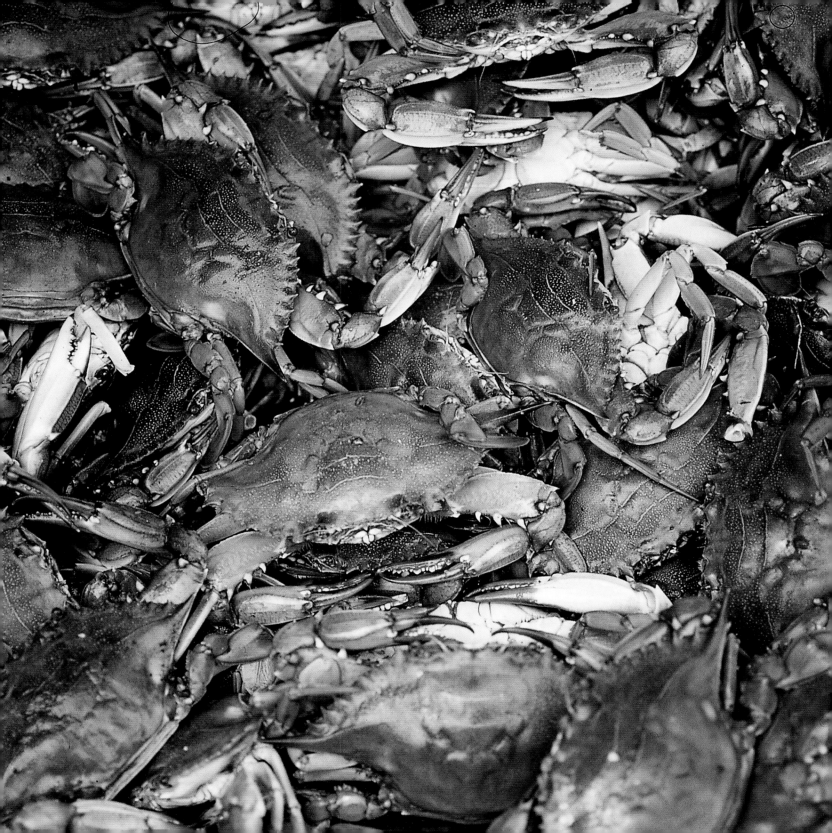

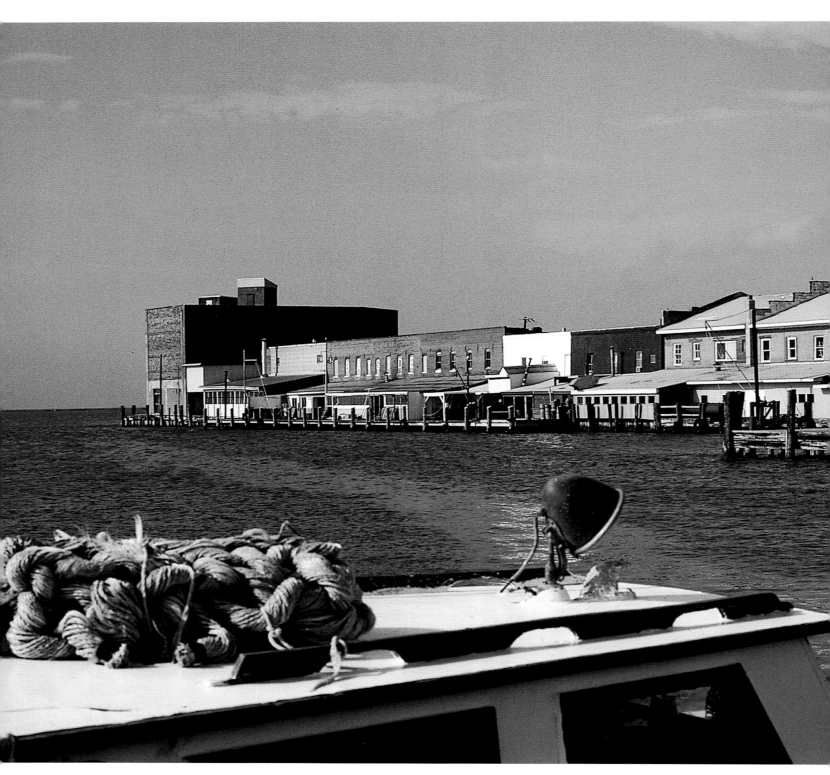

A workboat works quickly in the docking race, Somers Cove, Crisfield, during the town's annual Labor Day weekend crab festival.

LEFT
The Crisfield, Maryland, waterfront—"crab capital of the world"

he had owned and operated for twenty years. He parted with it, he says, because, with the oysters in such scarce supply, he couldn't get a decent crew. "Nobody would go with you," he laments. "You had to pick up anything that came along. I wasn't used to doing that."

Sloop-rigged boats like the *Clarence Crockett,* known as skipjacks, after a flying fish, are wide-beamed oyster dredgers. While watermen wielding "shaft tongs" work the rivers exclusively, the larger sail-powered dredge boats work the rivers' mouths and the bay. The nineteenth century produced fleets of oyster-dredging schooners, pungies, and bugeyes. A contemporary observer described dredging in Maryland then as "simply a general scramble, carried on in seven hundred boats, manned by fifty-six hundred daring and unscrupulous men, who regard neither the laws of God nor man." Skipjacks, designed especially for dredging, first appeared on the bay in the 1890s. A century later, they comprise the last commercial sailing fleet in America. Once, they had numbered in the hundreds. At this writing, there are only thirty-six left, concentrated largely around Deal and Tilghman islands. Twenty-two of them are listed on the National Register of Historic Places; at least a couple have found their way to maritime museums.

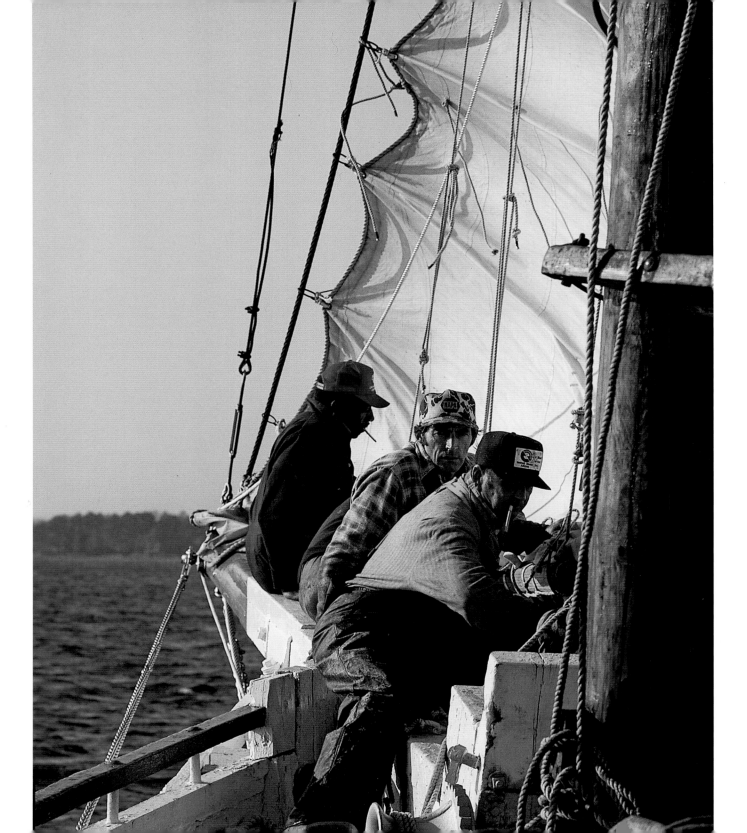

Says Deal Islander Glenn Webster: "They're old boats, but they're graceful. A lot of salt water's come under 'em, over 'em, and through 'em."

The boats are celebrated each Labor Day weekend on Deal Island with an annual skipjack race and festival. A Little Miss Skipjack is chosen, and the boats run with the wind down the bay. Eleven craft competed in the twenty-ninth annual races in 1988. The *Clarence Crockett* would have made twelve, but, as it was being lowered into the water after undergoing repairs, the boat sank the Friday before the Monday event. Just months before, a picture of the star-crossed vessel had appeared on a U.S. postage stamp to symbolize the entire skipjack fleet. More than a year later, the boat was still drydocked.

During the race, I sail on the *Thomas Clyde,* an eighty-year-old skipjack built in a place called Oriole by a man named Price, and named after his son. It is a big boat, with a fifty-eight-foot keel and a seventy-foot mast of varnished wood that looks like the bark was removed only recently. It belongs to Charles Abbott, Jr., president of the Deal Island Lions Club, which sponsors the race. His father had captained the boat before him, leading it to a first-place finish three years earlier. He was sick with diabetes then, but in his glory. Four months later, the senior Abbott died, at age sixty-one. "He sailed these boats all his life, since he was a boy," his son says. "That was his whole life."

Charles Abbott, Jr., forty-four, is a short, wiry man who chain-smokes and wears a black cap and a worried look. Before she'd met him, Jeanne Abbott had never been on a boat, "much less on a skipjack. I didn't know what the life was like. It's a lot of worry. You worry about what you're catching. You worry about your boat. You worry about being able to sell your product and you worry about your wife spending your money. Vacations? I take them most of the time with my children. He goes on them when he's forced to. If I had a choice, I wouldn't want to become married to a waterman. They become hardened men. They have a hard life and they age so young."

But there she is, married twenty-five years, wearing enameled anchor earrings and lugging a videotape camera to record the race. Jeanne and Charles Abbott have three children, two daughters and a son. Charles P. Abbott, 3d, twenty-four, crabs summers with his dad, but his primary occupations are part-time student at the University of Maryland Eastern Shore and prison guard in Princess Anne.

Jeanne is one of fifty passengers on the boat. The group includes outlanders like Joe Serino, from New Jersey by way of Chincoteague, Virginia, where he's been vacationing. A software installer for Bell Atlantic, he wants to be on board because "twenty years from now, there may not be any of these."

Also along for nostalgia's sake is Ricky Webster, one of Jeanne's four

OPPOSITE
Pulling in the jib sail of the skipjack *Thomas Clyde* at the end of a day's oyster dredging on the Choptank River

OVERLEAF
Labor Day weekend skipjack races off Deal Island

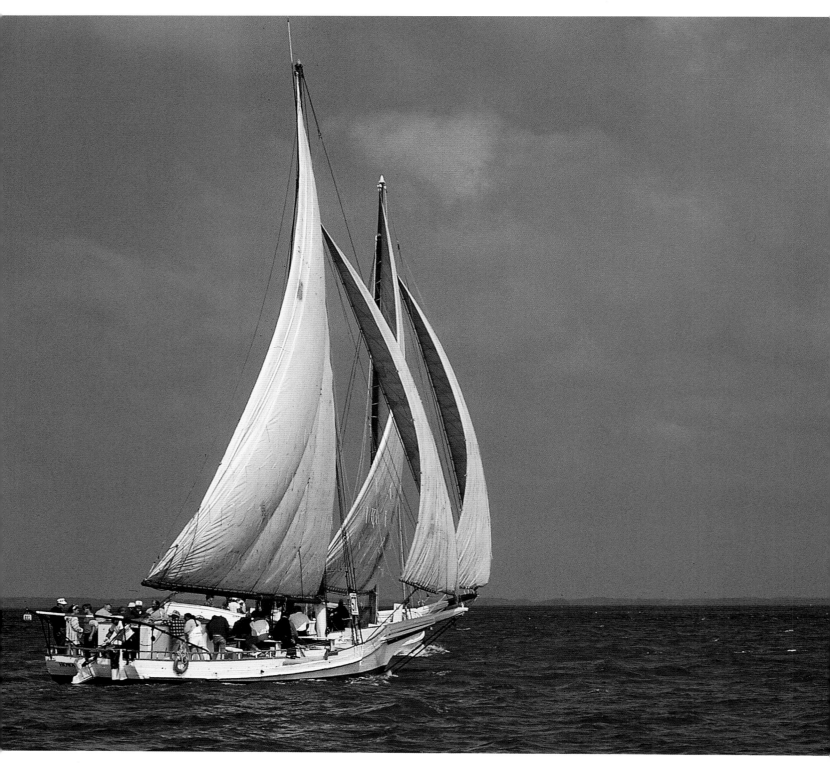

Sunrise on a skipjack in
the Choptank River near
Cambridge, Maryland

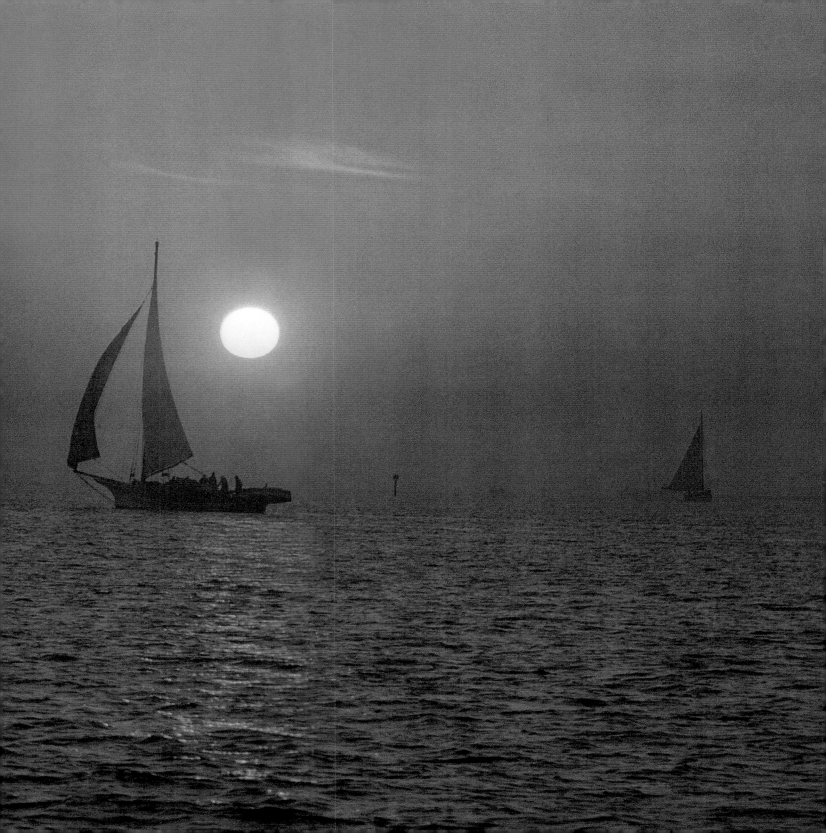

Skipjack Captain Charles Abbott of the *Thomas Clyde*

brothers. All of them had "followed after Charles" on the water, Jeanne says. "They thought it was a way to get rich." But only Glenn and Danny are still at it. Ricky and Doug have both trained to become electrical engineers and moved to Ashland, north of Richmond. Ricky works now at the naval weapons facility at Dahlgren, on the Potomac. "I used to be a waterman, but it got too rough on me," says Webster, thirty-five, who had gone ashore three years before after fifteen years on the water, part of it spent working for Abbott and his father. "I just needed a more steady income."

Webster had gone "spatting" with Abbott the previous spring, planting oyster shells as part of a state "repletion" program. The idea was that the oyster larvae would affix themselves to the shells, become "spat," or baby oysters, and thereupon grow to maturity, a process that takes three or four years. Though away from it most of the time, Webster deeply misses living the life of a waterman. "I think about it often," he says. "That's why I like getting jobs close to the water. At least I can look at it."

Charles's brother Allen, twenty-seven, still a waterman, is also along for the ride on the *Thomas Clyde*. Miriam Abbott, Charles's mother, stays below, as she had often done when her husband was alive. "She's not a lover of the water," explains Jeanne Abbott.

It is almost 10 A.M. when the skipjacks leave the channel separating Deal Island from the mainland. Under power from small "push boats" lowered into the water behind the skipjacks, the fleet reaches the starting point an hour behind schedule. The early-morning winds are too strong for small craft; Charles delays the race to give the smaller boats a fighting

chance. But he does so to his own disadvantage. The *Thomas Clyde* is a bigger boat, with more sail to unfurl.

"Put a mainsail in her," Charles instructs his crew. "Let's race or go home." Says Jeanne, "It's about time."

They follow an eight-mile course, down and back. The boats bunch up at the start, but as the race progresses, the *Thomas Clyde* trails. "I'd like to win it, but that's not my principal interest," says Abbott. "Just promoting the race and making people aware that these boats are still around, that's more important."

Abbott's outlook softens the outcome. Except for one boat that lost the top of its mast and pulled in its sails, the *Thomas Clyde* comes in last. Two months later, at the skipjack races off Sandy Point, it will finish first, but that will be its high point. On the Choptank River, the week after the Sandy Point races, the *Thomas Clyde* and most other skipjacks will finish out of the money.

Most people from the Washington and Baltimore metropolitan areas know the Choptank only as a body of water that must be crossed on

Racing canoes paddle past a row of skipjacks at Deal Island

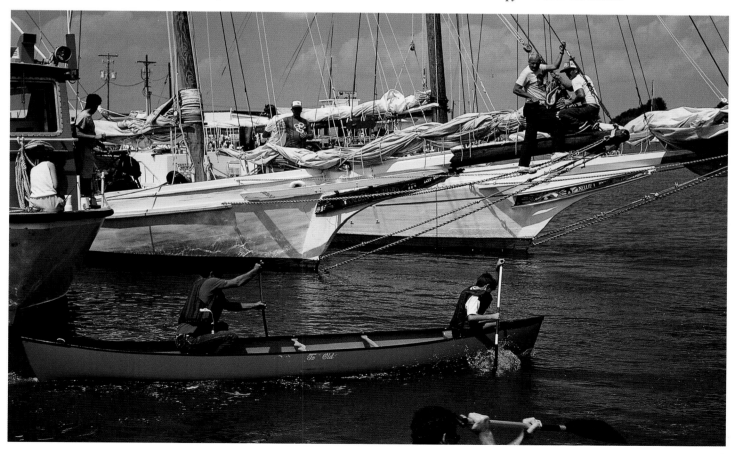

the way to Ocean City, a bottleneck before the completion of the new, four-lane bridge that arches high enough over the river to allow boats to pass under it. But the Choptank, on Maryland's Eastern Shore, was the skipjack captains' odds-on favorite place to find oysters in the fall of 1988. So all but two of the seventeen skipjacks working the bay—down from twenty-one the year before—headed there to kick off what they hoped would be a better season than the last, which had been the lowest on record, a mere 360,000 bushels compared to one million just three years before. The dreaded parasite MSX (from "multi-nucleate sphere unknown") has taken its toll, killing the oysters and the hopes of the watermen. Many oyster-shucking houses have simply shut down for lack of work.

The oyster-dredging season begins officially on November 1. By law, watermen may dredge under the power of push boats two days a week ("The drag [on the bottom] is more steady, but it's not as fast," says Abbott) and under sail for three. Under power, the crew of the *Thomas Clyde* harvested 52 bushels the first day, far below the legal limit of 150 but not bad at $20 a bushel. The second day, however, brought gale-force winds, and the boat stayed in. "You can make a little money catching thirty to forty bushels, but you gotta make a living for the crew, too," said Abbott. Before the captain and crew can make anything, Abbott explains, the "boat" gets thirty percent, to cover the costs of repairs, sails, and dredges. In addition, everyone chips in $400 a week for food and fuel.

Darryl Larrimore, a waterman from Tilghman Island, lasted one day. "I'm done," he said, after a disappointing catch and problems keeping a crew. I'd met him the year before, trying without success to sell his skipjack, the *Nellie Byrd*, to the Chesapeake Bay Maritime Museum in St. Michaels. In three years, Larrimore hadn't made any money oystering and was anxious to dispose of his fifty-three-foot skipjack, an antique built in 1911. But Larrimore, only thirty-five, was himself on the way to becoming a living symbol of an almost bygone era. As he had descended the stairs of the museum office, he'd noticed old photographs of working sailboats lining one wall. The way things were going, Larrimore said, "it's going to be all you can do: remember. We're going to be up with all those pictures. Just a memory."

But there were other skipjack captains who hadn't give up, yet.

This, the third day, has brought fair weather, blue skies, warmer temperatures and—until the midafternoon doldrums—mostly steady winds. In the predawn darkness, Abbott and his crew of five men, ages fifty to seventy-three, head out of the harbor into the wide river that separates Dorchester and Talbot counties. The lights of the new bridge shine in the distance as the skipjack flotilla, propelled by power push boats, heads for an oyster bar off Howell's Point. Once there, sails are

unfurled, and the skipjacks glide through the water, separately and together in quest of oysters.

With sails to the wind, the fifteen boats passing in the day are an impressive sight, but a far cry from the forty-seven skipjacks of 1962 or the seven hundred oyster-dredging sailboats on the bay a century ago.

"I guess I'm about the youngest [Deal Island] captain," says Abbott. "That's the problem. You can repair [the skipjacks] and keep them alive, but if you don't have any youth coming along, you can't repair the captains. Age is gonna catch up with 'em."

Abbott is skippering the *Thomas Clyde* after letting her sit idle for three winters while he went oyster hunting with a technologically more advanced patent-tong rig. With him now are men who had also worked for his father: uncles Price Webster, sixty-three, who doubled as cook, and Raymond Abbott, fifty, and Arthur (Popeye) Jones, seventy-three, Theodore Cephus, fifty-six, and James (Slick) Netter, fifty-nine.

None of their children have gone to work on the water. "I'm the onliest one," says Popeye Jones. "I had one boy dredge for about a week. He said, 'Dad, I don't know how you do it,' and quit" to work for Du Pont, in Delaware. "The only thing is I did it for too long. I should've quit years ago. It's got down to nothing. I remember 150 boats on this bay, schooners, bugeyes, everything. Not much here anymore. Oysters all but died out."

Observes Abbott, "Whether we make any money or not, we got to eat, don't we, Popeye?" Which is what they do, first thing in the morning, with Price Webster serving up eggs, sausage, and biscuits below deck. By 5:55 A.M., they are ready to go.

With Abbott at the helm signaling *Go!,* the men lower two metal dredges over the sides. After a minute or so, the dredges are raised from the bottom by a winch controlled by one man and powered by a Chevrolet V-6 engine. The contents are dumped on board. The kneeling men, wearing kneepads, rubber gloves, boots, and pants, cull the oysters from the muck and empty shells, then sweep the debris overboard.

"Drop 'em down, Popeye," Abbott commands. "Away!"

The ritual begins at 6:50 A.M. and continues until 1:35 P.M., with half an hour out for a midday meal of Price Webster's bean soup, biscuits, and rice pudding. After lunch, the wind all but stops for another ten or fifteen minutes, and so does the dredging. The skipjacks drift with the wind, and the crews relax. "We'll be here an hour," predicts Popeye. When work resumes after ten minutes, the "drags" yield mostly shells.

"There used to be so many oysters," says Cephus. "By this time, we'd have 120 to 150 bushels. Now, you're lucky to catch 50 bushels all day. Years ago, we used to anchor in these creeks, stay aboard until Friday evening, then go home. Now, we go home every night. People aren't going to do that anymore, stay away from their homes to be on these boats."

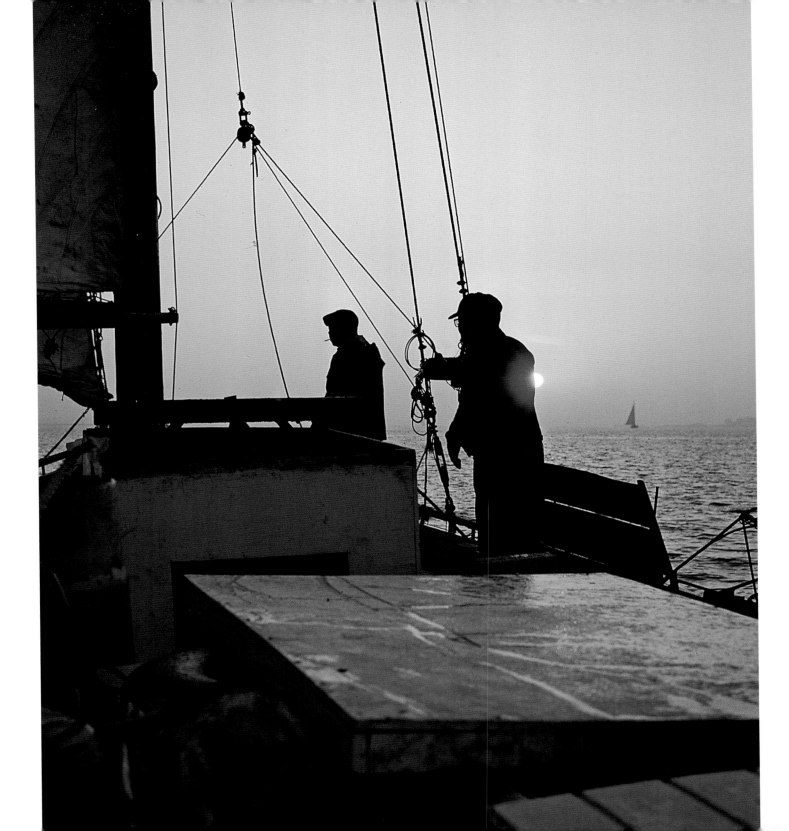

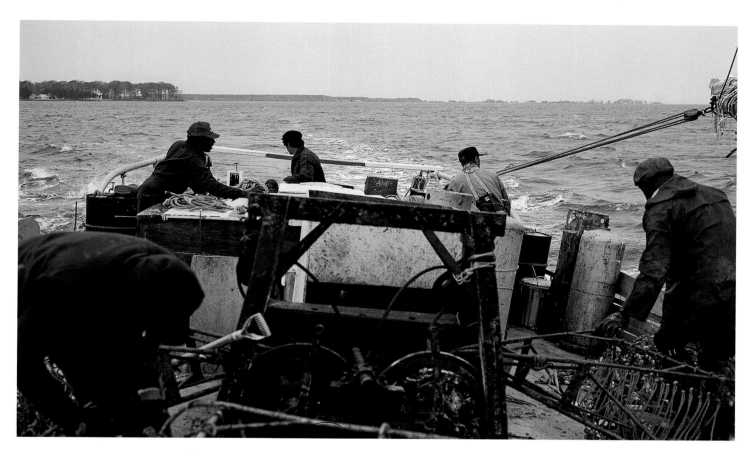

On board the *Thomas Clyde* on the Choptank River on an oyster-dredging sweep

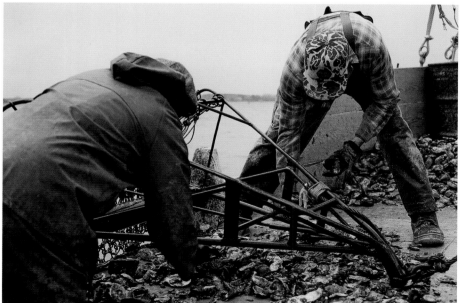

LEFT
Arthur ("Popeye") Jones and Raymond Abbott culling oysters on board the skipjack *Thomas Clyde*, Choptank River, Maryland

OPPOSITE
Sunrise seen from the skipjack *Thomas Clyde* out oyster dredging near Cambridge, Maryland

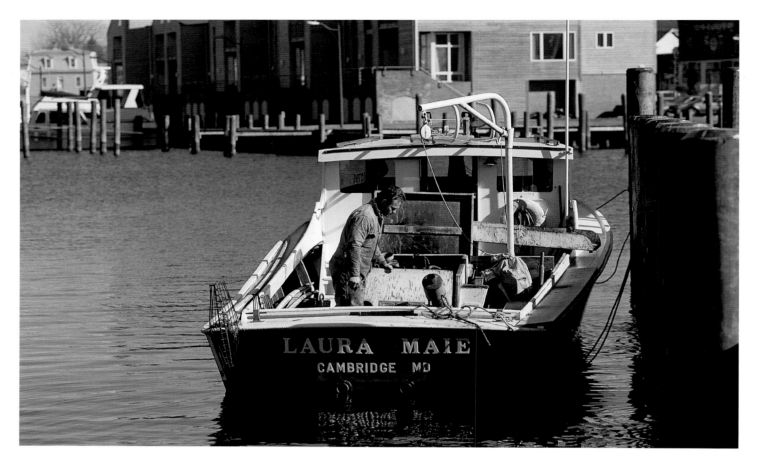

Oyster boat, Cambridge, Maryland

"I know where I'm going—home in a minute," Abbott says.

By 1:45 P.M., the push boat, powered by an Oldsmobile engine controlled from the skipjack, has been lowered into the water and is moving the *Thomas Clyde* to port. On the way in, the skipjack passes a dozen stationary workboats with men manually lowering and raising shaft tongs for oysters—"shaft tongers," these watermen are called. A Department of Natural Resources policeman—a remnant of the Maryland Oyster Navy, which tried to keep law and order on the Chesapeake in the nineteenth century—cruises by.

"What happened, Charles? Run out of wind?" he asks.

"Oh, Lord . . ."

"Right good-sized tow from what I could see earlier," the policeman says, stopping to peek at the catch. His cursory check reveals no oysters smaller than the three-inch cull-law limit.

At dockside, the men of the *Thomas Clyde* unload thirty-one bushel baskets of oysters. They hook them to a crane, which lifts them up and deposits them on shore. The oysters move up a conveyor belt into the

waiting trucks of the Robert H. Cannon Company. The day's gross is $620; the net is $65 per man.

"I'm trying to think of something positive to say," says Abbott. "I can't think of anything except it was a beautiful day, weather-wise. All we can do is hang on, do the best we can . . . until the oyster industry comes back. We don't even want to really stop and think about it. I don't know where else I'd turn, where to start at this point in time. Don't know how to do anything else, really." He is just thankful, he says, that his kids are grown and his wife has a good fulltime job, on land.

Across the harbor from where the *Thomas Clyde* docks are the $200,000 Cambridge Landing town houses. They come with individual "deep-water" boat slips for pleasure craft. On the other side of Cambridge Creek are the Market Square town houses, almost as pricey. Their presence hints at the tidal wave of new outside wealth engulfing the old Chesapeake Bay fishing towns, even as the dwindling skipjack fleet sails into the sunset.

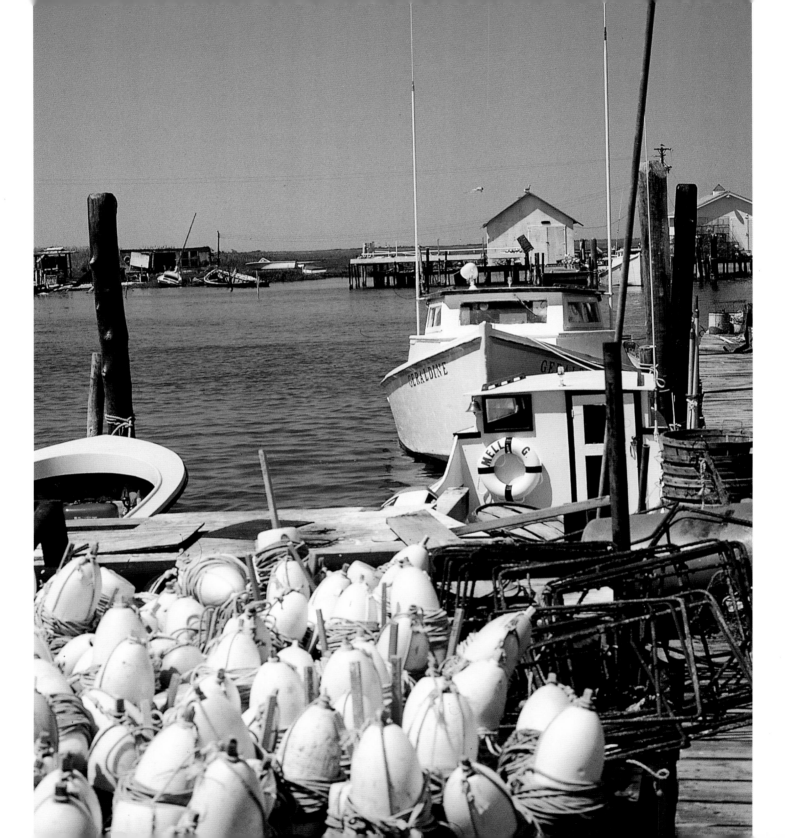

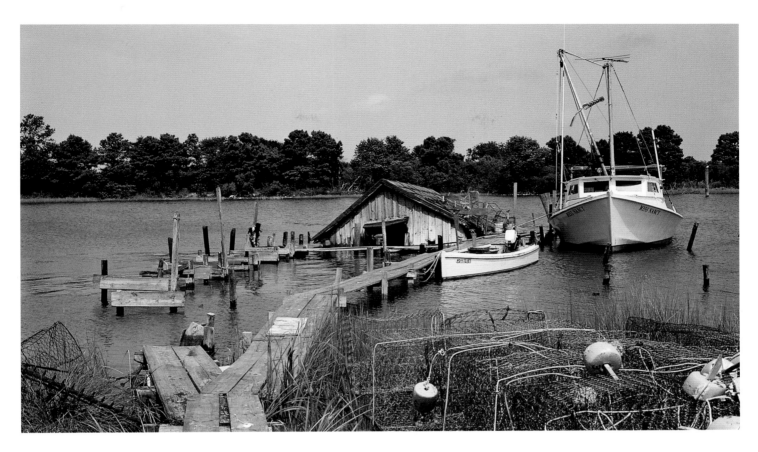

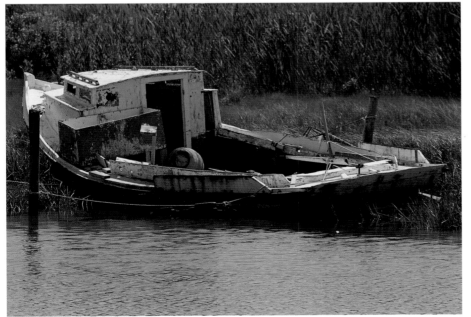

A rickety pier on Big Thoroughfare at Ewell, Smith Island

LEFT
A derelict workboat at Tangier Island

OPPOSITE
Crab pots and the buoy markers that will be tethered to them, Tangier Island, Virginia

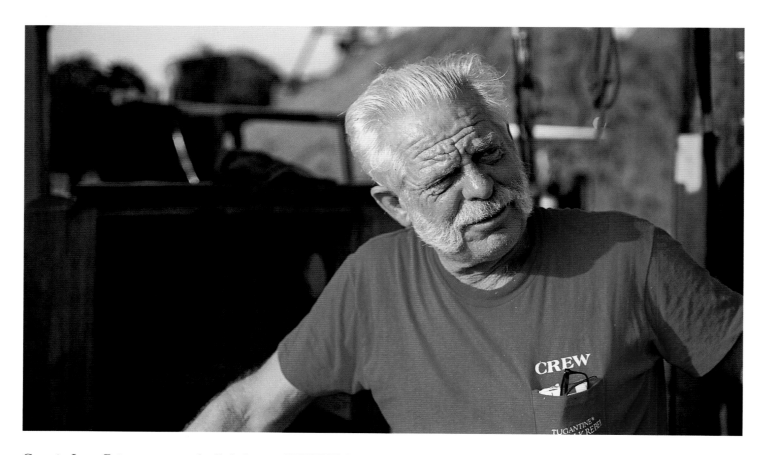

Captain Lane Briggs operates the Rebel Marine Service in Norfolk and owns a boat he calls a "tugatine," a converted tug dubbed the *Norfolk Rebel* used for hauling around the bay. He is pictured at Onancock, on Virginia's Eastern Shore.

RIGHT
Stern of the *E. C. Pruitt*, a workboat at Tylerton

OPPOSITE
A sunken punt at Rock Hall, Maryland

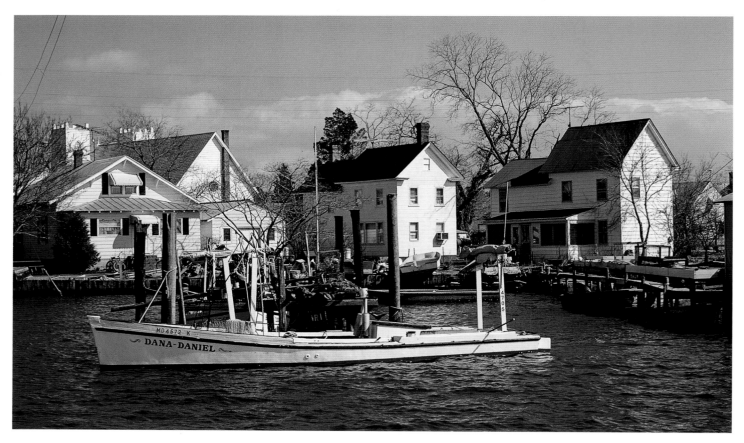

A crab scraper moored along the Big Thoroughfare against the modest skyline of Ewell, Smith Island.

RIGHT
The class cat at the one-room schoolhouse that served Tylerton, the third and smallest Smith Island village, separated by water from the other two, Ewell and Rhodes Point. The schoolhouse closed in 1996, and the building was sold to a Pennsylvania couple who used it as an occasional weekend retreat.

OPPOSITE
Ruke's is one of two general stores where watermen gather to exchange information and opinions in Ewell, Smith Island.

Laughing gulls (*Larus atricilla*) land on a
Crisfield City Dock piling.

Bay grasses at Eastern Neck Wildlife Refuge

Sailing near Deal Island

Sailing on the Tred Avon River

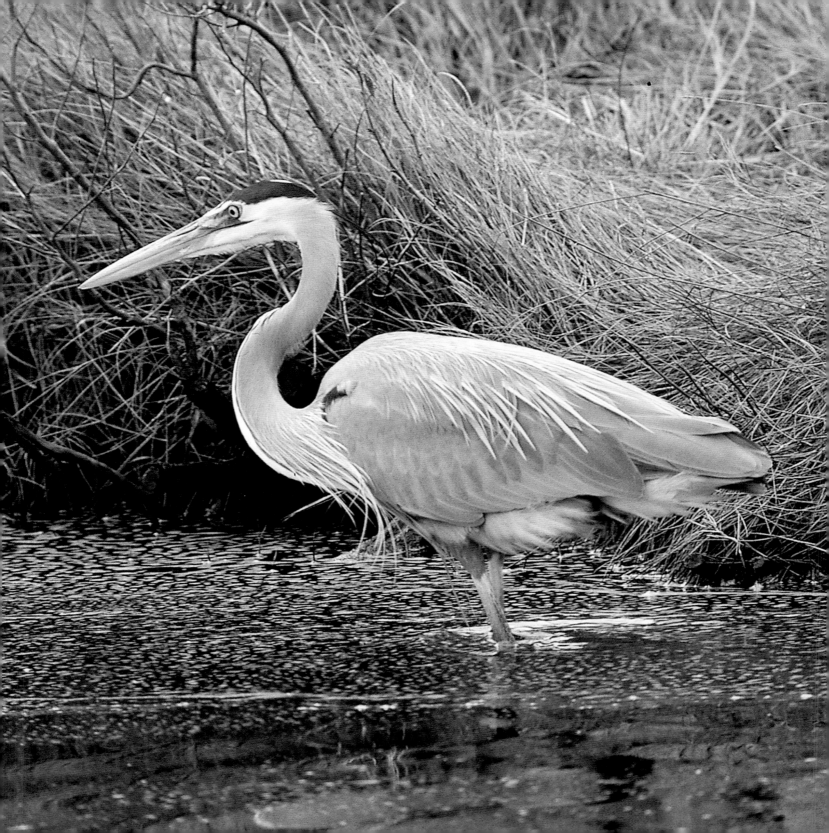

Tidewater Towns/ Chesapeake Cities

"Perhaps your job's on 'The Hill' but your heart's on 'The Bay,'" reads the promotional brochure. "Maybe you're looking for a calmer, more scenic homefront, without sacrificing the excitement the Nation's Capitol provides. If so, Windward Key is for you." These luxury bayfront town houses, priced from $238,000 to $343,000, are "your chance to enjoy the serene . . . life on the Chesapeake, ever convenient to the business and cultural energy of downtown Washington and Baltimore."

Like the Cambridge condos, Windward Key in Chesapeake Beach on the Western Shore is another sign of the times in the tidewater towns and cities around the nation's largest estuary. The pendulum is swinging again: Chesapeake towns that grew slowly or not at all, declined precipitously, and more or less existed for a long time in quiet, uneventful obscurity are once again on the rise. With most of the region seemingly tied to megalopolis, it appears nearly everyone wants a piece of the bay.

From Rock Hall to St. Michaels, Tilghman, Oxford, and Cambridge, from Chesapeake Beach to Solomons, formerly sleepy or unfashionable little settlements have been born again and turned trendy. Sailboats and yachts are replacing workboats and skipjacks. Watermen are fleeing inland, finding land jobs and servicing the newcomers in the ever-changing, increasingly recreation-centered bay economy. But in mining the new motherlode of tourist dollars, Chesapeake towns risk losing the very features that have made them attractive to outsiders in the first place.

It is, as former Maryland Governor William Donald Schaefer has observed, "a tough paradox." "Very simply," Schaefer observed, these towns "wouldn't exist were it not for the prosperity the bay and its products once provided them. Unfortunately, the heyday of the seafood industry is gone." Towns such as Solomons and Rock Hall, which the governor had visited on consecutive days, "now look to the bay to provide prosperity not just from oysters and crabs but from tourists and new residents."

For Washingtonians and Baltimoreans, the bay has increasingly become a place for recreation and respite, rather than a source of

Great blue heron (*Ardea herodias*) fishing for lunch, Eastern Shore

The Robert Morris Inn is a popular Oxford restaurant and hotel named after the man whose son and namesake financed the American Revolution and subsequently died in debtor's prison. The inn, at Morris Street and The Strand, includes the remains of the Robert Morris house, built in 1774.

An aerial view of Oxford, Maryland, platted in 1683 at the southern tip of a peninsula between the Tred Avon and Choptank rivers. Oxford is said to have rivaled Annapolis during the eighteenth century as the colony's busiest port.

The Strand–Oxford shoreline, Maryland

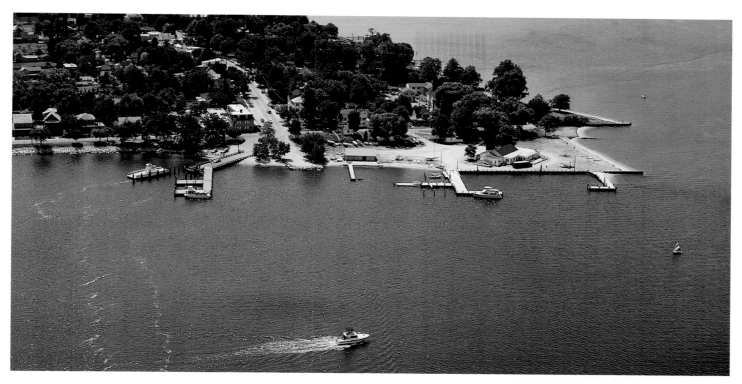

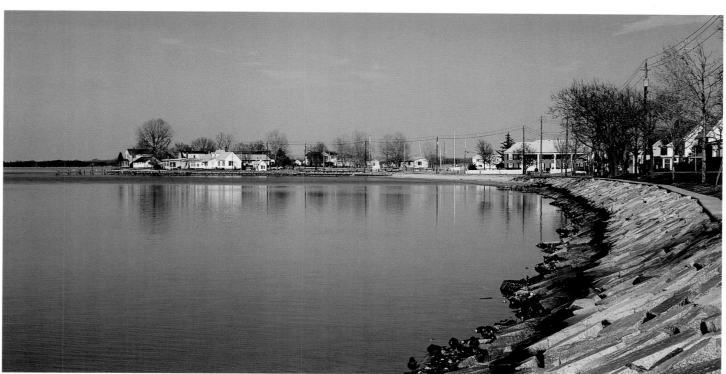

Clayton's Seafood House on the Choptank
in Cambridge, Maryland

The Hooper Island screwpile lighthouse, in retirement, is now a fixture on land at the Chesapeake Bay Maritime Museum in St. Michaels, Maryland.

St. Michaels Inn marina and waterfront condos at St. Michaels

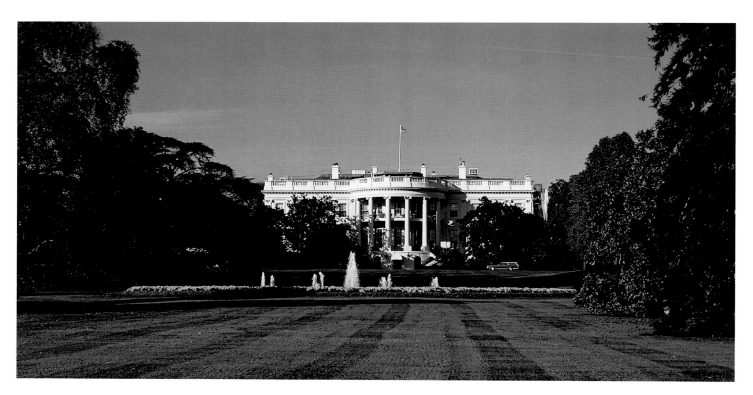

livelihood. Baltimore remains a major American port. But its shipyards have shut down. Fells Point, long a hangout for merchant seamen, is being gentrified. Harbor Place is glitz for out-of-towners: a formula mall plopped down on the waterfront, with store prices beyond the means of most city residents, who mainly stroll the area. Beyond the much-ballyhooed Inner Harbor, downtown Baltimore is largely deserted after dark. At the other end of the Baltimore–Washington Parkway, boats still take tourists on rides down the Potomac, but the once-bustling

Cherry blossoms, Washington, D.C.

OPPOSITE, TOP
The White House

OPPOSITE, BOTTOM
The Tidal Basin and the Jefferson Memorial, Washington, D.C., at cherry blossom time

LEFT
Soldier at Fort McHenry, Baltimore Harbor. Here British bombs burst in air—inspiring Francis Scott Key to write "The Star-Spangled Banner"—during the War of 1812.

BELOW
The battery at Fort McHenry

OPPOSITE, TOP
Two Marines on the U.S.S. *Trenton*

OPPOSITE, BOTTOM
Much of the Baltimore renaissance centers around redevelopment of the city's Inner Harbor, where tourists and pleasure craft have replaced watermen and workboats.

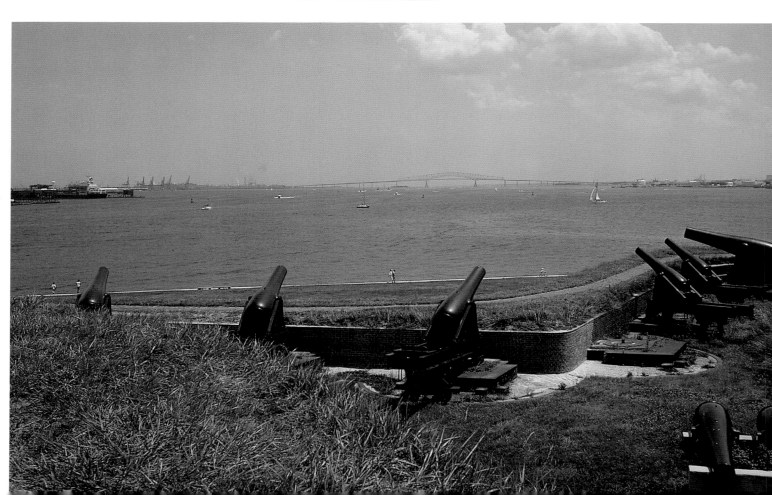

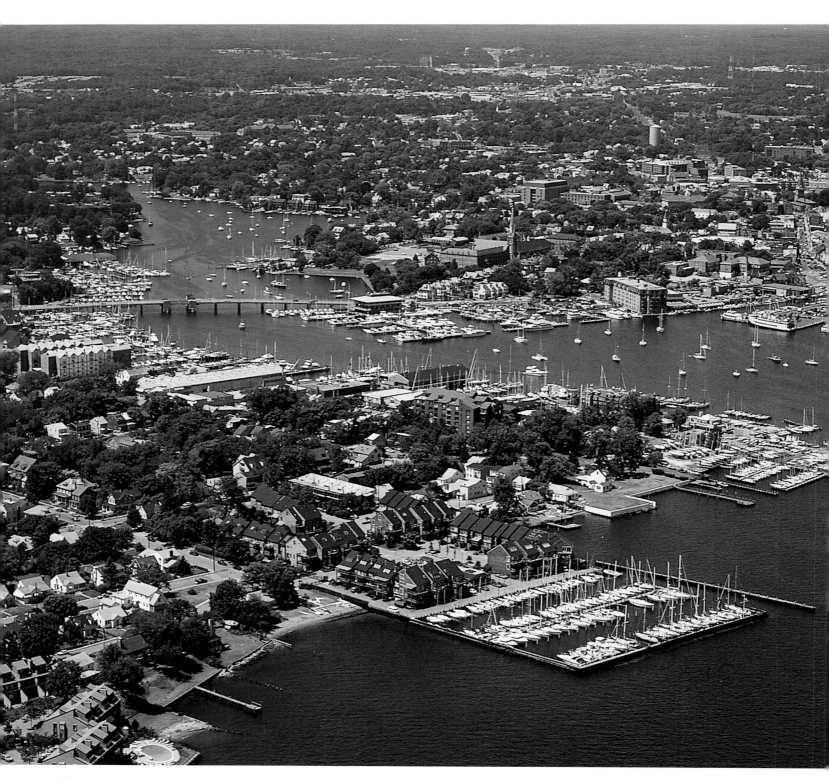

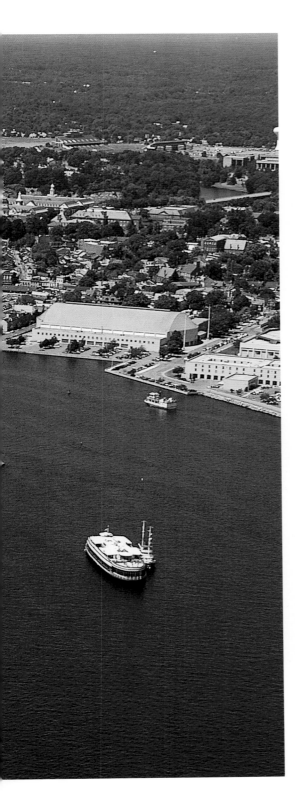

Washington waterfront isn't what it used to be: only a fragment of the old remains in the Southwest seafood market. There, Eastern Shore accents mingle with a variety of local and foreign tongues.

In recent years, the city of Annapolis has graciously provided free dock space to watermen and workboats from the lower bay, but watermen have virtually deserted "America's Sailing Capital" as a home port. The City Dock, once dominated by workboats, is now overrun by yachts. Pete's

An ancient cannon stands guard over the parade grounds at the U.S. Naval Academy.

Aerial view of Annapolis, Maryland's capital city, sailboat mecca, and home of the U.S. Naval Academy

place, a popular Main Street pool hall and neighborhood tavern I often visited when I lived in Annapolis during the 1981 Maryland General Assembly, has become a fern bar. The Haunted Bookshop down the street was priced out by rising rents that are both cause and effect of the town's "renaissance." Even gritty Eastport, across Spa Creek from downtown Annapolis, lost much of its special local flavor after Davis', a black-owned neighborhood bar, was bought by whites and turned into the gentrified "Davis' Pub," and McNasby's Oyster Co. shut down. McNasby's was once one of seven seafood-processing plants in Annapolis. When it closed in 1987, it was the last oyster-shucking house operating on the Western Shore. Efforts to reopen it as a watermen's cooperative in 1989 failed; it became a retail seafood sit down and carryout place instead. Still, insisted Annapolis Mayor Dennis M. Callahan, "We want to make sure the Maryland waterman doesn't go the way of the American cowboy."

Farther south on the Western Shore, Galesville on the West River has undergone similar changes. The Woodfield Fish & Oyster Co. now

The U.S. Naval Academy's sailboat training fleet

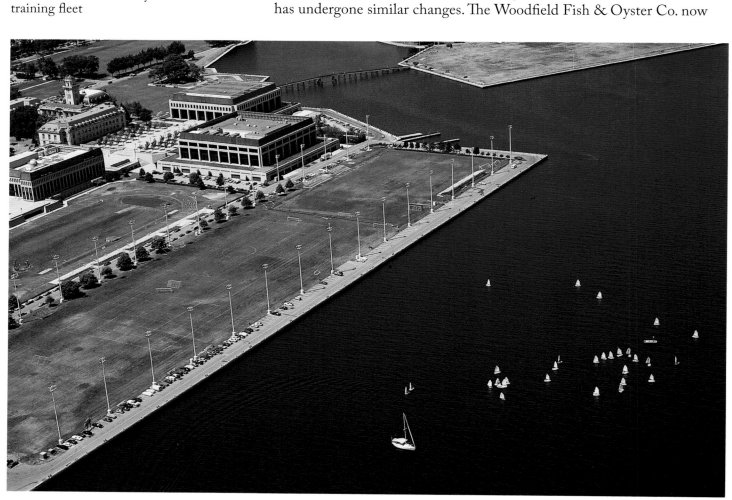

specializes in making ice for marinas. With so many retired people and so few young families, the local school has shut down for lack of students. Not even as remote a community as Ewell on Smith Island has escaped the pressures of change. There, some of the older homes have been bought as vacation retreats by city dwellers. In the 1980s, a Delaware developer sought to build one hundred town houses, a marina, and an airstrip. To gain local support, he made leading watermen partners, but the effort deeply divided the islanders. With the conservationist Chesapeake Bay Foundation—which has an outpost in the Smith Island community of Tylerton—leading the charge, the issue landed in the courts. Ultimately, the developer lost the battle and retreated. But change seems as inevitable as the erosion that eats away at the Smith Island shore.

The forces of gentrification have reached all the way down to Tidewater Virginia. Around Newport News, developers have sought to build a major marina and condominium complex at the Deep Creek inlet, off Hampton

A new house located across the marsh on the south side of Ewell, Smith Island, a watermen's bastion that has so far escaped the pressures of growth

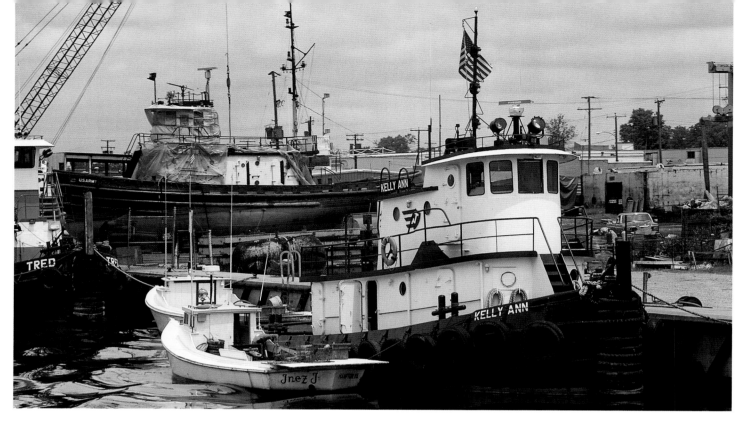

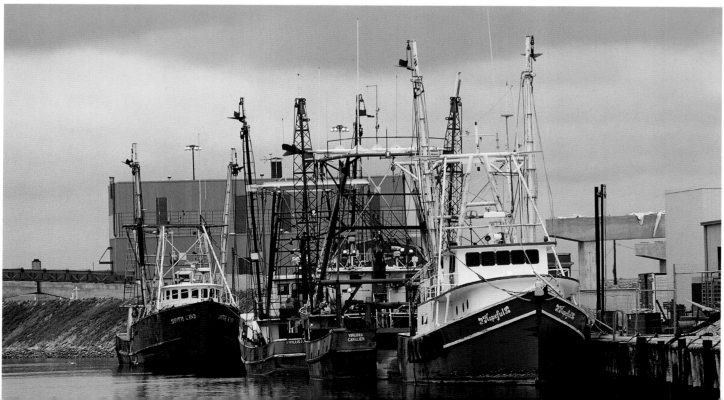

Roads, where oyster tongers have traditionally brought their catch to the piers of Menchville.

That there would be any towns at all in Chesapeake country was not always a sure thing. Tidy New England, with its myriad towns, town governments, and town meetings, was not the way of the spirited Chesapeake. Not that the colonial governors on both sides of the ocean didn't try. Both by executive fiat and legislative ordinance, they decreed the platting of towns, as much for control as for culture. The towns were ports of entry and exit, places for taxes and customs to be collected, where colonial trade could be directed to and from England. The planters, naturally enough, resisted. Plantations were, in effect, small self-sustaining villages. In any event, the easy access afforded by the rivers that laced Chesapeake country appeared to make towns and cities an unnecessary bother.

Eventually, however, towns took root, primarily on the water, and cities grew—though not many. Georgetown and Alexandria were thriving tobacco ports. The capital cities of Annapolis, Washington, and Williamsburg were planned for and built on public lands. Hampton early on became a Virginia port by governmental decree. Baltimore, Chestertown, Oxford, Cambridge, and Onancock, among others, owe their beginnings to legislative acts.

OPPOSITE, TOP
Tugboats at Newport News, Virginia

OPPOSITE, BOTTOM
Tugs and workboats, Newport News

Hopkins & Brothers General Store, Onancock, Virginia

A small punt on the Onancock River,
Virginia's Eastern Shore

Washing down, Onancock, Virginia

Workboats at Onancock, sunset

The towns grew along with the economy of the Chesapeake Bay. Baltimore became famous for its world-class clipper ships and bustling commercial harbor. Oxford was the most active port on the Eastern Shore before the American Revolution. St. Michaels became a large boatbuilding center. Solomons and Galesville achieved prominence as oyster-packing towns, Rock Hall as a booming fishing village, Crisfield as the seafood capital of Maryland, Chesapeake Beach as a turn-of-the-century resort.

But nothing stays the same, and the wave of the future is sweeping over the old bay communities. From Chesapeake Beach to Rock Hall to Solomons, the tale is much the same.

The Chesapeake Beach story dates to the turn of the century, when Colorado railroad builder Otto Mears ("the pathfinder of the San Juans") envisioned a "Monte Carlo on the Bay." To that end, he built the Chesapeake Beach Railway from Washington. Despite his efforts, the resort never achieved the status he sought for it, but for decades it was a place where white working-class Washingtonians could go to enjoy the

boardwalk and the bay. Then the railroad went belly up in the Depression, and gas rationing in World War II dealt an additional blow. With the opening of the Bay Bridge in 1952, only legalized slot machines fueled the local economy; but they were outlawed in 1968, and the amusement park closed four years later. James W. Williams, in his 1975 book, *Otto Mears Goes East: The Chesapeake Beach Railway*, called Chesapeake Beach "a ghost town haunted by the spirits of the men who . . . seemingly wasted their substance on its development."

North Beach, a mile up the bay, offered summer homes and a bustling shopping district for the patrons of Chesapeake Beach. But as Chesapeake Beach slid into decline, so, too, did North Beach. Both towns—together known as "The Twin Beaches"—were down in the dumps when I first visited in the middle of the 1970s. North Beach more so; it was a hangout for bikers, drunks, and drug addicts, a Skid Row-by-the-Bay.

The residents resisted change. Getting by on modest incomes, they were working-class people, many of them retired, living year-round now in the small vacation cottages they had winterized. For a long time, they simply tolerated the trash, the tramps, and the troubles that seemed to engulf their town. For the one antique dealer, life in North Beach was a little like the urban pioneering he had left on Capitol Hill. Promising but dicey. Then a few newcomers moved in and joined with disgruntled natives to elect a reform-minded mayor and council. Mayor W. Alan "Buck" Gott moved quickly to remodel the town hall, demolish the alcoholics' motels, and secure $3 million in state and federal grants for civic improvements. He hired Washington-area consultants with visions of a North Beach resort renaissance. The consultants also invested in waterfront lots, which would doubtless grow in value thanks to their efforts.

Then, in a close election in November 1986, the voters ousted Gott—who would soon be indicted and convicted of mishandling town funds—and returned his predecessor to office. Mayor Russell Hall, a well-digger by trade, represented the older residents of limited income and education who feared the financial commitments made by Gott would bankrupt the town and raise their taxes. With Gott gone, North Beach residents on fixed incomes breathed easier. The North Beach Bayfest the reformers had started became an annual tradition, drawing thousands of outsiders to the town, but the full-scale North Beach "renaissance" and the forces of gentrification suffered at least a temporary setback.

If North Beach had been down and out, Chesapeake Beach was merely stagnant in the 1970s. Its potential did not go unrecognized for long. Soon after the amusement park closed, attempts to sell off the land for development triggered conflict-of-interest charges against the town's elected leaders. Like its neighbor to the north, Chesapeake Beach became bitterly divided. Eventually, the political wars cooled. The old amusement

OVERLEAF
Once, the Eastern Shore was isolated and provincial; it may still be provincial, but it is no longer isolated. Completion of the first span of the Chesapeake Bay Bridge in 1952 forever ended the peninsula's physical—if not its psychological—separation from the Western Shore.

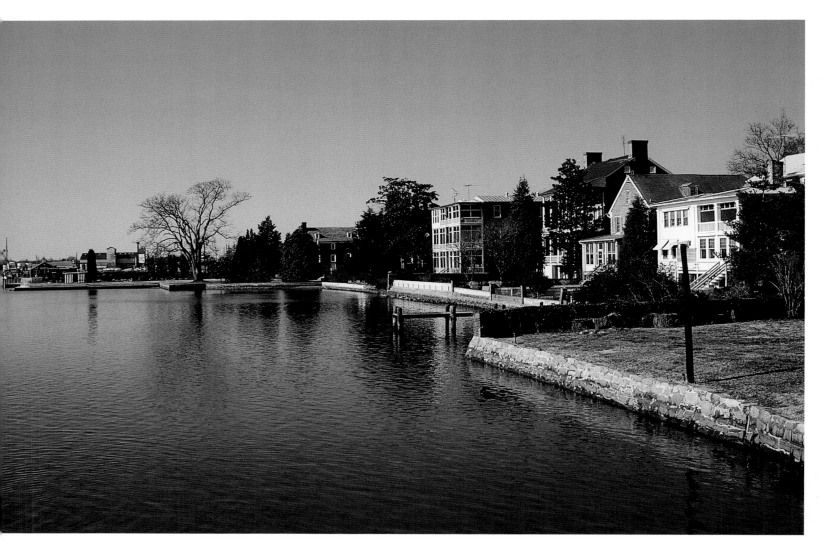

Handsome eighteenth-century houses line the Chestertown frontage of the Chester River.

park property was sold. The old train station became a railroad museum. On adjoining land arose "Chesapeake Station," a subdivision of rustic-looking town houses that slope down toward the bay, with street names recalling the town's glory days: Carousel Way, Band Shell Court, Arcade Court. Within a few years, the last of 118 units were offered at $199,000 to $239,000. "On a clear day, you can see from the Bay Bridge all the way down to Plum Point," enthuses sales manager Ellen Ford. "Compared to Annapolis prices, we're very reasonable, and we're only thirty-four miles from Capitol Hill."

In no time, the new growth split the natives, some of whom were benefitting while others were hurting. The Windward Key town houses were welcomed by Mayor Gerald Donovan, who owned a piece of the

land, but gave Bill Edwards, a ten-year resident, high blood pressure. Since the seventy-four town houses took away public access to the bayfront, Edwards said, the town should be known as "Chesapeake No Beach." He—and others among the town's 2,500 residents—proceeded to challenge Donovan and his council supporters at the polls.

"If you liked Windward Key, you'll love the next four years," said an anti-Donovan campaign leaflet. "But if the beach destroyers made you as angry as it did us, then do something about it. Would you rather watch the moon rise over the bay or watch a townhouse porchlight?"

Donovan, lifelong resident and leading businessman, was the heir of the amusement-park interests. His father before him had been mayor, and Donovan had once been a political outsider himself, attacking what he

Courthouse Square in Chestertown, seat of Kent County, Maryland, home of Washington College and site of the Chestertown Tea Party

termed "the rubber stamp council." Now he and his council members were the targets of others.

"The real crux," says Donovan, who owns the Rod 'n' Reel Restaurant and manages a charter fishing fleet, "is newcomers come in and, because they're here, nobody else is allowed to come in." Donovan expected the town to be enriched by new taxpayers supporting recreational facilities and by a new public beach he hoped to secure. He presented himself as the best of the old Chesapeake Beach, waging his campaign with a pre-election "Drug-Free Jamboree—a Community Celebration of Life for the Entire Family."

Donovan's opponents were not uniformly newcomers, however. Some had been around for years, and they worried that there would be no place for them or their children in the new Chesapeake Beach. "I'd like to see a little low-cost development, too," said Barbara Carver, running for the town council on the anti-Donovan slate. She worried also about increased traffic that growth brought. "We used to have one traffic light that blinked in the wintertime because you didn't need it," she said wistfully. "What are we going to have now?" Asked her slate-mate Bill Edwards, "Who says you can't keep a small town small?"

But if the campaign was hard-fought, the election was one-sided. An overwhelming majority of the residents who voted liked the way the town had changed. Donovan and his slate won handily. Growth had received a firm mandate. "I see this as the land of opportunity," says Patty Cramer, Windward Key sales manager, who has moved down from Annapolis. In Maryland's expanding capital city, she says, "I just felt so closed in. Here, there is a lot of room to grow"—with, for some lucky residents of Chesapeake Beach at least, an exquisite bay view.

Across the Chesapeake and above the Bay Bridge, another town is booming—but not for the fishermen who have made Rock Hall in Kent County something of a bay institution. As Route 260 dead-ends at Chesapeake Beach (with a spectacular view of the bay and Eastern Shore), Route 20 terminates at Rock Hall. On a clear day, you can see the Francis Scott Key Bridge, the part of the Baltimore Beltway spanning the Patapsco River, almost directly across the bay, and the twin spans of the Bay Bridge to the south. By boat, Rock Hall is a mere eighteen nautical miles from Baltimore, sixteen from Annapolis. Here the car radio receives Washington and Baltimore stations, but the traffic tie-ups they report sound like bulletins from another planet. This part of Maryland looks north and east, to Delaware, New Jersey, and Pennsylvania. The people drive to the malls of Dover, Delaware, to shop, and the pleasure boats berthed here are mostly from Delaware and elsewhere north of the Mason-Dixon Line.

For generations, Rock Hall's prosperity has rested on the rockfish— known in other areas as striped bass—which were plentiful in the upper

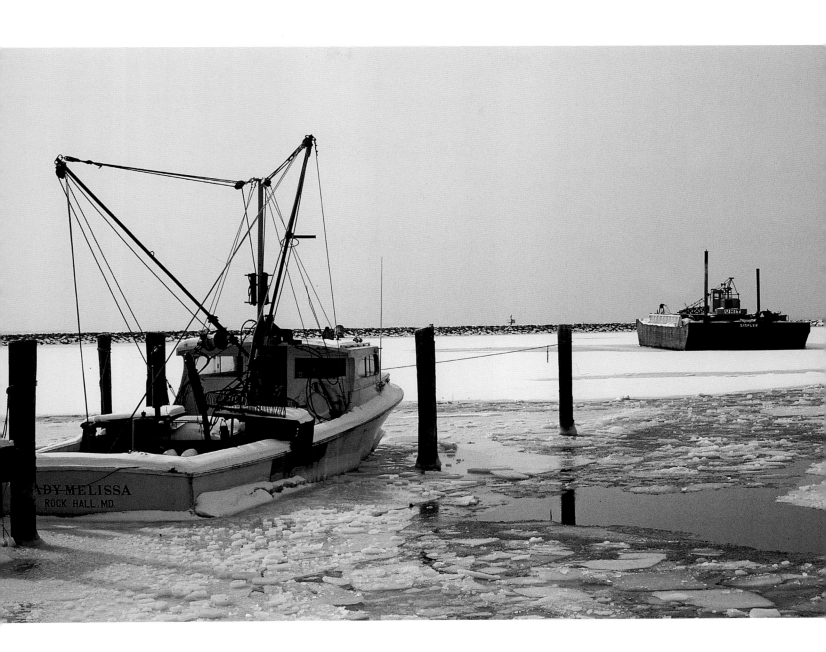

Chesapeake Bay. Fishing was a year-round activity. In severe winters, the rockfish grouped together on their way to the rivers to spawn in the spring. The town's snug little harbor was home to a large charter-fishing fleet that catered to outsiders who wanted to catch the much-desired rock. Then the rockfish declined, and so did the town. A state ban on commercial rockfishing seemed to seal its fate. With the oyster beds washed away by Hurricane Agnes in 1972, that left clamming. Despite the freshwater floods and the pollution, these mollusks had managed to rebound. Three or four summers of little rain on the bay had translated into high salinity and an abundance of clams.

Some forty Rock Hall watermen were clamming, working with hydraulic dredges to harvest the catch, strictly for the New England market. But even clamming is in trouble. Bacteria found in some Chesapeake Bay clams the previous summer has led to the enactment of restrictive legislation by Massachusetts. Whereas New England officials had previously barred only certain shippers from the market, now they were threatening to ban *all* Chesapeake clams.

Ron Fithian, the thirty-eight-year-old president of the Kent County Watermen's Association, lives in a rustic new home in the woods, built not with money made on the water, but with profits from his wife's successful carpet-cleaning and dyeing business. For the most part, her customers aren't even in Kent County. Her rug-cleaning truck travels mostly to Delaware and to the Western Shore, around Baltimore.

"When I was coming up, the seafood business was booming around here," Fithian says. "It was unbelievably different. You'd see a tractor-trailer load of oysters going up this road, a tractor-trailer load of fish going down that road. You'd just automatically become a waterman. At least a lot of us did."

Most of the oysters would be trucked to Virginia to be shucked. Now, not only aren't there enough to fill a truckload going out of town, there aren't even enough to keep local packing houses going. The two dozen waterfront packing houses have dwindled to three, and the Rock Hall Clam and Oyster Co. is the only one still shucking clams. Slips for workboats are in such short supply—and rented at such premium prices—that the county is preparing to reserve seventy-five for workboats alone.

My first visit to Rock Hall was in the summer of 1980. We were fleeing a late-afternoon summer storm in a forty-six foot motor-sailer. From the town's safe harbor, protected by jetties, we listened to Mayday calls on the marine radio, and then we went ashore to eat at Hubbard's Pier and Seafood Restaurant. By the summer of 1988, Hubbard's—once Maryland's largest buyer and seller of rockfish—had been sold and torn down. The

Waterman's Crabhouse Restaurant, Rock Hall, Maryland

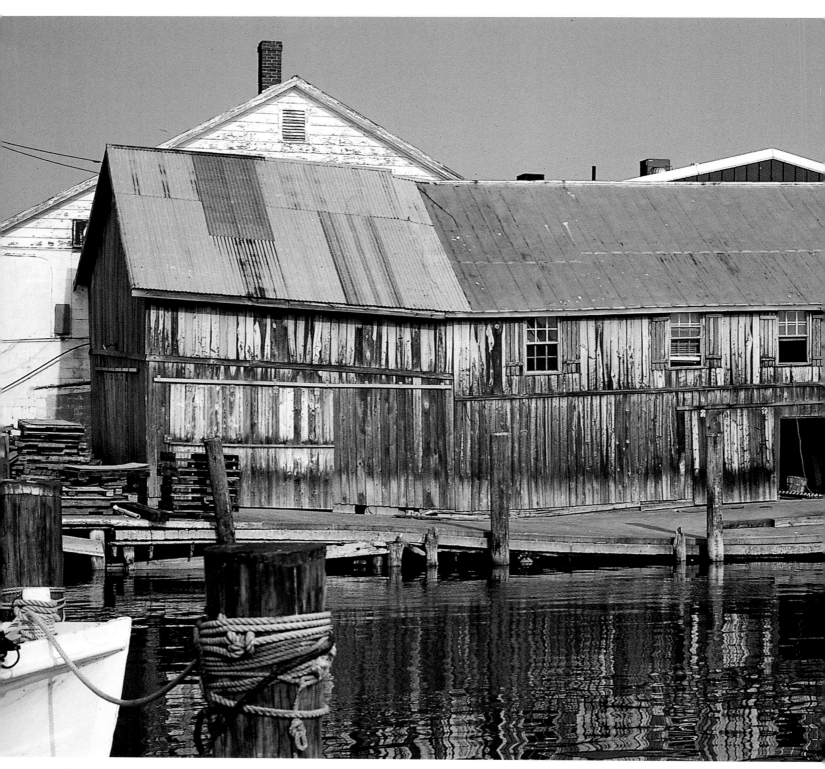

Hubbard's Seafood (*left*) in Rock Hall, a small fishing village in Kent County, was razed to make way for Rock Hall Landing Marina (*above*), a new marina and condominium complex—the forces of gentrification at work on Maryland's Upper Eastern Shore.

way things were, owner Chuckie Woodfield had no choice. The new owners were seeking the town's permission to build a "boatel," gift shops, and a pleasure craft marina.

Now that Hubbard's has closed, watermen find refuge at the Someplace Else restaurant, around the corner.

"It's a great town," says Calvin Kendall, a sixty-two-year-old regular and a longtime waterman.

"It was," says Martin Legg, a welder who works on boats.

"This was really a fishing town. We all fished," continues Kendall. "The younger guys would jump into one thing—fish, oysters, crabs, clams—when it was hot, then get into something else. I ran a charter boat for thirty years here. Did an excellent business. Mostly out of Pennsylvania. It petered out ten or twelve years ago. It declined to a point where people started going other places. Rockfish—that was our backbone."

Kendall is taking the day off from clamming. He can afford to. In 1979, he built one of the town's first new marinas; in 1984 he was renting slips for $1,000 a year to seventy-three pleasure craft and seven workboats.

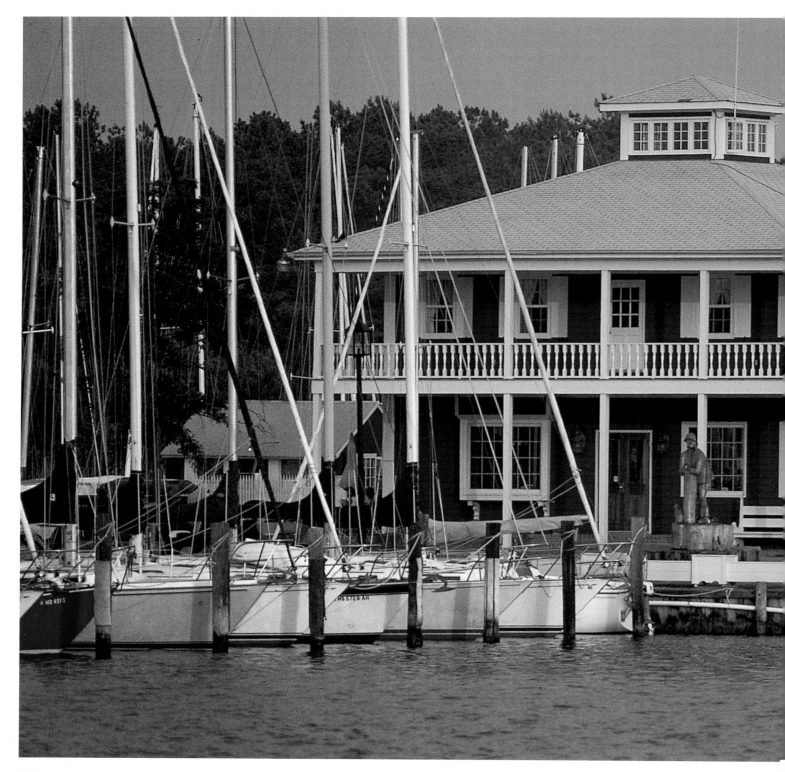

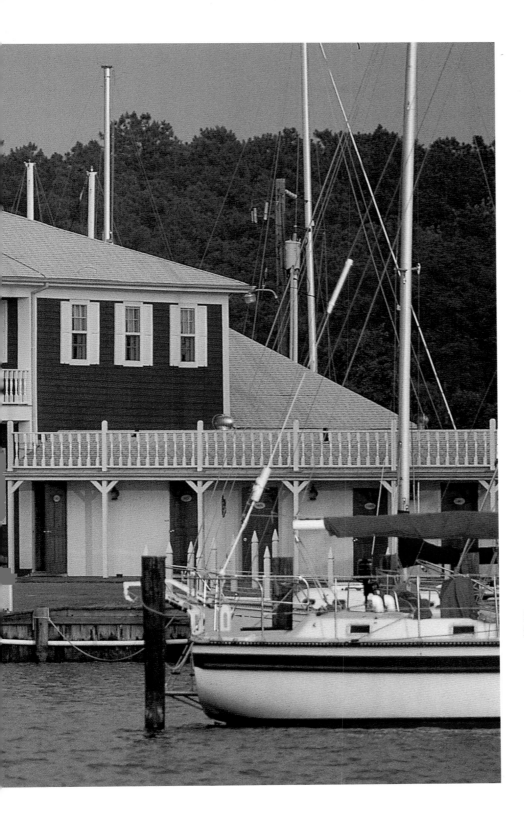

Sailing Emporium, a marina and gift shop
in Rock Hall, Maryland

In December 1986, he sold the marina to a construction man from Connecticut who changed the name to Windmill Point and added a five-unit motel. The slip fee: $1,900 a year, competitive with other marinas in town. The owner has also purchased the adjacent Northside Marina, with fifty-six slips for power boats—and he has a healthy waiting list.

It is uncertain how much longer the watermen can make a living out of Rock Hall, but the pleasure boat business is booming. In 1979 Kendall had problems getting a quorum of town officials to approve his marina, but there was no local opposition. Now outside developers are pressing the town government—still run by the locals—to accept growth and change, and opponents are legion.

"Future Site of Marine Complex," says the sign on the now-vacant waterfront land that had been Hubbard's—but development plans have run aground on the shoals of local resistance. Opponents moved the question to referendum—and defeated it four to one. Now the developers are back with a modified plan for sixty-eight slips and sixty-eight condominium "boatel" units.

The corporate name and partners—who come from Wilmington, Delaware, and Arnold, in Anne Arundel County north of Annapolis—keep changing, reflecting the investors' impatience with the pace of things. Still, it is only a matter of time, folks reason, before they get their way. There are some in town—including the town manager—who hope they will.

"This is a small community, shut out from the world for 250 years," says town manager Joe Mangini, originally from Delaware, "and now the world's discovered them. It's taken them a while to get used to, and some want to cling to the past." I am talking with him at his office in the municipal building, a converted elementary school that also houses the mayor's office, the town museum, and a Head Start program. The town, he says, "is going to have to go forward. Development's going to occur. I'm a firm believer in controlled development and not wiping everybody out. You try to talk to them to blend their project into the community. You don't want to incur a bunch of legal battles."

Rock Hall needs more to make money from tourism, which Mangini sees as the town's salvation. At this writing, there is but one bed-and-breakfast and one motel, soon to be torn down to make way for the waterfront redevelopment. "There are no shops and stores to go to. People can eat, sleep in Chestertown. The only tourists we see come by boat and can't go anywhere else. Mostly, they stay on the waterfront and don't come into town for services."

The boomlet began after the Army Corps of Engineers dredged the channel and raised the jetties.

Already, there are 1,000 slips around Rock Hall Harbor. With 120 slips, the Sailing Emporium is home to boats like the *Floating Prime*

from Philadelphia and the *Branch Office* from Wilmington. The Cat's Paw Chandlery gift shop sells jewelry, nautical wear, and other accoutrements of yachting life. Across the harbor, the four-story Rock Harbor condominiums loom, almost a high-rise on the townscape.

In this town of 1,700 ("Nice People Live Here," says the welcome sign), thirty-five percent are over sixty, according to Mangini. Although gentrification is not yet evident in the storefronts on Main Street or in the old frame houses that line the side streets, locals feel that newcomers threaten to overwhelm the natives.

"Twenty years ago," says Calvin Kendall, "a native knew just about everybody who lived in the whole community and all the surrounding rivers and creeks. Today, I bet I don't even know a third of them. It's very hard for you now to buy a home on a river or a creek. A $50,000 home twenty years ago would now sell for $400,000 at least. You can almost name your price. Even old people who love Rock Hall and have lived here all their lives, they've outlived their means, you might say. I think it's gonna run most of the local people out. I don't see how they can survive it. It's gonna happen to everyone around this waterfront. If they don't work at the marina or try to work on the water, a young guy has to commute every day or move away."

It is that way down in Solomons, too. "We used to tie up at Solomons in the wintertime commercial fishing. Now, I don't think you can get a place to tie up there, either."

Woodcarver Otis Stephens at The Mariners' Museum in Newport News, Virginia

Indeed, only a handful of watermen still work out of Solomons, a narrow sliver of an island at the southern tip of Calvert County. Here, where the Patuxent empties into the bay, the transformation is virtually complete: a marina gift shop occupies the former bank building, and the Calvert Marine Museum now occupies the old high school and the Lore oyster-packing plant.

"Money talks, and millionaires are buying up property, and there is no way to stop them," says Leroy ("Pepper") Langley, seventy-three, a fourth-generation resident and master woodcarver at the marine museum he helped start. "The real-estate taxes are going up so high, we have to sell and move out, because we can't afford to pay taxes like the [new] people who come here. There's no use anybody coming to Solomons to look for the old water town Solomons once was, because it's not here."

But come they do.

Sixty miles south of Washington, the old town is booming with a new purpose: making money from tourists and pleasure boaters. "It's just getting more crowded," says Andrea Taggs, a gift-shop employee at Zahniser's Marina, which has grown from thirty slips in 1960 to nearly three hundred less than three decades later. "I can see the island slowly sinking from more cars," she says.

ABOVE
Two docked dinghies at the Calvert Marine Museum, Solomons, Maryland

RIGHT
Bay boats on display at the Small Craft Shed of the Calvert Marine Museum

Taggs herself is part of the change. She came to Solomons from Washington in 1982. For the first time, she notes wistfully in June of 1988, there are no working skipjacks anchoring in Solomons. "It's just all tourism and [pleasure] boating," she says. "It's sad, but that's how we have to make our money."

The annual "blessing of the fleet" aptly demonstrates her point. The ceremony "originated many years ago to bless the fishing fleets for safe and successful seasons," according to the Solomons Island Yacht Club. By all other accounts, though, Solomons never had such an event before the yacht club began sponsoring it in the late 1960s, and the blessed fleet now consists almost entirely of sailboats, yachts, and sportfishing boats.

The growth has been nothing if not spectacular, enough to support ten marinas, fourteen restaurants, four bed-and-breakfasts, a Comfort Inn with "jacuzzi suites," and a new 170-unit Holiday Inn conference center, which often hosts four meetings at once.

"When I first came here in 1982, it was difficult to get a hamburger after 7 P.M. in the off-season," says Cluney Stagg, at the Chesapeake Biological Laboratory, situated at the island's end, near the former site of Isaac Solomon's seafood packing plant. Now he can count fourteen "places to get a drink" on the island.

The marinas account for 1,500 pleasure boat slips, double the number a decade ago, and, at this writing, more piers are in the works. Moreover,

SMALL CRAFT SHED

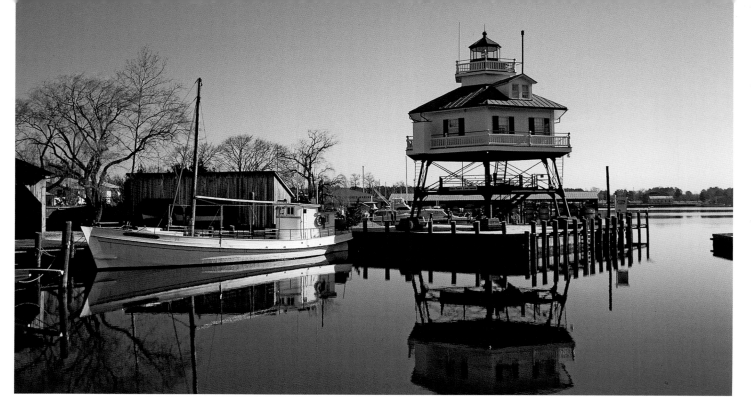

The Drum Point lighthouse has become a historical exhibit at the Calvert Marine Museum, Solomons, Maryland.

1,500 condominium units are to be built around the island community of 700 year-round residents, named for a Baltimorean who started his oyster business here in 1865.

"We have a goldmine here because of the proximity of Washington," said Skip Zahniser, whose father began building piers in Solomons during World War II. The dualization of Route 2-4 down the entire peninsula of Calvert County has helped. So has the Governor Thomas Johnson Bridge, built in 1977 across the Patuxent River to connect Calvert and St. Mary's counties.

"You could just pave Solomons with condos," says Ellen Zahniser, an Annapolis transplant and Skip's wife, "but there's more to it than that. The only thing I care about is good taste and good quality for the people now living here."

What remains to be seen, according to Brian Rothschild, president of the business-oriented Solomons Civic Association, is whether "we can maintain the quality of the past under the pressure of all this change— whether we move the community more toward a St. Michaels or Ocean City-type atmosphere."

If visitors seeking an authentic bay fishing village find a veneer of quaintness that is mostly history under glass, that is just fine with Rothschild, a professor of fish population dynamics at the Chesapeake Biological Laboratory, a Solomons fixture since 1925. "Look at Europe,"

he says. "When you go around Europe, you have a feeling of the past, but when you think about it, it's past under glass, too. But it's still neat."

Clearly, Solomons will not return to its watermen's roots. The only question remaining for the town is one of class. St. Michaels represents the gentrified Chesapeake community as museum town, where membership in the maritime museum includes sailboat-docking privileges. What Rothschild opposes, an "Ocean City-type atmosphere," was characterized by the working-class citizens who fished and crabbed off the Solomons bulkhead until such activities were banned in 1988. These people would not patronize the pricey gift shops, restaurants, and marinas to have a good time; but they took up parking spaces, they often left litter, and some Solomons residents regarded them as unsightly.

Others suggest racial overtones as well in the ban on fishing from the bulkhead. "A lot of black people fish there who can't afford boats," says Captain Edward Riley Harrison, sixty, a white man who lives across the street from the bulkhead and opposes the ban. "When my boys were coming along, they made spare money and stayed out of trouble crabbing on that pier."

Captain Harrison, originally from Tilghman Island, has been a

Coiled rope and tire fenders on tugboats at Chesapeake City, Maryland, the unofficial capital of the Chesapeake and Delaware Canal. Linking the two bays, the C & D Canal is a freighter channel and a part of the inland waterway for yachts and sailboats.

In the 1980s, electronic automation replaced Coast Guard personnel at the Thomas Point lighthouse, erected in 1875 off the Western Shore south of Annapolis.

Solomons resident for twenty-eight years. When he first came to town, "it was a much slower pace of living, there was much less hustle and bustle, and everybody was much more friendly." His title came from working on the water, but these days he mostly barbers. The bulkhead battle turned him into an island activist as well, and he gathered sixty names on a petition against the fishing ban.

Also skeptical about the bulkhead ban is Jack Johnson, proprietor for twenty-nine years of H. M. Woodburn & Co., a bait and tackle shop and one of the few businesses catering to the bulkhead fishermen. "They come in and buy quite a lot of stuff from me—crab nets, bait, soft drinks, ice, snacks. I don't make that much. It's the principle involved. The water's supposed to be for everybody. Fishing made this town, and they're trying to do away with it. I believe a lot of this over here is really racial. They don't like to see a black man over here fishing. A lot of white folks fish there, too."

Such sentiments notwithstanding, the newcomers of Solomons wanted the bulkhead anglers out, and they succeeded. Heeding the pleas of restaurant owners and other shopkeepers, the Calvert County commissioners approved the bulkhead ban, and posted signs warning of a $100 fine. In Solomons, it seemed that an era had ended.

Then lightning struck. Call it bad luck, divine retribution, or a blessing in disguise. Just as the busy summer season of 1988 was getting under way, Maryland highway officials found structural cracks on the Governor Thomas Johnson Bridge and immediately closed the 1.4-mile span for almost three months while eight piers were repaired. In one of the fastest-growing areas of southern Maryland, that translated into a 63-mile detour and disruption of the community's booming economy.

The bulkhead fishing ban remained in force, but the businesses that had lobbied for it suffered even without the unsightly fishermen. The 12,000 daily automobile bridge crossings ceased, and business in Solomons dropped by forty percent weekdays and twenty percent on weekends, despite advertisements touting "broken bridge specials." Edgar Woodburn watched business drop at his Pier 1 restaurant by as much as half—though his Woodburn's Food Market, catering to the locals, whose tie to St. Mary's had been severed, enjoyed increased sales of ten to twenty percent.

For the duration, the state ran ferries back and forth across the river. There were brisk sales of newly minted T-shirts reading "Troubled Bridge Over Waters" and "Patuxent River Boat People." Somehow, the townspeople adjusted to the slower pace, a throwback to a quieter time before roads overshadowed rivers, when the towns of Chesapeake Bay still belonged to the locals.

Cove Point lighthouse, Calvert County,
Maryland

Havre de Grace lighthouse, built in 1827 at Concord Point

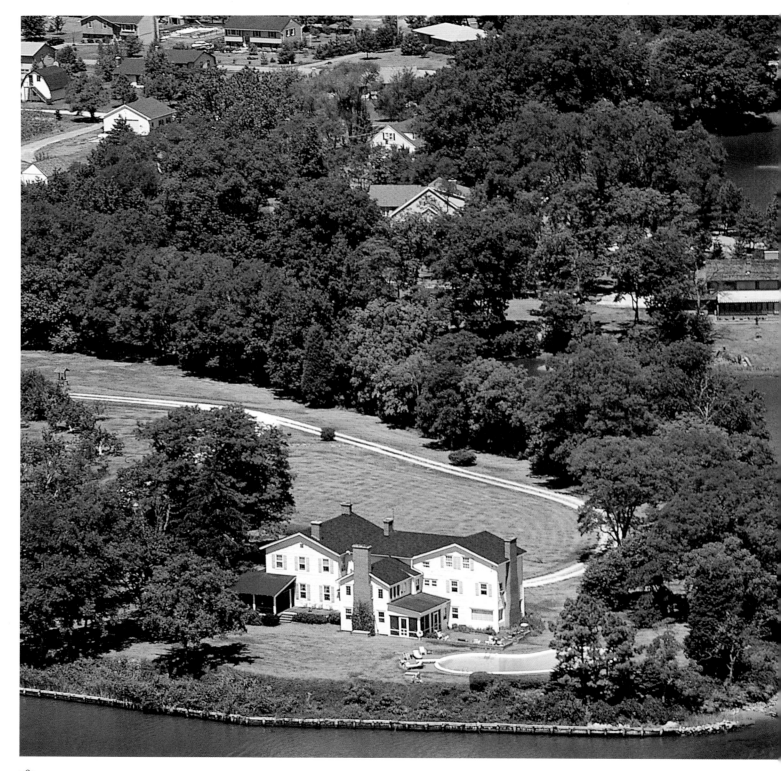

A bird's-eye view of the new gentry on Maryland's Eastern Shore

Boats and more boats on Maryland's
Eastern Shore

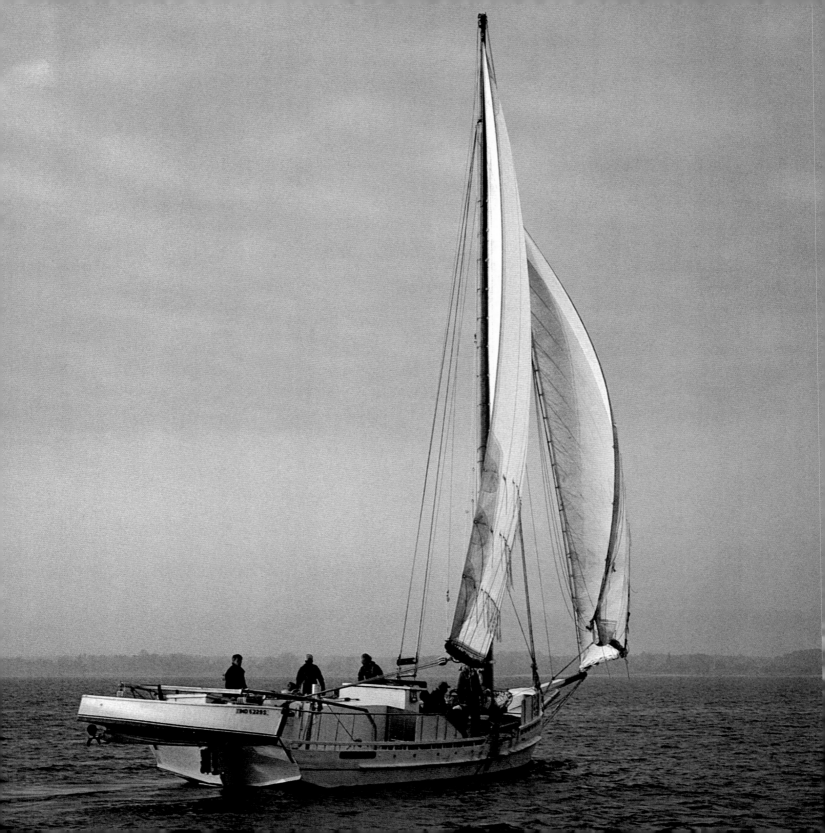

Chesapeake Country: Back to the Future

The Chesapeake Bay is one of the rich agricultural regions of the earth, and its fertility can be compared only with that of the valleys of the Nile and the Ganges and other great rivers.

—*Maryland, Its Resources, Industries and Institutions,* 1893

Starting in 1966, the big event in Maryland's "Mother County" each October had been the St. Mary's County Oyster Festival. Shuckers from all over the Chesapeake and elsewhere came to the fairgrounds outside Leonardtown to compete for the national title of U.S. National Oyster Shucking Champion—and for the right to represent the United States in the Oyster Opening International in Galway, Ireland. Almost inevitably, the winners were Marylanders, or at least they came from somewhere in Chesapeake Bay country.

Then, little by little, shuckers from the Gulf and from the Pacific Northwest gained the ascendancy. Chesapeake shuckers were older and fewer. In recent years, it seemed, the Maryland Oyster Festival had become a showcase for some of the cleanest, fastest shuckers—from other parts of the country.

In 1988, something else happened to the Oyster Festival. It became the Seafood Festival. The oysters had become so scarce that the event no longer seemed to justify the name. Well past the summer season, the food tents were selling crab soup.

Across the bay, at Kent Narrows, oyster shuckers' shanties that had been there for years—symbols of the shuckers' impoverished status but also of their survival—were razed. Two miles east, off Route 50, $200,000 condominiums had sprouted, within sight of the few shanties left. The condo development, called Oyster Cove, is marketed to Annapolitans and Washingtonians willing to trade a longer commute for the view. The condo complex includes a marina; to build it, the developer dredged an oyster bar, destroying all the oysters.

In our time, some fundamental changes have occurred on and around the Chesapeake Bay. Oyster Cove now recalls a memory, no more a reality,

George Price, at eighty, was the oldest contestant in the amateur shuckers category at the St. Mary's Seafood Festival, 1988.

OPPOSITE
An oyster-dredging skipjack working in the Choptank River from Cambridge, Maryland

187

and the reality of the Seafood Festival speaks for itself. Can Chesapeake culture be Chesapeake culture without the muck-encrusted oyster and the people who catch, shuck, and eat it?

There have always been oysters on the bay, long before Captain John Smith observed them on his 1608 exploratory voyage. In the early nineteenth century, boats came to the Chesapeake from the mid-Atlantic states and from New England to dredge for oysters. The industry received another boost with the opening of the first packing plant in Baltimore in 1834. Henceforth, raw oysters brought to Baltimore could be shipped by rail to points north and west. The bay was suddenly filled with dredgers. No matter that dredging was outlawed in 1832. It was a law routinely violated. Recognizing reality, an 1865 law allowed dredging under sail only by vessels licensed in Maryland; to enforce it, the state, in 1868, commissioned its own fleet of patrol boats "to constantly cruise in search of violators of the Oyster Laws." The "Oyster Navy" was armed—but so were the dredgers, some of whom conscripted immigrants from Baltimore into virtual slavery on board their vessels (those who rebelled were often "boomed" overboard). As in the Wild West, life on the Chesapeake was cheap.

Oyster dredging on the *Thomas Clyde*

The oysters received something of a reprieve during the Civil War—as they would in subsequent conflicts when watermen went to war—giving the bivalve stock a chance to replenish itself. But oyster harvesting reached its all-time peak in 1884, when 15 million bushels were taken from the bay bottom.

"It is a harvest which no man has sown; a free gift from bounteous nature," said members of Johns Hopkins University in a report prepared for the Maryland board of the 1893 World's Columbian Exposition. "Our opportunities for rearing oysters are unparalleled in any other part of the world. When we have learned to make wise use of our opportunities, and when the oyster-beds of the bay have been brought to perfection, a harvest of 400 million bushels in half a century will not be regarded as evidence of fertility."

But overharvesting took its toll. By 1910, the crop amounted to a mere 3.5 million bushels. The 1940 crop was under 4 million—far short of the 400 million forecast fifty years earlier.

Still, there was always more to the bay than oysters. "The waters covering this extensive area," the scientists of Johns Hopkins wrote in 1893, "bear on their surface, and contain hidden in their depths, a great store of good food, which forms a very important addition to the list of land products. Ducks, geese and other birds are shot along the shores; while the many varieties of fish, the crabs, the terrapins and the oysters offer conclusive proof as to the richness of life in the bay itself."

It seemed, indeed, an endless resource. Certainly, there had been

A painted turtle (*Chrysemys picta*) poses at Blackwater National Wildlife Refuge, Dorchester County, Maryland

A screech owl (*Otus asio*) at Elk Neck National Wildlife Refuge

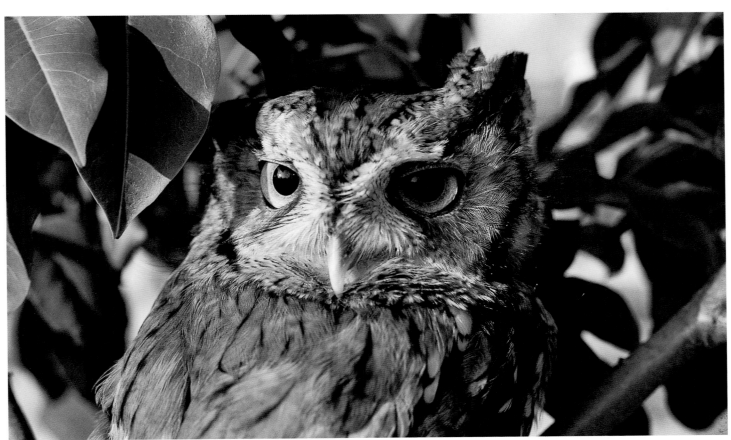

disasters: an avalanche of fresh water from Hurricane Agnes in 1972 lowered the bay's salinity and swept away the oyster beds. Sediment and herbicides spilling from the land into bay tributaries seemingly destroyed underwater grasses that nurture aquatic life. Parasites of uncertain origin attacked the oysters. Pollution-related low oxygen levels in deep water, combined with high water temperatures above, resulted in unexpected fish kills. Man-made intrusions have also taken a toll: the decline of the Susquehanna River–spawning shad was often blamed on the lack of a fish ladder up the Conowingo Dam.

But whatever the whims of nature or the damage done by man, there had always been a cycle to bay life that carried the Chesapeake culture and the people who depended on it through tough times. Watermen crabbed summers, oystered winters, and trapped eels or fished in between. If one resource was scarce, they simply adjusted their lives accordingly.

"It's always been nature would send something along to take up the slack," says Ron Fithian, Rock Hall waterman and president of the Kent County Watermen's Association. "You used to have five industries to choose from. Now, there are two—crabbing and clamming. Oystering's a

Eel grass, Blackwater National Wildlife Refuge

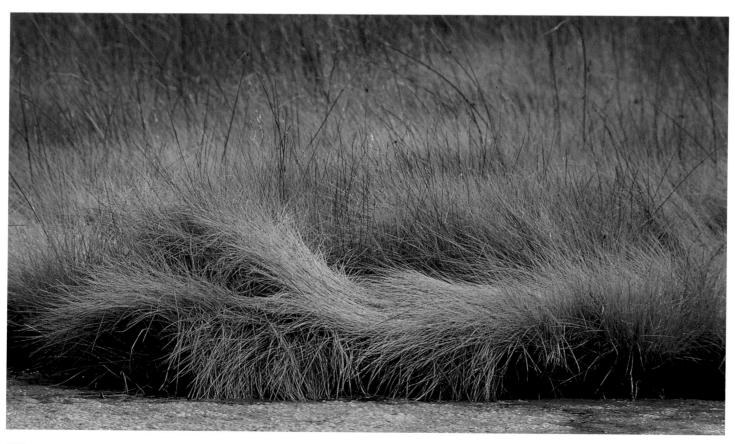

joke. Fishing is nonexistent. Now, if clamming comes up short, you don't have any place to turn."

In addition to enforcing culling laws, dredging regulations, and restrictions on the catch, bay managers have over the years moved empty "seed" shells from the Upper to the Lower Bay, where the salinity provides a more favorable climate for baby oysters. This form of "oyster culture" has been long advocated. "Why not give oyster culture a fair trial?" asked oyster expert Caswell Grave around the turn of the century. "To place new cultch on these exhausted grounds—to plant them with the kind and quantity of oysters suited to their ability to produce, and to give to the grounds and their product the attention they need, requires the interest of private ownership and control." Private leasing or ownership of oyster bars was not to be the way of Maryland, but the state has engaged in small-scale oyster seeding for a number of years, with only limited success.

Since the 1960s, the state has been moving oyster shells in a futile effort to reverse the oyster decline; but the oyster-seeding program appears headed for the heights of folly. The state proposed in 1988 to allow its contractor to dredge the Man O' War Shoals oyster bar, about two miles

Bay grasses at Blackwater National Wildlife Refuge

Shrubs along the Chesapeake, Eastern
Neck National Wildlife Refuge

A barn near Piney Point, St. Mary's County, Maryland

Oyster aquaculture, at Piney Point, St. Mary's County, Maryland. Attempts to culture oyster crops here have met with limited success. However, private aquaculture, especially in Virginia waters, and oyster sanctuaries in Maryland that are off-limits to watermen have contributed to a modest rebound in oyster harvests in the twenty-first century.

east of the mouth of the Patapsco River. To reap the 96 million bushels of fossil shells, the dredging company would also scoop up and destroy the live oysters above them, thus eliminating one of the few healthy oyster beds remaining in the Upper Bay—in a year when Maryland watermen were looking at a second consecutive season of 400,000 bushels, the lowest harvest since the Civil War. The proposal ran aground, stalled if not stillborn.

If government policies to revive the resources of the bay sometimes seem lacking in logic, Maryland at least is making an effort. Traditionally conservative Virginia has long eschewed many of the regulations and limits that appeared to give the bay a fighting chance. But as the fisheries have declined, the commonwealth's laissez-faire attitude has gradually yielded to a more activist approach.

It is not easy to grasp the decline of a great estuary often referred to as the most-studied and least-understood body of water in the world. Scientists have grappled with it for years. Many watermen, citing a recent rockfish resurgence, and an abundance of clams, refuse to acknowledge a problem. Cruising the Chesapeake for thirty-eight days in the summer of 1980, I saw for myself a body of water that did not—at first glance—look as bad as the picture painted by the seemingly alarmist "Save the Bay" environmentalists.

To my unscientific eye, the problems of the bay seemed far from obvious. For all the talk about crowded waters, I discovered a bay largely devoid of vessels. Except around Annapolis, St. Michaels, and the Bay Bridge on weekends, I concluded, ninety percent of the bay's estimated 200,000 boats were berthed at marinas most of the time. Moreover, instead of overdeveloped shorelines, I found a largely pristine coast, with much the same view, I imagined, as John Smith had enjoyed nearly four centuries before.

"You can't look at one fish kill and say the bay is polluted or at one productive area and say the bay is healthy," Jay Taft, of the Johns Hopkins Chesapeake Bay Institute, told me. But my voyages with the scientists of that summer and fall only seemed to support my skepticism. Was the glass half full or half empty?

In one July week of field work, the scientists surveyed the bay on a 106-foot twin-hulled research vessel named the *Ridgely Warfield*. Consuming a small fraction of the twenty-seven million in federal dollars spent researching the bay over five years, the expedition embarked from Annapolis for the estuary's mouth, 120 miles south. On the way, we stopped nine times to measure water temperature and electrical conductivity, information from which salinity would be determined. From the catamaran research ship carrying Taft and his inquisitive crew, the shore was barely visible through a heavy drizzle. Anchored freighters

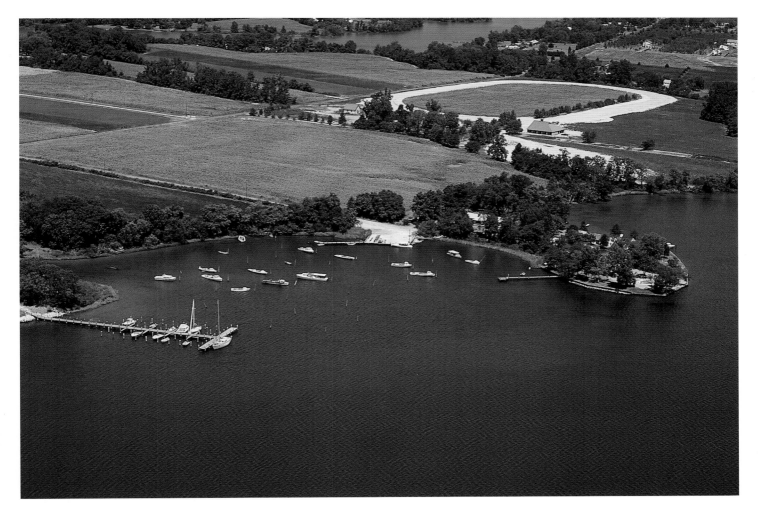

A small marina on Maryland's Upper Eastern Shore

loomed like ghostly silhouettes through the wet haze, their deck lights shining. The first stop was Thump's Point. Next came Chesapeake Beach. Then, Sharp's Island lighthouse, still bearing the name of the vanished isle. Only five or six watermen's workboats were out on this dreary day. At some stops, the crew merely collected a bucket of water for analysis and then moved on.

"It's not a *National Geographic* special or a Jacques Cousteau movie," warned Taft, a serious man in his middle thirties with wire-rimmed glasses and hair parted down the middle. "It becomes dull and routine, not very glamorous." But even though the trip afforded a glimpse of the routine, it was far from dull. Taft became seasick and retreated to his bunk. Almost everyone else was similarly affected by the rocking, bouncing, jarring motions of the wind-and-wave-whipped boat. It wasn't the normal summer storm, violent but short, raking the skies with

lightning, thunder, and heavy rains. Rather, it was a sustained squall with thirty-mile-an-hour winds that stirred and flapped six-foot whitecaps against the bows of the oversized catamaran.

At the height of the storm, the crew lowered the cylindrical measuring meter into the murky depths, while the scientists inside the floating laboratory recorded the results and tried desperately to keep their balance—and their lunch.

As the *Warfield* moved past the mouth of the Patuxent, the skies above were clearing. The rain let up in the afternoon, but not the punishing winds as the ship plowed through the wide Lower Bay. Past Smith Point, at the lower lip of the mouth of the Potomac, we were in Virginia, an unmarked border crossing. Few other boats shared the water, and no land appeared on the horizon. All there was, it seemed, was open sea.

The research vessel arrived at the naval amphibious base at Little Creek, Virginia, shortly after 7 P.M. The next morning, at exactly 0700, as promised in the official "Chesapeake Bay Nutrient Study Cruise Plan," the *Warfield* chugged off to work. For a total of eight grueling days, the *Warfield* would cross and recross the mouth of the bay, following a carefully prescribed route and routine. Its crew would check first for salinity, then, dropping a light meter into the water, for turbidity or cloudiness. The crew's final task was to pump aboard water samples, which would be analyzed for nutrient content.

More than any one sewage plant or any single industrial polluter, it is the nutrients—elements such as nitrogen and phosphorus—that, in overabundance, suck the life-sustaining oxygen from the waters. Washed by rain from farms, shopping centers, and subdivisions into 150 rivers and creeks feeding the bay, the nutrients settle in the sediments on the bottom and then seep into the water. But nobody knew how much and to what effect.

Another key question was how fast the bay flushes the pollution from its system, as water travels back and forth between the Chesapeake and the Atlantic. To find out, some of the same scientists working on the nutrient study had deployed sixty current-measuring devices from the Chester River in the Upper Bay to the area just outside the Chesapeake Bay Bridge-Tunnel, where the estuary meets the ocean. There the meters recorded the flow automatically every thirty minutes. The "stations" where nutrient samples were taken were already marked by buoys, placed there to signal the nearby current meters—the ones that hadn't disappeared. "If the fishermen have a bad day," said Taft, "they'll go to one of our buoys, drag around it, and turn in a meter for a $250 reward. They cost $7,500 each and we're willing to pay to get them back."

The scientists are serious about their work, but not without a sense of humor. While deploying the current meters, they wore "CRIMP" T-shirts—for Chesapeake Research Information Model Program—and on the

CLOCKWISE FROM TOP LEFT
The nearly deserted bay shore at Cape Charles, Virginia, a major automobile ferry port before construction of the Chesapeake Bay Bridge-Tunnel linking the Eastern Shore and Tidewater Virginia

Where the Patapsco River meets the bay lies North Point. At the tip of this peninsula, five thousand invading British soldiers landed during the War of 1812. Fort Howard was established here in 1896 as the chief coastal artillery defense for Baltimore. It now contains a park and a veterans hospital.

A stormy afternoon sky is a regular summer occurrence around the Chesapeake. This ominous cloud looms off Charlestown, Maryland, on the Northeast River, near the head of the bay.

The bay shore at Point Lookout State Park, where the Potomac meets the Chesapeake. The site of a Civil War prison for Confederates, Point Lookout is said to be inhabited by ghosts.

The piers of Oxford, a former waterman's town that has evolved into an upscale recreational and retirement village, on the Tred Avon River

Placid Mobjack Bay, Virginia, was once a bustling watermen's thoroughfare, and prior to that a busy Indian encampment.

way down the bay, they joked about "crimping." Someone suggested serving "crimpcakes" and handing out "crimp statues" at a "crimp award" ceremony.

It was calmer on the second day. About a dozen large foreign freighters anchored offshore, awaiting their turn at the Hampton Roads coal-mining dock as the freighters farther north waited to get into Baltimore. To save time, the *Warfield* did not anchor at each station; despite the calm waters, it tended to drift. At one point, a larger freighter loomed off starboard as she drifted into a shipping lane. The *Warfield* went into reverse, and the crew returned to work. As the day wore on, Charlotte, the cook, sunbathed on the front deck while the radio station from the mainland played, "Won't you let me take you on a sea cruise?" An afternoon haze made the big freighters anchored around the *Warfield* seem to be "floating in the sky," as Jay Taft observed.

While the federal government's bay program proceeded, encompassing as many as forty different contracts at once, other scientists and officials have turned their attention to more immediate indicators of the bay's economic vitality. Each fall since 1939 the University of Maryland has conducted a survey of baby oysters, known as spat. A good "spat set" in any given year can mean a large harvest of mature oysters three or four years later.

The spat counts had fluctuated, but invariably since the freshwater floods of Hurricane Agnes in 1972, the annual oyster spat survey had yielded bad news. Then came the sweltering summer of 1980, which caused crops to die and people to suffer and, incidentally, produced the best class of baby oysters the bay had seen in years. Scientists and watermen surveying the murky bay bottom found spat on bars that had yielded none in years. They attributed the bumper baby crop to the water's high salt content, a byproduct of the dry, hot summer and the lack of fresh water.

The annual survey took eight days to cover nine hundred nautical miles with stops at two hundred selected oyster bars on the bay and its tributaries. I joined the survey on the first and fourth days, covering the lower Potomac and the bay waters off the midshore. The expedition began by 7 A.M. on a cool September morning from Colonial Beach, Virginia, a faded resort town on the Potomac where the river is miles wide. As dawn broke, I drove across the Route 301 bridge from Maryland's Charles County to Virginia's Northern Neck. The early-morning mist was still rising from the river.

While sampling spat, the assemblage of scientists, politicians, public officials, and watermen on board the research vessel *Aquarius* also sampled the crop of mature oysters, finding them plump and tasty at the mouth of the Potomac, on the Eastern Bay, and in Tangier Sound, and not so good in some Eastern Shore tributaries. Along with the oysters, they dredged up a few crabs in the Potomac and an empty sardine can in the Eastern

Bay. But it was spat they were looking for. And from Jones Shore on the Potomac to Bugsby Bar in Eastern Bay, they found it, in abundance—baby oysters from eraser-tip size to one-inch lengths attached to mature oysters or empty shells planted by the state.

The spat strike appeared to reverse a trend. "Year by year, you could see the zeros moving further and further south," said Tony Mazzaccaro, assistant director of the University of Maryland's marine advisory program. But 1980 was different.

"Look at that," said Don Webster, another University of Maryland scientist, pointing to a shell with eight spat at Jones Shore bar. "That's what you like to see. Jesus Christmas! They're all over the damn place. That's what you'd like to see on the whole bay. Your only problem would be marketing, and that's a problem I'd like to tackle."

It got better. One oyster found at the mouth of the Potomac had fifty-one spat. The spat set was not universal; there were none on samples dredged from the Potomac just below the Route 301 bridge. Nor did spat appear near the mouth of the Chester River on the Upper Eastern Shore of the Chesapeake Bay.

The fourth day of the survey dawned bleak and gray on the Eastern Shore. The sixty-five-foot research boat embarked from the Kent Island narrows, sped northward at eighteen knots, retraced its path through the channel, and wound up at Knapp's Narrows by Tilghman Island. Clusters of workboats were anchored above oyster bars known to generations of watermen as Shell Hill, Hollicutsnoose, Helsinki, and Scotland. At Herring Island bar, surveyors found thirty-four spat per bushel, compared to ten the year before. At Ashcraft, they found 114, compared to four. At Hambleton's Hill, 441 spat per bushel appeared on shells planted earlier

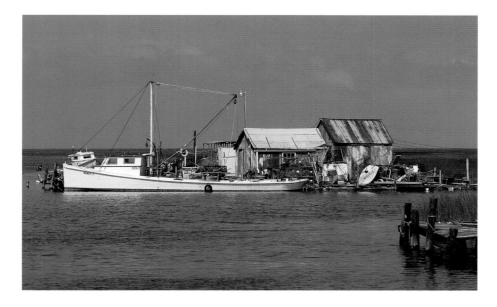

Workboat at dockside in Rhodes Point, Smith Island

in the year. At another locale, a soda bottle was covered with twenty-five baby oysters. The next day, the *Aquarius* worked the Talbot County creeks and the Tred Avon River where, apparently for the first time in recorded oyster history, some 800 spat per bushel were found. On the upper reaches of Broad Creek, the count was 3,000 spat per bushel, and it was even higher way up Harris Creek.

It seemed a miraculous comeback, and the spat surveys of 1981 and 1982 brought more good news. But the bad news arrived soon enough. Starting in 1985, the MSX (for multi-nucleate sphere unknown) and dermoparasites took their toll on the mature crop of oysters. In 1986, for the first time in half a century, the bay yielded less than a million bushels of oysters. The relation of the parasites to the estuary's water quality and pollution was uncertain, but it was clear that the oysters could not long thrive in an oxygen-choked environment. "The Great Shellfish Bay" was what the Indian name *Chesapeake* meant, but the title to which so much history, culture, and literature attached no longer fit.

Stressed is the single word that seems to sum up the scientific view of the estuary in the U.S. Environmental Protection Agency's long-awaited report to Congress in 1982. Large sections above the Bay Bridge were "over-enriched" with nutrients. Since these same areas had suffered the sharpest losses of bay grasses, the agency suggested a correlation. The grasses had failed to return, EPA postulated, because excessive nutrients had spawned organic matter, which shaded the light and robbed the oxygen the plants needed. Toxins from industrial sources were also present in the bay, but their effects were less certain and appeared to be concentrated in a few "hot spots" like Baltimore Harbor and the Elizabeth River, by Norfolk. As for cleansing itself, the bay's ability to flush out all the impurities was not as complete as widely assumed. All this could help explain the decline of certain Chesapeake Bay fisheries. Or could it?

Scientific observers who followed the bay study closely are quick to note its shortcomings. The 1982 EPA report was "technically pretty good but rests on relationships they were unable to establish," said Kevin Sullivan, then director of the Smithsonian's Chesapeake Bay Environmental Center. The environmentalists took it all to mean that, yes, the bay is in bad shape. "Bay is dying, scientists warn," the Chesapeake Bay Foundation began a fundraising appeal, quoting a *Baltimore Sun* headline. "What is most alarming," the foundation said, "is this new research shows the Bay to be in *worse shape* than originally believed. It is now up to us to take immediate action to stop this decline of the Bay *before it's too late.*"

"Dying or Evolving, the Chesapeake Bay Shows Signs of Stress," headlined the *Wall Street Journal.* "The bay isn't going to die tomorrow," says William C. Baker, executive director of the Chesapeake Bay

Foundation and signer of the urgently worded fundraising appeal. "But the bay is at a critical crossroads."

There are more than enough villains to blame. Industries have to clean up their act, as do farmers who use chemicals too close to the creeks, developers who build too close to the shore, and municipalities that build polluting sewage treatment plants. It will cost billions to restore the bay to its former glory, if indeed it can be done at all, and it cannot be done without a regional and even a federal effort. President Reagan paid a symbolic visit to Tilghman Island. Successive EPA administrators pledged their support. The EPA administrator, the governors of Maryland, Virginia, and Pennsylvania, and the mayor of the District of Columbia signed a historic Chesapeake Bay Agreement in December 1987, setting forth goals and timetables.

Conferences on bay clean-up topics are proliferating. At one such event, the bad news, from another study commissioned by the EPA, is that toxic contamination has been found not just in a few "hot spots" but throughout the bay in the quarter-inch-thick surface "microlayer" where fish eggs and larvae—on which creatures such as crabs feed—are found. More than half these organisms, the study says, may not survive microlayer pollution in this "vital zone of incubation for the early life stages of numerous fish and shellfish species." Just when it looked as though officials were beginning to bring the bay's problems under control, comes this new, unexpected threat, and nobody even knows where from. The chief candidates are the bay bottom, where chemicals have settled, and the air, polluted by car exhausts or smokestacks from nearby or distant sources.

"There is an urgent need," the report says, "for a detailed and comprehensive study of this problem." The painful paradox emerging is succinctly summed up by Will Baker, of the Chesapeake Bay Foundation. Due to nutrient clean-up efforts, notably removal of phosphorus from the effluent of the District of Columbia's Blue Plains treatment plant, aquatic grasses have returned to the Potomac, triggering a resurgence of fish from the Tidal Basin in Washington downriver for twenty miles. There are now twenty-seven professional bass fishing guides working this stretch of the river. Will there be "more fish but a toxic shadow?" Baker asks, adding: "It would be the height of irony if twenty years from now there was good water clarity and the species were back, but you couldn't eat them because they were above EPA levels for heavy metals, chromium, and other chemicals."

The "good" news, Baker observes from his travels around the Chesapeake Bay region, is that "from schoolchildren to members of the business community, everyone seemed to say, 'It's finally gone too far.' And people began to ask a simple yet pertinent question: 'When will pollution no longer be tolerated?'"

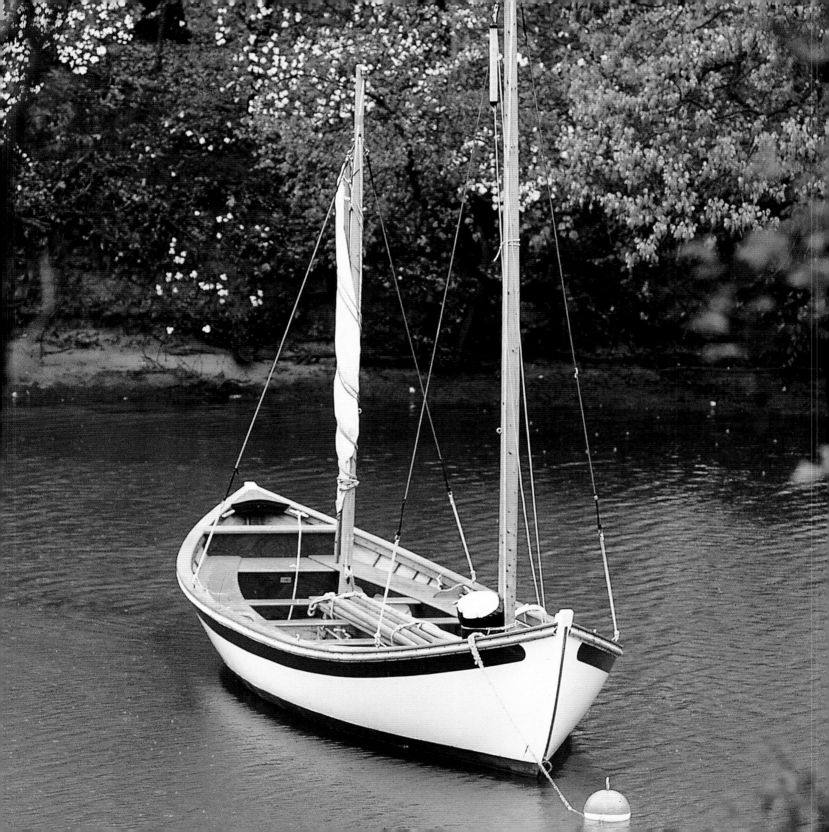

Epilogue

As the land goes, so goes the water.

The point is made time and again by public officials, by environmentalists, by scientists, and by students of the bay. How the land is used affects the estuary. It's not just the visual pollution of a cluttered shoreline. It's the less obvious effects. Chemicals wash off farms tilled at water's edge into the tributaries that feed the bay itself. Anything that strips away trees and ground cover, which act as natural filters—subdivisions, shopping centers, waterfront development—contributes to the runoff of deadly nutrients into the water.

The problem is unbridled growth.

At yet another conference spawned by the recent concern over the bay, the Chesapeake Executive Council's Year 2020 Panel unveiled its forecast and prescription for the future. "Today, unmanaged new growth has the potential to erase any progress made in Bay improvements," the authors warn. "The Bay and rivers of the region have acted as powerful magnets to growth. . . . Between the mid-1950s and the late 1970s, more than 2,800 acres of wetlands were lost annually . . . we need to do things better . . ."

More than other states, Maryland is trying, but with some surprising and unintended results. With much fanfare, in 1984 the state enacted the Chesapeake Bay Critical Areas Act. The law set some limits on development within 1,000 feet of the bay and its tidal tributaries, and created a commission to attempt to enforce them. Maryland counties and municipalities in the Chesapeake Bay area were to prepare plans consistent with the state goals—or one would be imposed on them by the bureaucrats in Annapolis.

Serious talk of such legislation alone was enough to trigger a land rush among developers, who filed subdivision plans before the December 1, 1985, deadline. The market value of properties that had been "grandfathered" rose immediately. In fact, with growth targeted under the plan to occur in a few limited areas, such as Solomons Island, development pressures and prices have skyrocketed. Studies of transactions in Calvert County on the Western Shore and of Talbot and Dorchester on the Eastern Shore show that a "critical areas premium" has pushed up prices on a modest ten-year-old waterfront home by as much as $11,000. The critical areas law, a broker tells me, "has eliminated a fair number of people from the market. It used to be a family with an

A sailboat moored on the Wye River in Queen Anne's County, Maryland

income of $65,000 to $70,000 could buy a decent [waterfront] home. Now, they're not even in the running. There are hardly any waterfront homes under $200,000." One house his firm sold in 1982 for $100,000 was on the market in August 1987 for $200,000. "It's just a small, three-bedroom rambler, twenty-five years old, bulkheaded with a pier," he said, but with a water depth too shallow for most boats. It seems the best-laid plans to "Save the Bay" are merely accelerating its gentrification. If the Chesapeake shores are being preserved, one can legitimately ask, "for whom?"

Developers of new homes are also quick to capitalize on the government-imposed limits on growth. At Chesapeake Beach on Maryland's Western Shore, advertisements for the Windward Key luxury town houses urge buyers to "answer the call before it's too late." Who, with the wherewithal, could resist this plea:

> Windward Key. One Of Your Last Chances to Answer The Call Of The Wild. From Your Own Front Door. Make the Chesapeake Bay your front yard and you'll have some wild neighbors. Like flocks of mallards. Diamondback terrapins. And majestic whistling swans that return every year to winter. But at Windward Key, you'll enjoy some very civilized amenities, as well. Like a private marina, tennis courts, pool, fireplaces and garages that make your three story, three bedroom home on the bay even more special. However, because the shoreline is protected against further development, this may be your last chance to own a home on the bay. So answer the call before it's too late.

Further, if there is a loophole to be found, developers find it: On the East Fork of Langford Creek in Kent County on the upper Eastern Shore, one developer has acquired a 515-acre tract in which the 1,000-foot "critical area" has been enlarged. The law allows one house for every twenty acres, but the houses can go anywhere on the property, even on the waterfront. And because the previous owner had expanded his "critical area" to include adjacent land far from the creek, the developer can sell twenty-eight lots along a short stretch of the waterway—about three times as many as otherwise allowed.

Such apparent loopholes confound the neighbors. "We all [backed] the critical areas act, thinking it was intended to preserve a 1,000-foot buffer along the waterfront," says Chris Havemeyer, who lives across the creek from the planned development. "It would be nice to think that future generations would be able to go up the creek without there being wall-to-wall docks." The quality of life in rural Kent County—forty-five minutes northeast of the Bay Bridge and an hour's drive from Annapolis—is "the underlying reason why many have chosen to live here; it's a little oasis," says Jonathan Jones, a yacht broker who can see bulldozers at work across the creek from his family's land.

A dapper Englishman who lives on a 174-acre waterfront farm in Queen Anne's County, the developer describes himself as an environmentalist. Indeed, he has conveyed the development rights on his own property to the Maryland Environmentalist Trust. But six neighbors across Langford Creek from Marshall's development tract were not impressed. They went to court to block his plans, and Marshall offered to develop eighteen lots instead of twenty-eight. His opponents persisted; Marshall threatened. Should they prevail, he wrote the angry neighbors, economics would force him to develop as many as 150 lots over the entire tract. "Many will be on the forward slopes in full view," he wrote. "The environment will be largely destroyed. The farmland will go and the large lake, instead of being a permanent refuge for wildfowl, will be the center of a highly developed community."

Well, maybe he is right, some of the residents are saying to themselves, increasingly ambivalent about their own small battle to save the bay. Their lawsuit ran aground on a procedural matter and, taking Marshall's threat to heart, in April of 1989, they ended the litigation. In the complex Chesapeake ecosystem, where nature and humanity are often at odds, it sometimes seems that nothing at all is simple.

Despite the complexities, one thing is clear. "The Bay is the single most important, most valuable and significant aspect of the public features of Maryland," says Judge John North II, an Eastern Shoreman appointed to chair the state's Chesapeake Bay Critical Areas Commission. "It is the essence and core of the Maryland we know and love. Its preservation and restoration are most, most important." But whether the will to "Save the Bay" has come too late to matter, only time will tell.

Painted turtles (*Chrysemys picta*),
Blackwater National Wildlife Refuge

OVERLEAF, LEFT
An immature tricolored heron (*Egretta tricolor*) at Blackwater National Wildlife Refuge

OVERLEAF, RIGHT
Great white egret (*Casmerodius albus*),
Eastern Shore

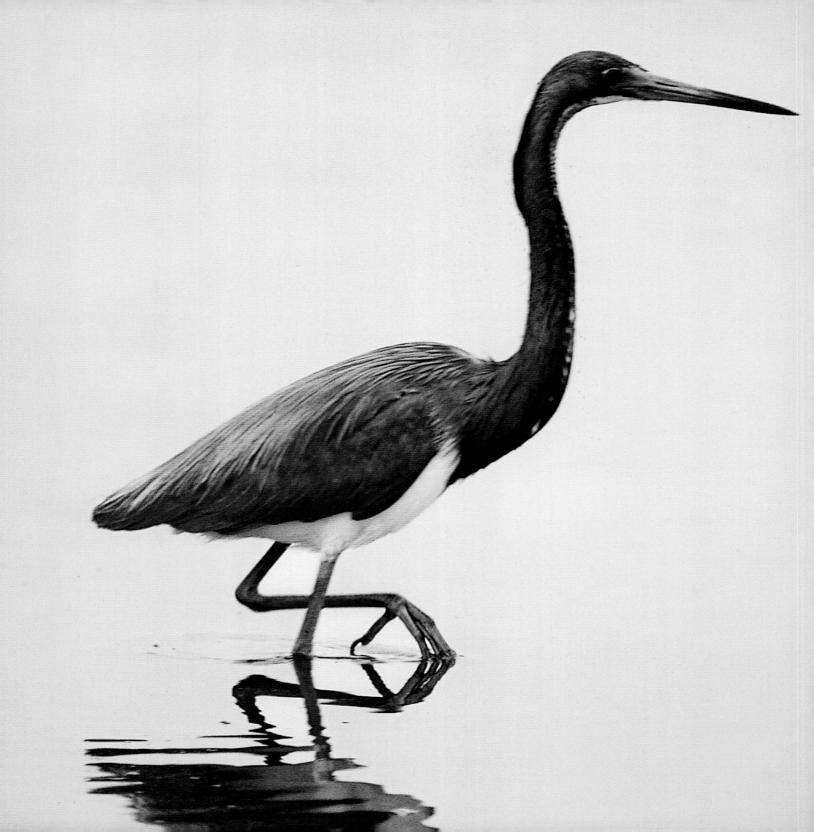

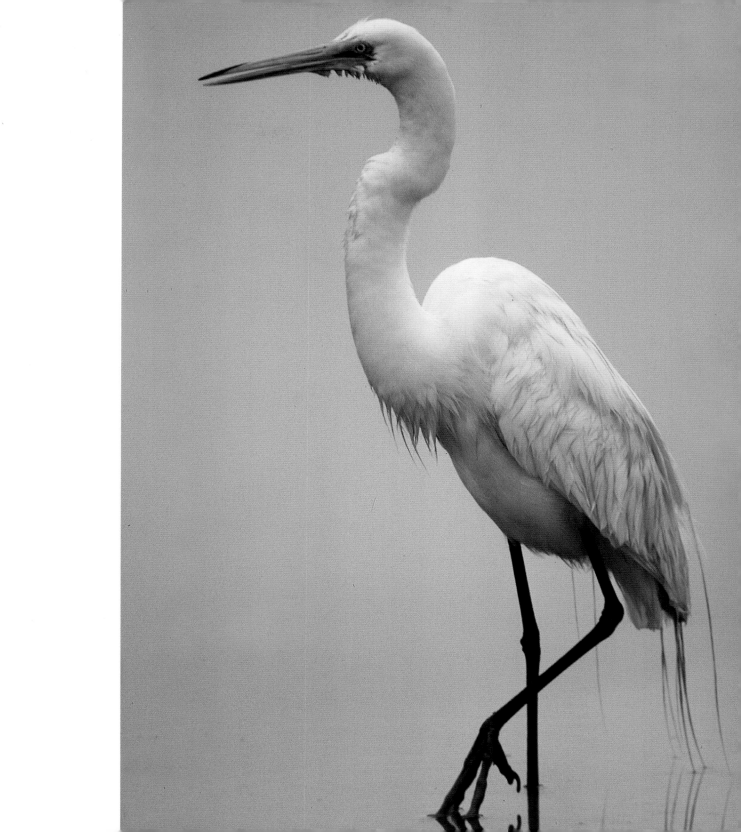

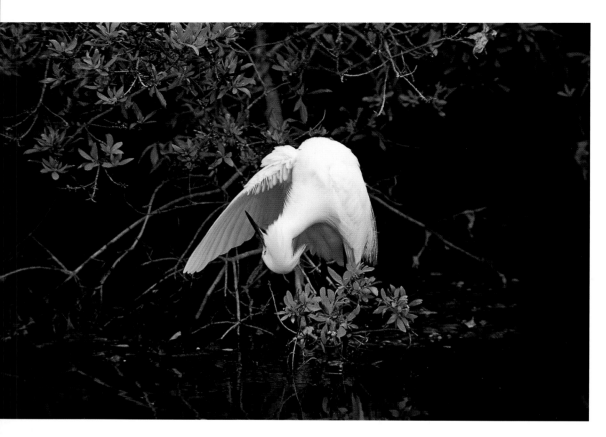

A snowy egret (*Egretta thula*) preening on the
Eastern Shore

It's feeding time for this great white egret
(*Casmerodius albus*) on the Eastern Shore

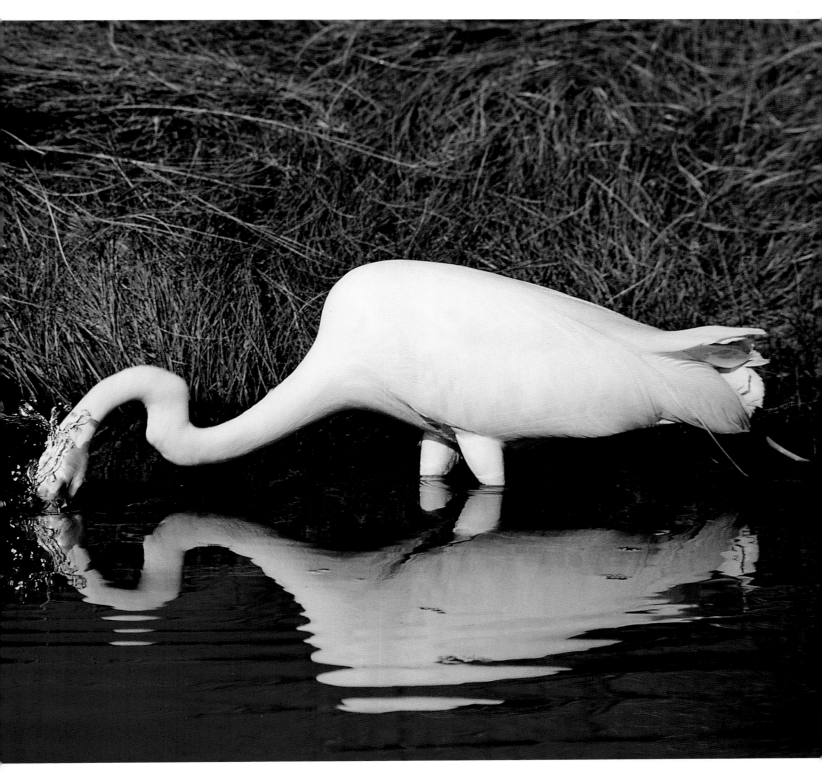

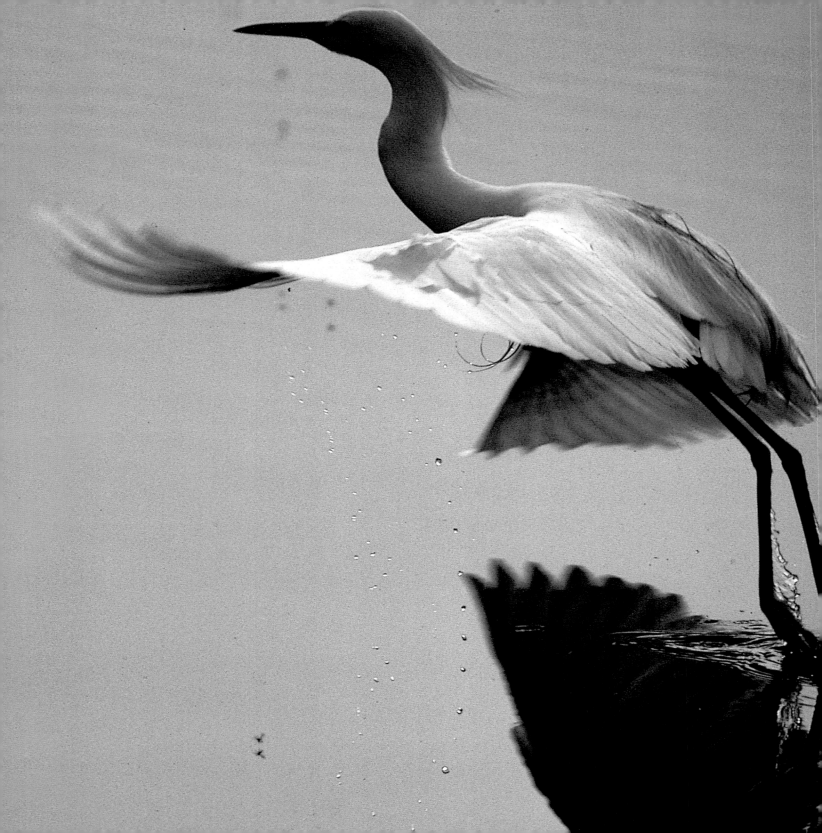

A snowy egret (*Egretta thula*)
ascending from the Blackwater
National Wildlife Refuge

OVERLEAF
Canada geese (*Branta canadensis*),
autumn, Dorchester County, Maryland

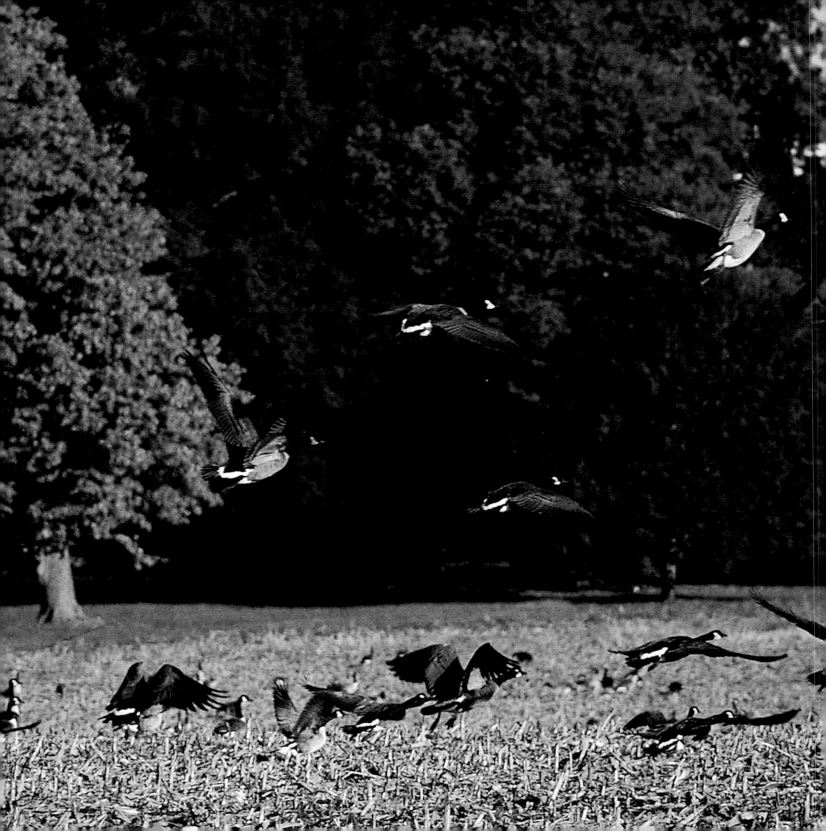

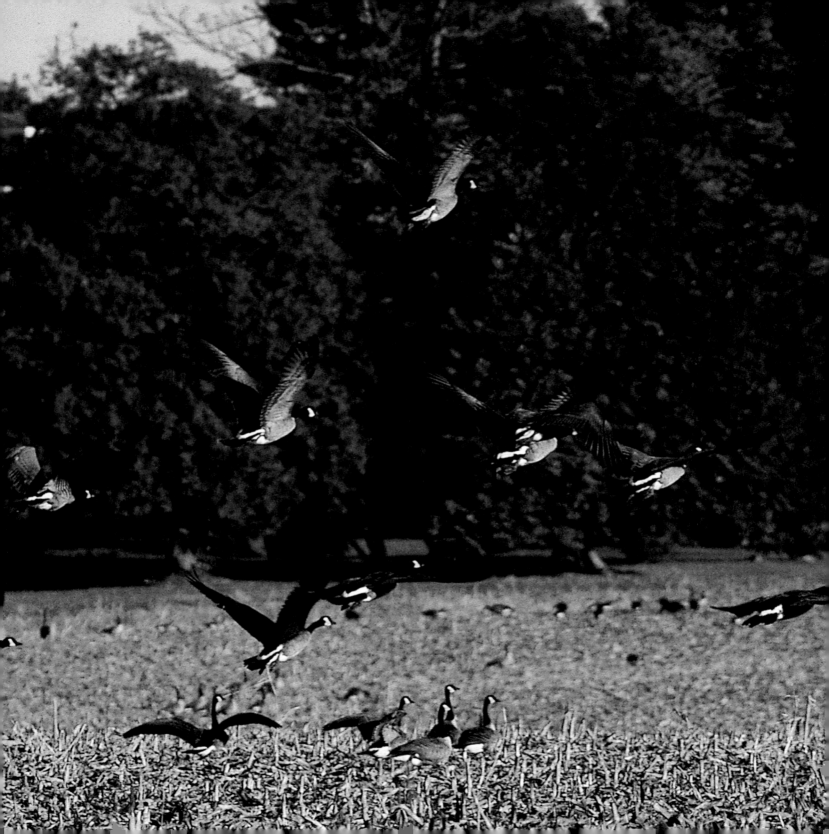

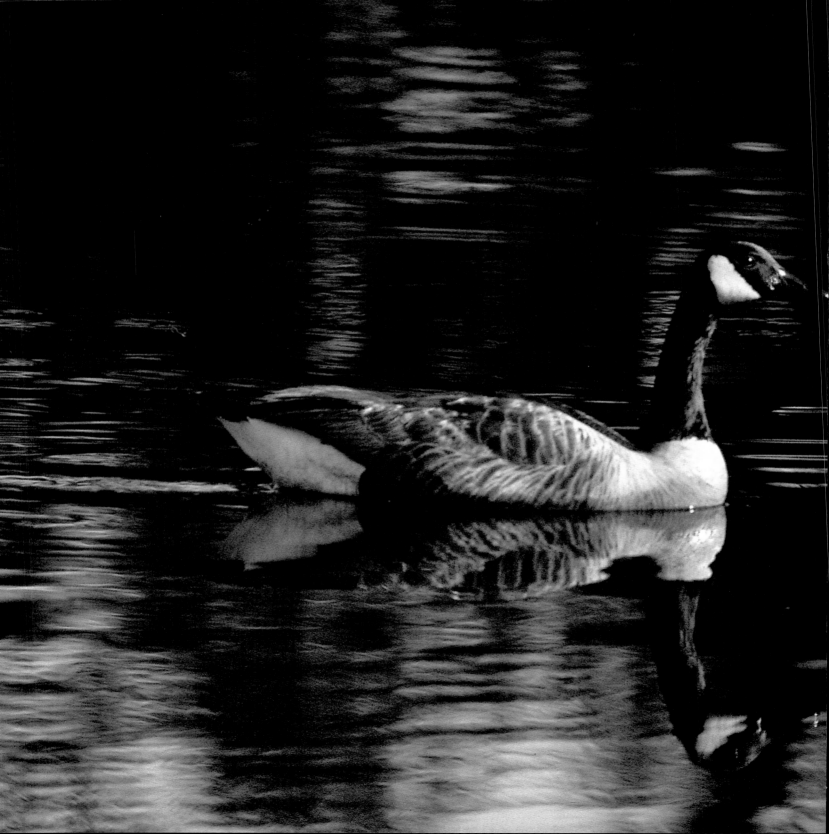

A Canada goose (*Branta canadensis*)
on the Eastern Shore of the
Chesapeake Bay

Black-crowned night heron (*Nycticorax
nycticorax*), a rare bird to see in daylight

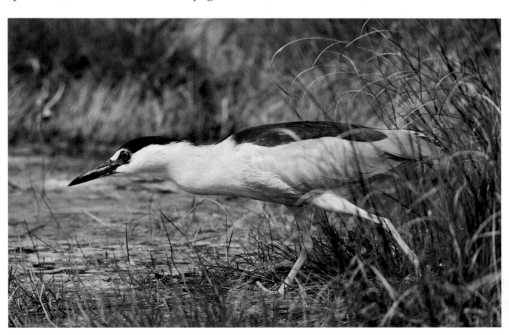

Marsh at Eastern Neck National Wildlife Refuge

Blue heron (*Ardea herodias*), Dorchester
County, Maryland

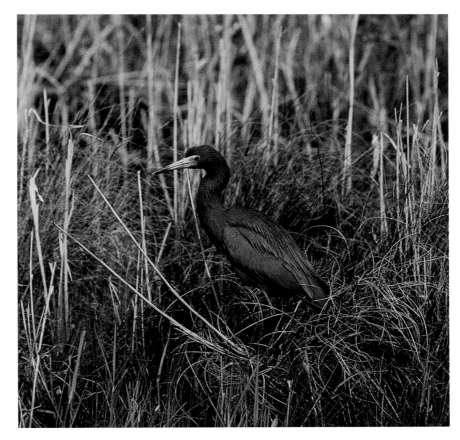

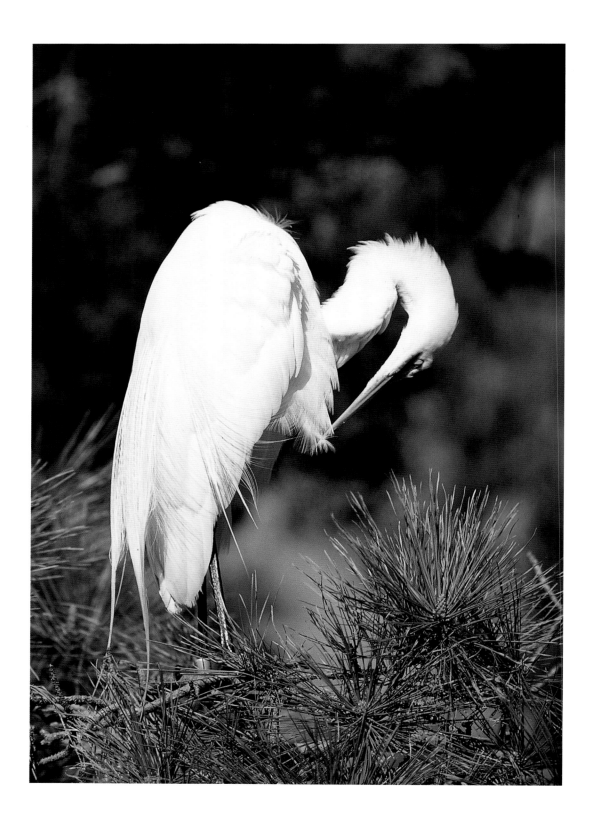

Suggestions for Further Reading

For more about the early exploration and settlement of Chesapeake Bay, the best sources are the primary sources: John Smith's *Jamestown Voyages under the First Charter, 1606–9,* edited by Philip L. Barbour (Cambridge: Cambridge University Press, 1969) and Father André White's *A Relation of Maryland* (1635; reprint ed., Ann Arbor, Mich.: Readex Microprint, 1966). Frances d'A. Collings, a Britisher who has come to know the bay, writes about Smith's explorations from a late twentieth-century viewpoint in an interesting booklet, *The Discovery of the Chesapeake Bay,* published by the Chesapeake Bay Maritime Museum in 1988. Virginia's 350th Anniversary Celebration Corporation published a series of pamphlets in 1957, the "Jamestown Booklets," which are still available from the University Press of Virginia, tracing the early years of the Virginia colony. *The Chesapeake in the Seventeenth Century* (New York: W. W. Norton & Co., 1979) is a useful anthology about the period and place. Robert Brugger gives an account of William Claiborne and the beginnings of Maryland in his monumental state history, *Maryland: A Middle Temperament* (Baltimore: The Johns Hopkins University Press, 1988).

A good sense of the James River, from Jamestown and its plantation shores through the Piedmont and beyond, can be gotten from Ann Woodlief's *In River Time: The Way of the James* (Chapel Hill, N.C.: Algonquin Books of Chapel Hill, 1985). The plantations have each published their own guidebooks, some better than others. Payne Tyler, related by marriage to descendants of our ninth president, has written *The James River Plantations Cookbook* (Williamsburg: Williamsburg Publishing Co., 1980), which runs the river's gamut of great houses—with recipes added for good measure.

Books about the watermen abound. *Beautiful Swimmers,* a Pulitzer Prize-winning volume by the late William Warner (New York: Penguin Books, 1977), ranks at the top. *The Watermen of the Chesapeake Bay* (Centreville, Md.: Tidewater Publishers, 1987) tells their story in the watermen's own words accompanied by the color images of the photographer John Hurt Whitehead III. John R. Wennersten's *The Oyster Wars of the Chesapeake Bay* (Centreville, Md.: Tidewater Publishers, 1981) is a rich account of that little-known chapter in American history, as bawdy, colorful, and violent as any frontier range war. *Working the Water* (Charlottesville: The Calvert Marine Museum and The University Press of Virginia, 1988) is a readable illustrated book about the culture of the water on the Patuxent River, a major Chesapeake tributary. Pat Vojtech's *Chesapeake Bay Skipjacks* (Centreville, Md.: Tidewater Publishers, 1993) offers a comprehensive and illustrated look at the fabled dredge boats. My own book, *Maryland Lost and Found: People and Places from Chesapeake to Appalachia* (Baltimore: The Johns Hopkins University Press, 1986; updated paperback edition entitled *Maryland Lost and Found . . . Again,* Centreville, Md.: Tidewater Publishers, 2003), contains chapters about the watermen of Smith Island, the rapidly eroding bay islands, and Talbot County, Maryland, the Chesapeake's "Land of the Gentry."

Tom Horton, a journalist who is also an unabashed environmentalist, blends fine writing and the sensitivity of his Eastern Shore upbringing in *Bay Country: Reflections on the Chesapeake* (Baltimore: The Johns Hopkins University Press, 1988). Horton has also published a poignant memoir about Smith Island, *An Island Out of Time* (New York: W.W. Norton, 1996). William B. Cronin's *The Disappearing Islands of the Chesapeake* (Baltimore: The Johns Hopkins University Press, 2001) offers a contemporary and historical account of an island culture all but swept away by the relentless waters of the bay. A bird's-eye view of Chesapeake country can be found in *Chesapeake: The Aerial Photography of Cameron Davidson* (Charlottesville, Va.: University of Virginia Press, 2011), with text by my former *Washington Post* colleague David Fahrenthold. For a historical overview of the policies and politics affecting the bay, see *Chesapeake Waters: Pollution, Public Health and Public Opinion, 1607–1972* by John Capper, Garrett Power, and Frank R. Shivers, Jr. (Centreville, Md.: Tidewater Publishers, 1983).

—E.L.M., 2014

Great white egret (*Casmerodius albus*), Eastern Shore, Virginia

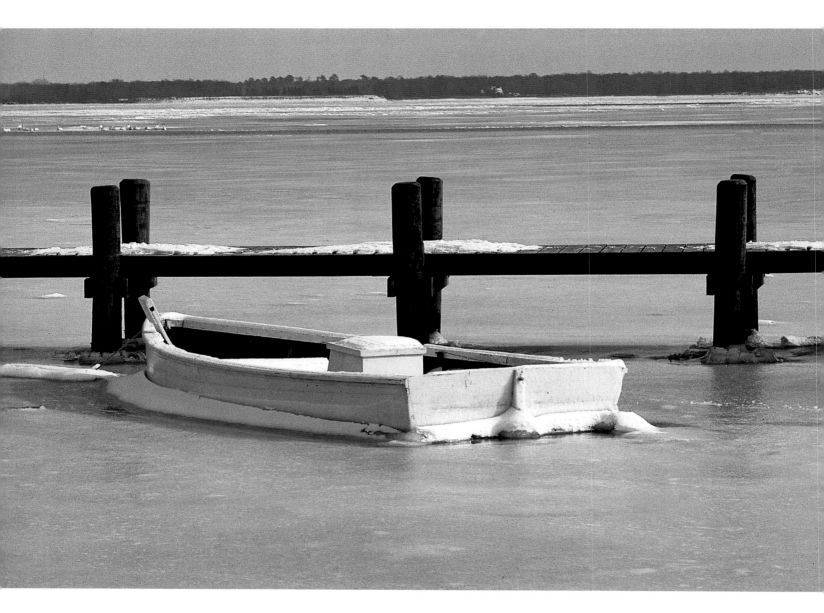

A boat in snow at the Eastern Neck
National Wildlife Refuge

Acknowledgments

The Chesapeake Bay sounds a chord of happiness and sorrow in me. My most exhilarating moments come from seeing a natural order manifest itself. When I am on the water in a sailboat, tasting the air and spray, feeling the waves of humidity rising off the water; or, if I am in the Blackwater marsh, feeling the sting of the mosquitoes, while watching a great blue heron feeding; or, if I am in Mobjack Bay, being part of the serenity, trying to conjure up the past, when the bay was full of Indians and, later, watermen, the awe of a natural order that preceded man raises a tide of emotion in me and a renewal of faith.

I record the scene with the two Leicas that hang from my neck. At the moment of snapping the shutter, I feel like an intruder. I rationalize that if I can give another person a closer look at nature, maybe he will feel as I do and allow room in his life for the natural world. If I have done this, then I have properly told *my* story. So, in this book, if I leave untold the other story, of the debris and detritus of human "progress," there are plenty of photojournalists and scientists to pick up this tale. My work celebrates nature. My role is to let you see its beauty close up, and to show you what we have the power to destroy, as well as contribute.

Any such work goes beyond a single contributor. This book would not have been possible without the encouragement of my wonderful wife, Joan, who traveled the whole mile with me, and my good friend Leo Lamer. As for Gene Meyer, I applaud his sensitive text and enlightening stories.

There are so many others to acknowledge: George Price, the oyster shucker; Charles Abbott, Wade Murphy, Art Daniels, Stephen Horner, watermen; Hill Carter and the many plantation, museum, and restoration personnel who gave of their time and knowledge so unstintingly. Thanks also to Amanda Adams, Ann Shields, Alan Axelrod, and Nai Chang of Abbeville Press, who believed in the project.

And, not least, thanks to the Chesapeake Bay—for being.

—Lucian Niemeyer

In writing this book, I owe a great deal to many people. Prominent among them are the residents of Chesapeake country, who graciously let me into their homes and into their lives. Also due thanks are my editors at *The Washington Post*, who have allowed me to follow the water in search of stories. I am indebted, too, to Lucian Niemeyer. As he expanded my horizons, I appreciated his willingness to focus his camera in new and different directions. Finally, I wish to thank my wife, Sandra Pearlman, for her insights, suggestions, and support.

—Eugene L. Meyer

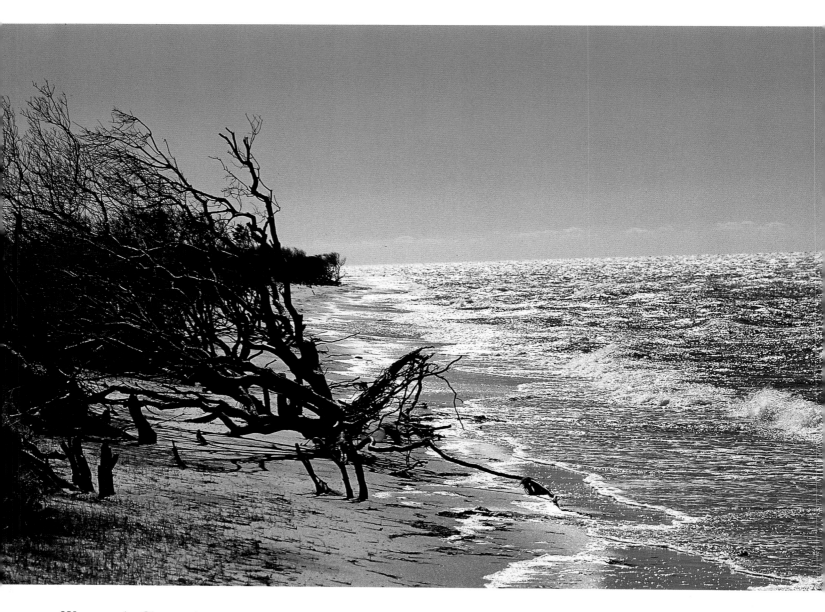

Waves on the Chesapeake at
Craddockville, Virginia

Index

Page numbers in *italics* refer to illustrations.

Abbot, Allen, *120*

Abbott, Charles, Jr., 10, 115–27, *120*

Abbott, Charles, Sr., 115, 120, 123

Abbott, Charles, P., 3d, 115

Abbott, C.J., 10

Abbott, Jeanne, 10, 115–21

Abbott, Miriam, *120*

Abbott, Raymond, 123, *125*

aerial views: of Annapolis, *55, 150–51*; of Maryland's Eastern Shore, *182–85*; of Oxford, *143*

Africa (ship), 53

agriculture, pollution caused by, 203

Alexandria, Va., 155

American Revolution, 17, *17*, 62, 66, 68, *142*

Annapolis, Md., *150–51*, 155, 162, 196; capital moved to, 52, 54; gentrification of, 14, 152; U.S. Naval Academy at, *55, 151, 152*; watermen and workboats at, 151–52

Aquarius (research vessel), 200–2

Arby's General Store, Wenona, Md., 102–7

Ark (ship), 50, 53, 70

Arlington (mansion), Va., 75

Armes, Ethel, 75

Army Corps of Engineers, 7, 172

Ashcraft bar, 201

Atlantic Ocean, flow of water between bay and, 199, 202

Back River, 6

Bacon, Nathaniel, 45

Baker, William C., 13, 202–3

Baltimore, Cecilius Calvert, 2nd Lord, 50, 52–53, 54, 56, 62–63, *92*

Baltimore, George Calvert, 1st Lord, 49–50

Baltimore, Md., 7, 18, 19, 61, 155, 158; as capital of Chesapeake country, 19; first oyster packing plant in, 188;

gentrification of, 147; Inner Harbor development in, 147, *149*

Baltimore Beltway, 164

Baltimore Harbor, *148*, 202

Baltimore Sun (newspaper), 202

Barber, Thomas, 70

Barnard, Henry, 70

Barney, Joshua, 17

barns, *65, 78–79, 192–93*

bass, 25, 203; striped (rockfish), 10, 164–66, 169, 196

Beauvue, near Leonardtown, Md., *65*

Berkeley, William, 45

Big Thoroughfare, Smith Island, Md., *108, 129, 132*

Bill of Rights, *90*

black-crowned night heron (*Nycticorax nycticorax*), 217

Blackwalnut Cove, *18*

Blackwater National Wildlife Refuge, Dorchester County, Md., 8–10, *30, 59, 189–91, 207, 208, 212–13*

Bloodsworth Island, Md., 10, 99–102

blue crab (*Callinectes sapidus*), 10, *97, 98*

bluefish, 25

boats, *14, 20, 32–34, 109, 131, 156, 174–75, 182–83, 222*; crab-scraping, *106, 108, 132*; sailboats, *21, 136–39, 152, 204*; tugboats, *154, 177. See also* skipjacks; workboats

Bowles, James, 63, 68

Bowles, Rebecca Addison, 68

Boyer, Joanne, *76*

Brandon Plantation, *94–95*

bridges: Chesapeake Bay, 159, *160–61*, 164, 196; Francis Scott Key, 164; Governor Thomas Johnson, 176, 178

Briggs, Lane, *130*

Briscoe, Emeline Dallam, 70

Briscoe, James, 80

Briscoe, Walter Hanson Stone, 70

Broad Creek, 202

buoy markers, *128*

butterfly, tiger swallowtail (*Papilio glancus*), *61*

Callahan, Dennis M., 152

Callum, Agnes Kane, 82

Calvary United Methodist Church, Rhodes Point, Md., *100–1*

Calvert, Cecilius, 2nd Lord Baltimore, 50, 52–53, 54, 56, 62–63, *92*

Calvert, Davis, 57

Calvert, George, 1st Lord Baltimore, 49–50

Calvert, Leonard, 50–51, *51*, 53, 54, 56, 63, 70

Calvert County, Md., 173, *180*, 205

Calvert Marine Museum, Solomons, Md., 173, *174, 175, 176*

Cambridge, Md., *126*, 127, *144*, 155

Cambridge Landing town houses, Cambridge, Md., 127

Canada geese (*Branta canadensis*), 28, *214–17*

Cannon, Robert H., Company, Cambridge, Md., 127

canoes, racing, *121*

Cape Charles, Va., *198*

Cape Henry lighthouse, Va., *37*

Carew, Jackie, 107, 108

Carter, Alice, 81

Carter, Anne Hill, 66, 68

Carter, Charles, 66, 70

Carter, Charles Hill, Jr. ("Hill"), 14, 81–82, *82, 83*

Carter, Charles Hill, Sr., 81

Carter, Charles Hill, 3d, 14

Carter, Elizabeth Hill, 66

Carter, Helle, *82*

Carter, Hill, 70, 74

Carter, John, 66

Carter, Louise, 74

Carter, Robert ("King"), 66
Carter, Robert Hill, 70
Carter, Robert Randolph, 81
Carver, Barbara, 164
Cat's Paw Chandlery, Rock Hall, Md., 173
Cephus, Theodore, 123
Charles, Prince of Wales, 57
Charles I, King of England, 49, 53, 62
Charles City County, Va., 83, 91
Charlestown, Md., 198
cherry blossoms, 146, 147
Chesapeake, origin of word, 17
Chesapeake and Delaware Canal (C & D Canal), 177
Chesapeake Bay: flushing abilities of, 199, 202; formation of, 17; nutrient content of, 199, 202, 203; pollution of, 166, 190, 196, 199, 202, 203, 205; rivers draining into, 17, 19; scientific research on, 196–200, 202; search for inland sea to Orient from, 18, 37, 41; storms on, 17, 197–99, 198; width and depth of, 17
Chesapeake Bay Agreement (1987), 203
Chesapeake Bay blue crab (Callinectes sapidus), 97, 98
Chesapeake Bay Bridge, 15, 159, 160–61, 164, 196
Chesapeake Bay Critical Areas Act (1984), 205–7
Chesapeake Bay Critical Areas Commission, 207
Chesapeake Bay Foundation, 13, 153, 202–3
Chesapeake Bay Maritime Museum, St. Michaels, Md., 122, 145
Chesapeake Beach, Md.: early history of, 158–59; gentrification of, 141, 158–64, 206
Chesapeake Beach Railway, 158–59
Chesapeake City, Md., 177
Chesapeake country: changes in, 25–30, 152–55, 158–78, 187–203; discovery and settlement of, 18–19, 37–57; historic events in, 17–18; unbridled growth in, 205–7; unique culture and identity of, 19, 24. See also specific sites and topics

Chesapeake Executive Council's Year 2020 Panel, 205
Chester River, 162, 201
Chestertown, Md., 155, 162, 163, 172
Chickahominy River, 40
"chicken neckers," 97
Choptank River, 96, 114, 118–19, 121–26, 124, 125, 143, 144, 186
Christopher Wren Building, Williamsburg, Va., 84
Churches: Calvary United Methodist (Rhodes Point, Md.), 100–1; St. Francis Xavier Roman Catholic (formerly Old Bohemia; near Georgetown, Md.), 44; Trinity Protestant (Dorchester County, Md.), 53; Trinity Protestant Episcopal (St. Mary's City, Md.), 54; United Methodist (Ewell, Md.), 102; Westover, (Charles City County, Va.), 91
Civil War, American, 17, 62, 188, 198; plantations and, 70–74, 75–77
Civil War, English, 53
Claiborne, William, 49, 50, 51, 53–55, 56, 57, 63
Claiborne, Md., 15, 49, 50
Claiborne Clarion, 15
clams, clamming, 166, 190, 196
Clarence Crockett, 110–13, 115
Clayton's Seafood House, Cambridge, Md., 144
climate change, 7, 8, 13–14
Cole, Roscoe, house, Colonial Williamsburg, Va., 46
College of William and Mary, Williamsburg, Va., 84
Colonial Dames of America, 56
Colonial Williamsburg, Va., 45–48, 60; Governor's Palace Gardens at, 45; replica of colonial capital at, 45; Roscoe Cole house at, 46
Concord Point, Md., Havre de Grace lighthouse at, 181
condominiums, 99, 145, 153–55, 169, 176, 187
Congress, U.S., 202
Conowingo Dam, 190
Constitution, U.S., 68, 90

Continental Congress, 68
Cornwallis, Charles, 1st Marquis, 17
Cornwallis, Thomas, 63
Courthouse Square, Chestertown, Md., 163
Cove Point lighthouse, Calvert County, Md., 180
crab pots, 12, 97, 105, 107, 108, 110, 128
crabs, crabbing, 96, 97, 105–10, 105–11, 128, 132, 190, 203; Chesapeake Bay blue (Callinectes sapidus), 10, 97, 98; cull laws and, 10, 99; methods of, 97, 107–8; soft-shell ("peelers"), 25, 106, 107, 108, 109, 110
crab-scraping boats, 106, 108, 132
crab shacks, 25, 99, 108, 109
crab-shedding floats, 106
Craddockville, Va., 224
Cramer, Patty, 164
Crisfield, Md., 11–13, 112–13, 134–35, 158
Crocheron, Md., 34
Custis, Mary, 75

Dallam, Emeline, 70
Daniels, Art, 10
Daniels, Joe, 99
Davis' (restaurant), Annapolis, Md., 152
day lilies, 60
Deal Island, Md., 10, 12, 121; accent of inhabitants, 102; annual skipjack race and festival on, 115–21, 116–17; history of, 99; watermen of, 99–121
Declaration of Independence, 62, 66
deer, white-tailed (Odocoileus virginianus), 29
development: attempt at curtailment of, 205–7; pollution caused by, 203. See also gentrification
dialects, of watermen, 13, 99
Discovery (ship), 37
Donovan, Gerald, 162–64
Dorchester County, Md., 8, 22–23, 28, 30, 34, 53, 59, 189, 205, 214–15, 219
Douglass, Frederick, 14
Dove (ship), 50, 51, 52, 53, 56
dovecote, Shirley Plantation, Va., 67
Drum Point lighthouse, Solomons, Md., 176

Eastern Neck National Wildlife Refuge, Kent County, Md., *frontispiece, 134, 192, 218–19,* 222

Easton, Talbot County, Md., 14

Eastport, Annapolis, Md., 152

E. C. Pruitt (workboat), *130*

Edwards, Bill, 163, 164

eel grass, *190*

eels, 25, *98, 190*

egrets: great white (*Casmerodius albus*), *frontispiece, 31, 209–11, 220*; snowy (*Egretta thula*), *59,* 210, *212–13*

Elizabeth River, 202

Elk Neck National Wildlife Refuge, *58, 189*

Elk Neck State Park, Md., *29*

English Civil War, 53

Environmental Protection Agency, U.S. (EPA), 202, 203

Ewell, Md., *42, 100, 102, 110, 129, 132, 133*; gentrification of, 13, 153, *153*

Farthing's Ordinary, St. Mary's City, Md., 56, *57, 64*

festivals: in Crisfield, *113*; St. Mary's County, 187, *187*; skipjack (Deal Island), 115–21, *116–17*

fishing, 25, 190, 203; for rockfish, 164–66, 169; from Solomons bulkhead, 177–78. *See also* crabs, crabbing; oysters, oystering

Fithian, Ron, 166, 190

Flowerdew Hundred Plantation, Va., *43*

Folke, Samuel Baker, 75

Ford, Ellen, 162

Fort Howard, North Point, Md., *198*

Fort McHenry, Baltimore, Md., 17, *148*

Fort Plantation, Surry County, Va., *40*

Francis Scott Key Bridge, 164

Fulton Fish Market, New York City, N.Y., 109–10

Galesville, Md., 152–53, 158

gardens: at Colonial Williamsburg, *45*; at Mount Harmon, *93*

geese: Canada (*Branta canadensis*), 28, *214–17*; snow (*Chen caerulescens*), *22–23, 26–27*

Generall Historie of Virginia, New England and the Summer Isles (Smith), 41–42, 43

general stores: Arby's (Wenona, Md.), 102–7; Hopkins & Brothers (Onancock, Va.), *155*; Ruke's (Ewell, Md.), *133*

gentrification, 13–14, 99, 102, 127, 141, 152–55, 158–78, 187; of Annapolis, 152; attempts at curtailment of, 205–7; of Baltimore, 147; of Chesapeake Beach, 141, 158–64, 206; of Rock Hall, 141, 164–73; of Smith Island, 13, 153, *153*; of Solomons, 141, 173–78

Godiah Spray Plantation, St. Mary's City, Md., *65*

Godspeed (ship), 37

Gott, W. Alan ("Buck"), 159

Governor's Palace Gardens, Colonial Williamsburg, Va., *45*

Governor Thomas Johnson Bridge, 176, 178

Grandview, Va., *24, 33*

grasses, 9, 108, *134,* 190, *191, 192,* 202, 203; eel, *190*

Grave, Caswell, 191

graveyards, *100, 102*

great blue heron (*Ardea herodias*), *140, 212–13,* 219

great white egret (*Casmerodius albus*), *frontispiece, 31, 209–11, 220*

green-backed heron (*Butorides striatus*), 28

grist mill, Mount Vernon, Va., 87

gull, laughing (*Larus atricilla*), *36, 134–35*

Gunston Hall, Va., *90*

Hall, Russell, 159

Hambleton's Hill bar, 201

Hammond, John, 53

Hampton, Va., 155

Hampton Roads, 18, 19

Hamlyn, Martha, 15

Harmon, Godfrey, *92*

Harris Creek, 202

Harrison, Edward Riley, 177–78

Haunted Bookshop, Annapolis, Md., 152

Havemeyer, Chris, 206

Havre de Grace, Md., 99; lighthouse at, *181*

Helsinki bar, 201

Henrietta Maria, Queen of England, 50

Heritage Tourism Program, 11

herons: black-crowned night (*Nycticorax nycticorax*), *217*; great blue (*Ardea herodias*), *140,* 219; green-backed (*Butorides striatus*), 28; tricolored (*Egretta tricolor*), 208

Herring Island bar, 201

Hill, Edward, 63

Hill, Edward, 2d, 63

Hill, Elizabeth, 66

H. M. Woodburn & Co., Solomons, Md., 178

Holland, Gary, 103–5

Holland Island, 11

Hollicutsnoose bar, 201

homes, *100, 162*; condominiums and town houses, 99, 127, 141, *145,* 153–55, *169,* 174–76, 187, 206; escalation in prices of, 162, 173, 205–6; thatched, 43, *65. See also* plantations

Hooper Island, *100*

Hooper Island lighthouse, St. Michaels, Md., *145*

Hopkins & Brothers General Store, Onancock, Va., *155*

Horner, Dave, 105

Horner, Ed, 107

Horner, Loudy (nephew), 105, 110

Horner, Loudy (uncle), 110–13

Horner, Stephen, 99, 105–10, *105*

Horner, Stephen, Jr., *105*

Hubbard's Pier and Seafood Restaurant, Rock Hall, Md., 166–69, *168–69,* 172

Hurricane Agnes, 108, 166, 190, 200

Hurricane Sandy, 11, 13

Indians: Bacon's Rebellion and, 45; Maryland settlers and, 49, 51, 52, 53; massacre of 1622 and, 43; Smith and, 38, 40–41, 42, 43

industrial wastes, 202, 203

Ingalls, Mabel Satterlee, 81
Ingle, Richard, 53, 63

James I, King of England, 38, 44
James River, 19, 37, 40, 61, 62, 63, 83
Jamestown colony, Va., 37–40, *37*, 42–48, 50, 63; demise of, 45–48; hardships faced by first settlers at, 37–38; Indian attacks on, 43, 45
Jamestown Festival Park, Jamestown, Va., *38, 39*, 56
Jamestown Tercentennial Exposition (1907), 56
Jefferson, Thomas, 19, *94–95*
Jefferson Island, *49*
Jefferson Memorial, Washington, D.C., *146*
Johns Hopkins Chesapeake Bay Institute, Baltimore, Md., 196–200
Johns Hopkins University, Baltimore, Md., 188
Johnson, Jack, 178
Johnson, Governor Thomas, Bridge, 176, 178
Jones, Arthur ("Popeye"), 123, *125*
Jones, Jonathan, 206
Jones Shore, Md., 201

Kendall, Calvin, 169–72, 173
Kent County, Md., 206–7; seat of, *163*
Kent Island, Md., 49, 50, 53–54, 56
Kent Narrows, Md., 99, 187
Key, Francis Scott, 17, *148*
Key, Francis Scott, Bridge, 164
kitchen, Wakefield Plantation, Westmoreland County, Va., *89*

land grants, 62–63
Langford Creek, 206–7
Langley, Leroy ("Pepper"), 173
Lanier, Mrs. Charles D., 77
Lanier, Sidney, 77
Larrimore, Darryl, 122
laughing gull (*Larus atricilla*), *36, 134–35*
Lee, Anne McCarty, 68
Lee, Arthur, 66
Lee, Francis Lightfoot, 66

Lee, Hannah, 70
Lee, Henry ("Lighthorse Harry"), 66–68
Lee, Henry, IV ("Black-Horse Harry"), 68
Lee, Margaret, 68
Lee, Mary Custis, 75
Lee, Matilda, 68
Lee, Philip Ludwell, 3d, 68
Lee, Richard, 63
Lee, Richard, 2d, 63
Lee, Richard Henry, 66
Lee, Robert E., 62, 68, 74, 75, 77; birthplace of (*see* Stratford Hall)
Lee, Thomas, 63–66, 68
Lee, Thomas Ludwell, 66
Lee, William, 66
Lee, Robert E., Memorial Foundation, 77
Legg, Martin, 169
Lesh, Kathleen, *38*
lighthouses: Cape Henry, *37*; Cove Point, *180*; Drum Point, *176*; Havre de Grace, *181*; Hooper Island, *145*; Thomas Point, *178–79*
lilies, day, *60*
Long Island, Chesapeake country compared to, 19–24
Lord Baltimore's World, St. Mary's City, Md., 56

McCarty, Anne, 68
McCarty, Elizabeth, 68, 75–77
McClellan, George B., 74
McNasby's Oyster Co., Annapolis, Md., 152
Mangini, Joe, 172, 173
Man O'War Shoals, 191–96
marinas, *145*, 153–55, *169–71*, 196, *197*
Mariners' Museum, Newport News, Va., *173*
Market Square town houses, Cambridge, Md., 127
Marshall (developer), 207
Marshall, Bobby, 11–13
Marshall, Janice, 11–13
marshes, 8, *22–23, 30, 31, 33, 58, 153, 218–19*
Maryland: attempt to curtail growth in, 205–7; border war between Virginia

and, 53–55; discovery and settlement of, 49–54, 56–57, 62–63; efforts to improve oyster crop in, 188–96. *See also specific sites*
Maryland Day, 51
Maryland Environmental Trust, 207
Maryland Oyster Navy, 18, 126, 188
Mason, George, *90*
massacre of 1622, 43
Mazzaccaro, Tony, 201
Mears, Otto, 158
Mencken, H. L., 19
Merrimack (ironclad), 17
microlayer, 203
Miss Kim (workboat), *97, 111*
Mobjack Bay, *198*
Monitor (ironclad), 17
Morris, Robert, Inn, Oxford, Md., *142*
Mount Harmon, Cecil County, Md., *92–93*
Mount Vernon, Va., 55, *86–87*
Mount Vernon Ladies Association, 77
MSX parasite, 122, 202
Murphy, Wade, *96, 97*, 98, 110
museums: Calvert Marine, 173, *174*; Chesapeake Bay Maritime, 122, *145*; Mariners', *173*

National Register of Historic Places, 113
Natural Resources Department (Maryland), 126
Naval Academy, U.S. (Annapolis), 55, *151, 152*
Navigation Acts, 62
Nellie Byrd (skipjack), 122
Netter, James ("Slick"), 123
Newport News, Va., 153–55, *154*, 173
Norfolk Rebel (tugboat), *130*
North, John, II, 207
North Beach, Md., 159
North Beach Bayfest, 159
North Point, Md., *198*
Northside Marina, Rock Hall, Md., 172
nutrient levels, 199, 202

Old Bohemia Church, near Georgetown, Md., *44*

Onancock, Va., *130, 155, 155, 157, 158*
Onancock River, *156*
Orient, search for inland sea to, 18, 37, 41
Otto Mears Goes East: The Chesapeake Beach Railway (book; Williams), 159
owl, screech (*Otus asio*), *189*
Oxford, Md., 99, *142, 143,* 155, 158, *198*
oxygen depletion, 199, 202
oyster boats, *126.* See also skipjacks
Oyster Cove town houses, Kent Narrows, Md., 99, *187*
Oyster Laws, 188, 191
Oyster Navy, 18, 126, 188
Oyster Opening International, *187*
oysters, oystering, 10, 18, 25, *42,* 99, 103, 105, 113, 122–27, *124, 125,* 155, 158, *186, 187–96, 188;* aquaculturing of, *194–95;* baby (spat), surveys of, 200–2; conservation laws and, 97, 188, 191; and dredging of bars, 187, 191–96; history of, 188; Hurricane Agnes and, 166, 190, 200; overharvesting of, 188; parasites and, 122, 202; seeding programs for, 120, 191; shucking contests, 187, *187*
Oyster Wars, 18, 55

painted turtle (*Chrysemys picta*), *189, 207*
Palmer's (Poole's) Island, Md., 49
parasites, 122, 202
Parliament, 53, 54
Patapsco River, 19, 164, *198*
Patuxent River, 17, 42, 61, 62, 63, *72–73, 77–80,* 173, 176
Patuxent River Naval Air Station, 80
Payne, "Uncle Billy," 75, 82–83
Payne, Wesley, 83
Pete's Place, Annapolis, Md., 151–52
Pilgrims, 43
Piney Point, Md., oyster aquaculture at, *194–95*
Piscataway Indians, 51
plantations, 14, 18, 61–83, 155; Brandon, *94–95;* Civil War and, *70–74, 75–77;* Flowerdew Hundred, *43;* Fort, *40;* Godiah Spray, *65;* land grants and, 62–63; Mount Harmon, *92–93;* rise of, 61–62; Shirley, 62, 63, *66–68, 67–69,*

70, 74, *81–82;* Sotterly, *62–63, 63, 68–74, 71–74, 77–81,* 82; Stratford, 62, *63, 68–70, 74–77, 76, 78–80, 82–83;* Wakefield, *16, 85, 88, 89;* Woodlawn, *90*
Plater, Elizabeth Sommerville, 70
Plater, George, II, 68
Plater, George, III, 68–70
Plater, George, IV, 70
Plater, George, V, 70
Plum Tree Island National Wildlife Refuge, Poquoson, Va., *32–33*
Pocahontas, 38, 40–41, *40,* 43
Point Lookout State Park, Md., *198*
pollution, 166, 190, 196, 199, 202, 203, 205
Poole's (Palmer's) Island, Md., 49
Pope, Nathaniel, 63
Poplar Island, Md., 7, 10, 49, *49*
Port Isobel Island, 13
Potomac River, 19, 61, 62, 66, *87, 198,* 200, 201, 203
Powhatan, 40, *40,* 43
Price, George, *187*
Prohibition, 80
Puritans, 52–53

Queen Anne's lace, *61*

Raleigh, Sir Walter, 37
Rappahannock River, 42
Reagan, Ronald, 203
recreation, 141, 147, 174
refuges. *See* wildlife refuges, national
resort towns, 158–64
Revolutionary War, 17, *17,* 62, 66, 68, *142*
Rhodes Point, Md., *25, 100–1,* 201
Richardson, Jim, 15
Richmond, Va., 19, 83
Ridgely Warfield (research vessel), 196–200
Roanoke colony, Va., 37, 41
Robert E. Lee Memorial Foundation, 77
Robert H. Cannon Company, Cambridge, Md., 127
Robert Morris Inn, Oxford, Md., *142*
rockfish (striped bass), 10, 25, 164–66, 169, 196
Rock Hall, Md., 13, *35, 131,* 141, 158, 164–73, *165–71*

Rock Hall Clam and Oyster Co., Rock Hall, Md., 166
Rock Hall Landing Marina, Rock Hall, Md., *169*
Rolfe, John, 40, 41
Rolfe, Thomas, 41
Roscoe Cole house, Colonial Williamsburg, Va., *46*
Rothschild, Brian, 176, 177
Ruke's, Ewell, Md., *133*

Sachs, Stephen H., 57
sailboats, sailing, *21, 136–39, 152, 204. See also* skipjacks
Sailing Emporium, Rock Hall, Md., *170–71, 172–73*
St. Clement's Island, Md., 50–51, *51,* 56, *57, 77*
St. Francis Xavier Roman Catholic Church, near Georgetown, Md., *44*
St. George's Island, Md., *34*
St. Mary's City, Md., 51–52, *52,* 53, 54, *54,* 56, *57,* 64, *65*
St. Mary's College, 56
St. Mary's County, Md., *34,* 52, 54, *74, 192–93, 194–95*
St. Mary's County Oyster Festival, 187
St. Mary's County Seafood Festival, 187, *187*
St. Michaels, Md., 14, 99, *145,* 158, 177, 196; Chesapeake Bay Maritime Museum in, 122, *145*
St. Michaels Inn, St. Michaels, Md., *145*
Sassafras River, *20, 21*
Satterlee, Herbert, 80–81
Saxis, Va., *106*
Schaefer, William Donald, 141
Scotland bar, 201
screech owl (*Otus asio*), *189*
Sea Raven (workboat), *35*
Serino, Joe, 115
serpentine wall, Mount Harmon, Cecil County, Md., *92*
sewage treatment plants, 203
shad, 25, 190
"shaft tongers," 113, 126
Shell Hill bar, 201

Shirley Plantation, Va., 14, 62, 70, 81–82; Civil War and, 74; dovecote at, *67*; family ties of Stratford and, 66–68; great house at, *68–69*; origins of, 63; storage building at, *67*

skipjacks, 10, 11, 19, *103*, 113–27, *114*, *116–19*, *121*, *124*, *125*, 174, *186*; annual race of (Deal Island), 115–21, *116–17*. See also workboats

slavery, 14, 62, 70, 74, 75, 82–83

Smith, John, 19, 38–43, *40*, 188, 196; abrasive personality of, 38–40; Chesapeake Bay explored by, 41–42; saved by Pocahontas, 38, 40–41

Smith Island, Md., 7, 11–13, *25*, *31*, 41, *42*, 55, 99, *100–2*, 110, *129*, *132*, *133*, *201*; Big Thoroughfare on, *108*, *129*, *132*; gentrification of, 13, 153, *153*

snow geese (*Chen caerulescens*), 22–23, *26–27*

snowy egret (*Egretta thula*), 59, 210, *212–13*

Society of the Ark and Dove, 57

Solomons, Md., 14, 141, 158, 173–78, *174–76*, 205; Calvert Marine Museum in, 173, *174–76*; fishing from bulkhead in, 177–78

Solomons Island Yacht Club, 174

Someplace Else (restaurant), Rock Hall, Md., 169

Somers Cove, *113*

Sommerville, Elizabeth, 70

Sommerville, William, 70, 74

Sommerville, William Clarke, 68

Sotterly Mansion Foundation, 81

Sotterly Plantation, St. Mary's County, Md., 14, 62–63, *63*, 68–74, *71–74*, 77–81, 82; Civil War and, 70–74; family ties of Stratford and, 68–70; manor house at, *71*; origins of, 62–63; Patuxent River view from, *72–73*

southern hospitality, 62

South Marsh Island, *58–59*

spat surveys, 200–2

Stagg, Cluney, 174

staircase, Mount Harmon, Cecil County, Md., *93*

Standish, Miles, 43

"Star-Spangled Banner, The" (anthem; Key), 17, *148*

State House, St. Mary's City, Md., *52*, *54*, 56

Stephens, Otis, *173*

Storke, Elizabeth McCarty, 68, 75–77

Storke, Henry, 75

storms, 17, 197–99, *198*

Strand-Oxford shoreline, Md., *143*

Stratford Hall, Westmoreland County, Va., 14, 62, 63–68, 70, 74–77, *76*, *78–80*, 82–83; brick horse barn at, *78–79*; Civil War and, 75–77; family ties of Shirley and, 66–68; family ties of Sotterly and, 68–70; origins of, 63–66; patriotism and public service as traditions of, 66; pen and inkstand, *80*; restoration of, 77

Streets, Laura Payne, 82–83

striped bass (rockfish), 25, 164–66, 169, 196

Stuart, Charles Edward, 77

Stuart, Richard Henry, 77

Sullivan, Kevin, 202

sunrise, *58–59*, *96*, *118–19*, *124*

sunset, *103*, *158*

Susan Constant (ship), 37, *39*

Susquehanna River, 17, 190

Susquehannock Indians, 42, 45

Taft, Jay, 196, 197, 199, 200

Taggs, Andrea, 173–74

Talbot County, Md., 202, 205

Tangier Island, Va., 41, 99, *109*, *128*, *129*

tavern, seventeenth-century, St. Mary's City, Md., *57*

thatched homes, 43, *65*

Thomas, Joshua, 99

Thomas Clyde (skipjack), 10, *114*, 115–27, *124*, *125*, *188*

Thomas Point lighthouse, Md., *178–79*

Tidal Basin, Washington, D.C., *146*, 203

Tidewater Express company, 110

tiger swallowtail butterfly (*Papilio glancus*), *61*

Tilghman Island, Md., 11, 14, *107*, 113, 203

tobacco, 19, 41, 61, 62, 63, *63*, 70, 155; air curing, *65*

Todkill, Anas, 42, 43

Toleration Act (1649), 53

tourism, 11, 14, 141, 172, 174

town houses, 99, 127, 141, 162–64, 187, 206

towns, 18–19, 99, 141–78; discouraged by protectionist statutes, 61–62; gentrification of, 141, 147, 152–55, 158–78; rise of, 155–58. See also specific towns

Tred Avon River, *138–39*, *143*, *198*, 202

tricolored heron (*Egretta tricolor*), 208

Trinity Protestant Church, Dorchester County, Md., *53*

Trinity Protestant Episcopal Church, St. Mary's City, Md., *54*

trotlines, 97, *97*, *98*

tugboats, *154*, 177

turtle, painted (*Chrysemys picta*), *189*, 207

Tylerton, Md., 11–13, *130*, *132*, 153

United Methodist Church, Ewell, Md., *102*

University of Maryland, 200–2

U.S.S. Trenton (ship), *149*

Virginia: border war between Maryland and, 53–55; discovery and settlement of, 37–48, 51, 53, 56; laissez-faire attitude toward bay in, 196; plantation life established in, 61–62. See also specific sites

Virginia Bill of Rights, 90

Virginia Trading Company of London, 37, 38, 40, 44, 53

wagon, seventeenth-century, *64*

Wakefield Plantation, Westmoreland County, Va., *16*; original outline of, *88*; out-kitchen at, *89*; replica of, *85*

Wall Street Journal (newspaper), 202

War of 1812, 17, 70, 99, *148*, *198*

Washington, George, 17, 55, 66, 68, 77, *87*, 90; birthplace of, *16*, *85*, *88*, *89*

Washington, Mary, 75

Washington, D.C., 19, 61, 68, *146*, 147–51, *147*, 155, 158

Waterman's Crabhouse Restaurant, Rock Hall, Md., *166–67*

watermen, 10, 19, 25, 30, *42*, 97–127, 141, 153, 188, 190, 196–97, 201; Annapolis as port for, 151–52; border wars and, 55; of Deal Island, 99–121; decline in number of, 11, 13, 97, 99, 103–5; dialect of, 99; flexibility of catches available to, 190; graves of, 100; of Rock Hall, 166, 169, 172; of Solomons, 173, 177; tourism and, 11, 14. *See also* skipjacks; workboats
Webster, Danny, 120
Webster, Don, 201
Webster, Doug, 120
Webster, Glenn, 115, 120
Webster, Price, 123
Webster, Ricky, 115, 120
Wenona, Md., *12*, 102–7, *103*
West, Cecily Sherley, 63
West, Sir Thomas, 63
Westover Church, Charles City County, Va., *91*

Whitbeck, Matt, 8
White, Father Andrew, 51
White, Steven, 11
White House, Washington, D.C., *146*
white-tailed deer (*Odocoileus virginianus*), 29
wildlife refuges, national: Blackwater, 8–10, *30, 59, 189–91, 207, 208, 212–13*; Eastern Neck, *134, 192, 218–19, 222*; Elk Neck, *58, 189*; Plum Tree Island, *32–33*
Williams, James W., 159
Williamsburg, Va., 45, *45–48*, 60, 84, 155
windmill, Flowerdew Hundred Plantation, Va., *43*
Windmill Point, Rock Hall, Md., 172
Windward Key town houses, Chesapeake Beach, Md., 141, 162–64, 206
Woodburn, Edgar, 178
Woodburn, H. M., & Co., Solomons, Md., 178

Woodfield, Chuckie, 169
Woodfield Fish & Oyster Co., Galesville, Md., 152
Woodlawn Plantation, Fairfax County, Va., *90*
workboats, 11, *35, 104, 106, 107, 113, 129, 130*, 151, *154, 158, 165*, 166, 197, 201, *201. See also* skipjacks
World's Columbian Exposition (1893), 188
World War I, 18
World War II, 18, 159
Wren, Christopher, Building, Williamsburg, Va., *84*
Wye River, *204*

Yorktown Festival Park, *41*
Yorktown Victory Monument, *17*

Zahniser, Ellen, 176
Zahniser, Skip, 176

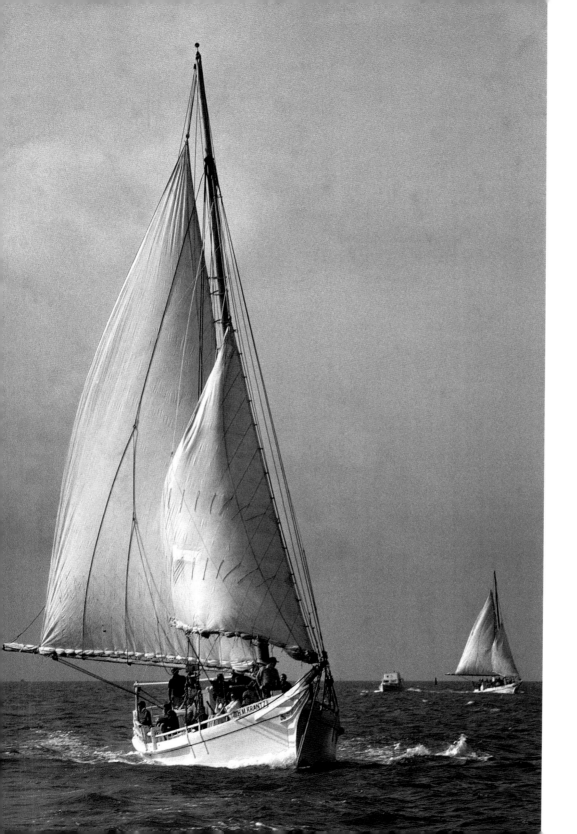

A skipjack under sail

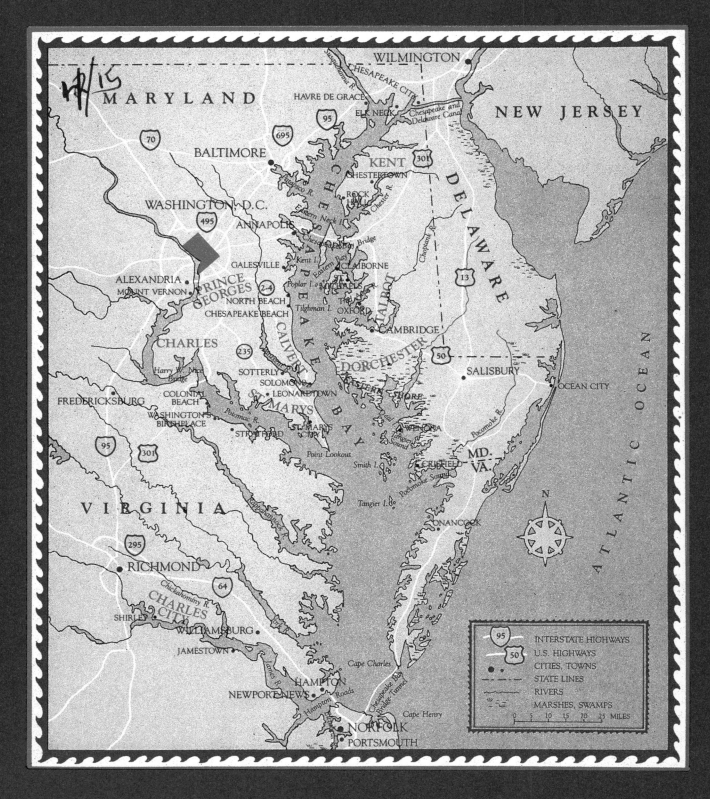